VISION AND
DIFFERENCE

VISION AND DIFFERENCE

Femininity, feminism and
histories of art

GRISELDA POLLOCK

ROUTLEDGE
London and New York

First published in 1988 by
Routledge
11 New Fetter Lane, London EC4P 4EE

Published in the USA by
Routledge, Chapman & Hall, Inc.
29 West 35th Street, New York, NY 10001

Typeset in Great Britain by
Mayhew Typesetting, Bristol
Printed in Great Britain at
The University Press, Cambridge

British Library Cataloguing in Publication Data

Pollock, Griselda
Vision and difference : femininity, feminism,
and histories of art.
1. Women artists—Historiography
I. Title
709'.2'2 N8354

ISBN 0–415–00721–6
ISBN 0–415–00722–4 Pbk

Library of Congress Cataloging in Publication Data

Pollock, Griselda.
Vision and difference : femininity, feminism,
and histories of art
Griselda Pollock.
p. cm.
Bibliography: p.
Includes index.
ISBN 0–415–00721–6 ISBN 0–415–00722–4 (pbk.)
1. Feminism and art. I. Title.
N72.F45P64 1988
704'.042--dc19

For Tony,
Benjamin and Hester

CONTENTS

ILLUSTRATIONS

Illustrations

Illustrations 5.1–5.9 are all by Dante Gabriel Rossetti. The titles are taken from the *catalogue raisonné* edited by Virginia Surtees. The quotation marks emphasize the tentative nature of the attributions.

Vision and Difference

Illustrations

The author and publisher are grateful to all those individuals and organizations listed above who have granted permission to reproduce pictures. Every effort has been made to obtain permission to use copyright material but if for any reason a request has not been received the copyright holder should contact the publisher.

ACKNOWLEDGEMENTS

It is normal to take this space to thank colleagues and friends who have helped in the making of a book. There have been so many contributions to the development and excitement of feminist art history that the list of names would and should be long. I hope those whose example and practices have helped me will find themselves acknowledged in due place throughout the text.

It is also common for authors to leave until last their families, as if the domestic backup is less valuable than the intellectual input of academic colleagues and friends. This is not so. The people who have given generously of their time, patience and support to make this book possible are my children and their father. The book is dedicated to them with deepest thanks. I have not yet found the balance between the passions of motherhood and the thrills of feminist scholarship. It is my children and their father who live out the painful effects of the struggle which feminism has brought to us. It is they above all and by name who must be acknowledged as my co-producers, Tony Bryant, Benjamin Pollock Bryant and Hester Pollock Bryant.

1

Feminist interventions in the histories of art: an introduction

Is adding women to art history the same as producing feminist art history?[1] Demanding that women be considered not only changes what is studied and what becomes relevant to investigate but it challenges the existing disciplines politically. Women have not been omitted through forgetfulness or mere prejudice. The structural sexism of most academic disciplines contributes actively to the production and perpetuation of a gender hierarchy. What we learn about the world and its peoples is ideologically patterned in conformity with the social order within which it is produced. Women's studies are not just about women – but about the social systems and ideological schemata which sustain the domination of men over women within the other mutually inflecting regimes of power in the world, namely those of class and those of race.[2]

Feminist art history, however, began inside art history. The first question was 'Have there been women artists?' We initially thought about women artists in terms of art history's typical procedures and protocols – studies of artists (the monograph), collections of works to make an oeuvre (*catalogues raisonnés*), questions of style and iconography, membership of movements and artists' groups, and of course the question of quality. It soon became clear that this would be a straitjacket in which our studies of women artists would reproduce and secure the normative status of men artists and men's art whose superiority was unquestioned in its disguise as Art and the Artist. As early as 1971 Linda Nochlin warned us against getting into a no-win game trying to name female Michelangelos. The criteria of greatness was already male defined. The question 'Why have there been no great women artists?' simply would not be answered to anything but women's disadvantage

1

if we remained tied to the categories of art history. These specified in advance the kind of answers such a question would merit. Women were not historically significant artists (they could never deny their existence once we began to unearth the evidence again) because they did not have the innate nugget of genius (the phallus) which is the natural property of men. So she wrote:

> A feminist critique of the discipline is needed which can pierce cultural-ideological limitations, to reveal biases and inadequacies *not merely in regard to the question of women artists, but in the formulation of the crucial questions of the discipline as a whole.* Thus the so-called woman question, far from being a peripheral sub-issue, can become a catalyst, a potent intellectual instrument, probing the most basic and 'natural' assumptions, providing a paradigm for other kinds of internal questioning, and providing links with paradigms established by radical approaches in other fields.[3]

In effect, Linda Nochlin called for a paradigm shift. The notion of a paradigm has become quite popular amongst social historians of art who borrow from Thomas Kuhn's *Structure of Scientific Revolutions* in order to articulate the crisis in art history which overturned its existing certainties and conventions in the early 1970s.[4] A paradigm defines the objectives shared within a scientific community, what it aims to research and explain, its procedures and its boundaries. It is the disciplinary matrix. A paradigm shift occurs when the dominant mode of investigation and explanation is found to be unable satisfactorily to explain the phenomenon which it is that science's or discipline's job to analyse. In dealing with the study of the history of nineteenth- and twentieth-century art the dominant paradigm has been identified as modernist art history. (This is discussed at the beginning of Essay 2.) It is not so much that it is defective but that it can be shown to work ideologically to constrain what can and cannot be discussed in relation to the creation and reception of art. Indeed modernist art history shares with other established modes of art history certain key conceptions about creativity and the suprasocial qualities of the aesthetic realm.[5] Indicative of the potency of the ideology is the fact that when, in 1974, the social historian of art T.J. Clark, in an article in the *Times Literary Supplement*, threw down the gauntlet from a Marxist position he still entitled the essay 'On the conditions of artistic *Creation*.[6]

Within a few years the term production would have been inevitable and consumption has come to replace reception.[7] This reflects the dissemination from the social history of art of categories of analysis derived from Karl Marx's methodological exerque *Grundrisse* ('Foundations'). The introduction to this text which became known only in the

mid-1950s has been a central resource for rethinking a social analysis of culture. In the opening section Marx tries to think about how he can conceptualize the totality of social forces each of which has its own distinctive conditions of existence and effects yet none the less relies on others in the whole. His objective is political economy and so he analyses the relations between production, consumption, distribution and exchange, breaking down the separateness of each activity so that he can comprehend each as a distinct moment within a differentiated and structured totality. Each is mediated by the other moments, and cannot exist or complete its purpose without the others, in a system in which production has priority as it sets all in motion. Yet each also has its own specificity, its own distinctiveness within this non-organic totality. Marx gives the example of art in order to explain how the production of an object generates and conditions its consumption and vice versa.

> Production not only supplies a material for a need, but also supplies a need for the material. As soon as consumption emerges from its initial natural state of crudity and immediacy . . . it becomes itself mediated as a drive by the object. The need which consumption feels for the object is created by the perception of it. The object of art – like every other product – creates a public which is sensitive to art and enjoys beauty. Production not only creates an object for the subject, but also a subject for the object. Thus production produces consumption, 1) by creating the material for it; 2) by determining the manner of consumption; 3) by creating the products initially posited as objects in the form of a need felt by the consumer. It thus produces the object of consumption, the manner of consumption and the motive of consumption. Consumption likewise produces the producer's *inclination* by beckoning to him as an aim-determining need.[8]

This formulation banishes the typical art historical narrative of a gifted individual creating out of his (*sic*) personal necessity a discrete work of art which then goes out from its private place of creation into a world where it will be admired and cherished by art lovers expressing a human capacity for valuing beautiful objects. The discipline of art history like literary criticism works to naturalize these assumptions. What we are taught is how to appreciate the greatness of the artist and the quality of art objects.

This ideology is contested by the argument that we should be studying the totality of social relations which form the conditions of the production and consumption of objects designated in that process as art. Writing of the shift in the related discipline of literary criticism,

3

Raymond Williams has observed:

> What seems to me very striking is that nearly all forms of contemporary critical theory are theories of *consumption*. That is to say, that they are concerned with understanding an object in such a way that it can be profitably and correctly consumed.[9]

The alternative approach is not to treat the work of art as object but to consider art as *practice*. Williams advocates analysing first the nature and then the *conditions of a practice*. Thus we will address the general conditions of social production and consumption prevailing in a particular society which ultimately determine the conditions of a specific form of social activity and production, cultural practice. But then since all the component activities of social formation are practices we can move with considerable sophistication from the crude Marxist formulation of all cultural practices being dependent upon and reducible to economic practices (the famous base-superstructure idea) towards a conception of a complex social totality with many interrelating practices constitutive of, and ultimately determined within, the matrix of that social formation which Marx formulated as the mode of production. Raymond Williams in another essay made the case:

> The fatally wrong approach, to any such study, is from the assumption of separate orders, as when we ordinarily assume that political institutions and conventions are of a different and separate order from artistic institutions and conventions. Politics and art, together with science, religion, family life and the other categories we speak of as absolutes, belong in a whole world of active and interactive relationships. . . . If we begin from the whole texture, we can go on to study particular activities, and their bearings on other kinds. Yet we begin, normally, from the categories themselves, and this has led again and again to a very damaging suppression of relationships.[10]

Williams is formulating here one of the major arguments about method propounded by Marx in *Grundrisse* where Marx asked himself where to begin his analyses. It is easy to start with what seems a self-evident category, such as population in Marx's case, or art in ours. But the category does not make sense without understanding of its components. So what method should be followed?

> Thus, if I were to begin with the population, this would be a chaotic conception of the whole, and I would then, by means of further determination move analytically towards ever more simple concepts, from the imaginary concrete to ever thinner abstractions

4

until I had arrived at the simplest determinations. From there the journey would have to be retraced until I had finally arrived at the population again, but this time not as a chaotic conception of a whole but as a rich totality of many determinations and relations.[11]

If we were to take art as our starting-point, it would be a chaotic conception, an unwieldy blanket term for a diversified range of complex social, economic, and ideological practices and factors. Thus we might break it down to production, criticism, patronage, stylistic influences, iconographic sources, exhibitions, trade, training, publishing, sign systems, publics, etc. There are many art history books which leave the issue in that fragmented way and put it together as a whole only by compiling chapters which deal with these components separately. But this is to leave the issue at the analytical level of the thin abstractions, i.e. elements abstracted from their concrete interactions. So we retrace the steps attempting to see art as a *social practice*, as a totality of many relations and determinations, i.e. pressures and limits.

Shifting the paradigm of art history involves therefore much more than adding new materials – women and their history – to existing categories and methods. It has led to wholly new ways of conceptualizing what it is we study and how we do it. One of the related disciplines in which radical new approaches were on offer was the social history of art. The theoretical and methodological debates of Marxist historiography are extremely pertinent and necessary for producing a feminist paradigm for the study of what it is proper to rename as cultural production. The difficult but necessary relation between the two is the topic of the second essay in this book. While it is important to challenge the paternal authority of Marxism under whose rubric sexual divisions are virtually natural and inevitable and fall beneath its theoretical view, it is equally important to take advantage of the theoretical and historiographical revolution which the Marxist tradition represents. A feminist historical materialism does not merely substitute gender for class but deciphers the intricate interdependence of class and gender, as well as race, in all forms of historical practice. None the less there is a strategic priority in insisting upon recognition of gender power and of sexuality as historical forces of significance as great as any of the other matrices privileged in Marxism or other forms of social history or cultural analysis. In Essay 3 a feminist analysis of the founding conditions of modernism in the gendered and eroticized terrain of the modern city directly challenges an authoritative social historical account which categorically refuses feminism as a necessary corollary. The intention is to displace the limiting effects of such partial re-readings and to reveal

5

how feminist materialist analysis handles not only the specific issues of women in cultural history but the central and commonly agreed problems.

There were, however, other new models developing in corresponding disciplines such as literary studies and film theory, to name but the most influential. Initially the immediate concern was to develop new ways of analysing texts. The notion of a beautiful object or fine book expressing the genius of the author/artist and through him (sic) the highest aspirations of human culture was displaced by a stress on the productive activity of texts – scenes of work, writing or sign making, and of reading, viewing. How is the historical and social at work in the production and consumption of texts? What are texts doing socially?

Cultural practices were defined as signifying systems, as practices of *representation*, sites not for the production of beautiful things evoking beautiful feelings. They produce meanings and positions from which those meanings are consumed. Representation needs to be defined in several ways. As Representation the term stresses that images and texts are no mirrors of the world, merely reflecting their sources. Representation stresses something refashioned, coded in rhetorical, textual or pictorial terms, quite distinct from its social existence.[12] Representation can also be understood as 'articulating' in a visible or socially palpable form social processes which determine the representation but then are actually affected and altered by the forms, practices and effects of representation. In the first sense representation of trees, persons, places is understood to be ordered according to the conventions and codes of practices of representation, painting, photography, literature and so forth. In the second sense, which involves the first inevitably, representation articulates – puts into words, visualizes, puts together – social practices and forces which are not, like trees, there to be seen but which we theoretically know condition our existence. In one of the classic texts enunciating this phenomenon, *The Eighteenth Brumaire of Louis Napoleon* (1852), Kark Marx repeatedly relies on the metaphor of the stage to explain the manner in which the fundamental and economic transformations of French society were played out in the political arena 1848-51, a political level which functioned as a representation but then actively effected the conditions of economic and social development in France subsequently. Cultural practice as a site of such representation has been analysed in terms derived from Marx's initial insights about the relation between the political and economic levels.[13] Finally, representation involves a third inflection, for it signifies something represented to, addressed to a reader/viewer/consumer.

Theories of representation have been elaborated in relation to Marxist debates about ideology. Ideology does not merely refer to a collection of

ideas or beliefs. It is defined as a systematic ordering of a hierarchy of meanings and a setting in place of positions for the assimilation of those meanings. It refers to material practices embodied in concrete social institutions by which the social systems, their conflicts and contradictions are negotiated in terms of the struggles within social formations between the dominant and the dominated, the exploiting and the exploited. In ideology cultural practices are at once the means by which we make sense of the social process in which we are caught up and indeed produced. But it is a site of struggle and confusion for the character if the knowledges are ideological, partial, conditioned by social place and power.

Understanding of what specific artistic practices are doing, their meanings and social effects, demands therefore a dual approach. First the practice must be located as part of the social struggles between classes, races and genders, articulating with other sites of representation. But second we must analyse what any specific practice is doing, what meaning is being produced, and how and for whom. Semiotic analysis has provided necessary tools for systematic description of how images or languages or other sign systems (fashion, eating, travel, etc.) produce meanings and positions for the consumption of meanings. Mere formal analysis of sign systems, however, can easily lose contact with the sociality of a practice. Semiotic analysis, approached through developments in theories of ideology and informed by analyses of the production and sexing of subjectivities in psychoanalysis, provided new ways to understand the role of cultural activities in the making of meanings, but more importantly in the making of social subjects. The impact of these procedures on the study of cultural practices entirely displaces pure stylistic or iconographic treatments of isolated groups of objects. Cultural practices do a job which has a major social significance in the articulation of meanings about the world, in the negotiation of social conflicts, in the production of social subjects.

As critical as these 'radical approaches in other fields' was the massive expansion of feminist studies attendant on the resurgence of the women's movement in the late 1960s. Women's studies emerged in almost all academic disciplines challenging the 'politics of knowledge'.[14] But what is the object of women's studies? Writing women back does indeed cause the disciplines to be reformulated but it can leave the disciplinary boundaries intact. The very divisions of knowledge into segregated compartments have political effects. Social and feminist studies of cultural practices in the visual arts are commonly ejected from art history by being labelled a sociological approach, as if reference to social conditions and ideological determinations are introducing foreign concerns into the discrete realm of art. But if we aim

7

to erode the false divisions what is the unifying framework for the analysis of women?

In their introduction to the anthology *Women and Society*, the collective responsible for the 'Women in Society' course at Cambridge University in the 1970s questioned the possibility of even taking the term women for granted:

> At first sight, it might seem as if concepts like male/female, man/woman, individual/family are so self evident that they need no 'decoding', but can simply be traced through various historical or social changes. These changes would, for example, give a seventeenth-century English woman a different social identity from a low-caste Indian woman today, or would ascribe different functions to the family in industrial and pre-industrial societies. But the problem with both these examples is that they leave the alleged subject of these changes (woman, the family) with an apparently coherent identity which is shuffled from century to century or from society to society as if it was something that already existed independent of particular circumstances. One purpose of this book, and of our course as it has gradually evolved, is to question that coherency: to show that it is constructed out of social givens which can themselves be subjected to similar questioning. This book, therefore, concentrates on themes that return to the social rather than to the individual sphere, *emphasising the social construction of sexual difference.*[15] (my italics)

At a conference the artist Mary Kelly was asked to talk to the question 'What is feminist art?' She redirected the question to ask 'What is the problematic for feminist artistic practice?'[16] where problematic refers to the theoretical and methodological field from which statements are made and knowledge produced. The problematic for feminist analyses of visual culture as part of a broader feminist enterprise could be defined in terms offered above, the social construction of sexual difference. But it would need to be complemented by analysis of the psychic construction of sexual difference which is the site for the inscription into individuals, through familial social relations, of the socially determined distinction which privileges sex as a criterion of power.

We do need to point out the discrimination against women and redress their omission. But this can easily become a negative enterprise with limited objectives, namely correction and improvement. In art history we have documented women's artistic activity and repeatedly exposed the prejudice which refused to acknowledge women's participation in culture.[17] But has it had any real effect? Courses on women and art are occasionally allowed in marginal spaces which do

not replace the dominant paradigm. But even then there is cause for alarm. For instance in my institution on a four-year degree scheme students are exposed to feminist critiques of art history and a course on contemporary feminist artists for a period of twenty weeks, one two-term course. None the less the question was raised by an external assessor as to whether there was not too much feminism in this course. Indeed we should be deeply concerned about bias but no one seems unduly concerned about the massive masculinism of all the rest of our courses. The anxiety reflects something greater at stake than talking about women. Feminist interventions demand recognition of gender power relations, making visible the mechanisms of male power, the social construction of sexual difference and the role of cultural representations in that construction.

So long as we discuss women, the family, crafts or whatever else we have done as feminists we endorse the social givenness of woman, the family, the separate sphere. Once we insist that sexual difference is *produced* through an interconnecting series of social practices and institutions of which families, education, art studies, galleries and magazines are part, then the hierarchies which sustain masculine dominance come under scrutiny and stress, then what we are studying in analysing the visual arts is one instance of this production of difference which must of necessity be considered in a double frame: (a) the specificity of its effects as a particular practice with its own materials, resources, conditions, constituencies, modes of training, competence, expertise, forms of consumption and related discourses, as well as its own codes and rhetorics; (b) the interdependence for its intelligibility and meaning with a range of other discourses and social practices. For example the visitor to the Royal Academy in London in the mid-nineteenth century carried with her a load of ideological baggage composed of the illustrated papers, novels, periodical magazines, books on child care, sermons, etiquette manuals, medical conversations, etc., addressed to and consumed in distinctive ways by women of the bourgeoisie hailed through these representations as ladies. They are not all saying the same thing – the crude dominant ideology thesis. Each distinctively articulates the pressing questions about definitions of masculinity and femininity in terms of an imperialist capitalist system, in ways determined by its institutional site, producers and publics. But in the interconnections, repetitions and resemblances a prevailing regime of truth is generated providing a large framework of intelligibility within which certain kinds of understanding are preferred and others rendered unthinkable. Thus a painting of a woman having chosen a sexual partner outside marriage will be read as a fallen woman, a disordering force in the social fabric, an embodiment of mayhem, a contaminating

9

threat to the purity of a lady's womanhood, an animalized and coarsened creature closer to the physicality of the working-class populations and to the sexual promiscuity of 'primitive' peoples, etc., etc.

But will it be read differently if the viewer is a woman or a man? Will the representation be different if the producer is a woman or a man? This is a question I address in Essay 3. One of the primary responsibilities of a feminist intervention must be the study of women as producers. But we have problematized the category women to make its historical construction the very object of our analysis. Thus we proceed not from the assumption of a given essence of woman outside of, or partially immune to, social conditions but we have to analyse the dialectical relation between being a person positioned as in the feminine within historically varying social orders and the historically specific ways in which we always exceed our placements. To be a producer of art in bourgeois society in late-nineteenth-century Paris was in some sense a transgression of the definition of the feminine, itself a class-loaded term. Women were meant to be mothers and domestic angels who did not work and certainly did not earn money. Yet the same social system which produced this ideology of domesticity embraced and made vivid by millions of women, also generated the feminist revolt with a different set of definitions of women's possibilities and ambitions. These were, however, argued for and lived out within the boundaries established by the dominant ideologies of femininity. In that subtle negotiation of what is thinkable or beyond the limits, the dominant definitions and the social practices through which they are produced and articulated are modified – sometimes radically – as at moments of maximum collective political struggle by women or less overtly as part of the constant negotiations of contradictions to which all social systems are subject. In those spaces where difference is most insistently produced, as I define the eroticized territories of the modern city in Essay 3, it is possible to outline in larger characters the differential conditions of women's artistic practice in such a way that its delineation radically transforms the existing accounts of the phenomenon. In Essay 3 on 'Modernity and the spaces of femininity' my argument is addressed to feminists engaged in the study of the women impressionists, but equally it is a critique of both modernist and social art historians' versions of 'the painting of modern life' which exclusively consider the inescapable issues of sexuality from a masculinist viewpoint. My aim is precisely to show how a feminist intervention exceeds a local concern with 'the woman question' and makes gender central to our terms of historical analysis (always in conjunction with the other structurations such as class and race which are mutually inflecting).

A particularly fruitful resource for contemporary cultural studies has

been 'discourse analysis', particularly modelled on the writings of the French historian Michel Foucault. Foucault provided an anatomy of what he called the human sciences. Those bodies of knowledge and ways of writing which took as their object – and in fact produced as a category for analysis – Man. He introduced the notion of discursive formation to deal with the systematic interconnections between an array of related statements which define a field of knowledge, its possibilities and its occlusions. Thus on the agenda for analysis is not just the history of art, i.e. the art of the past, but also art history, the discursive formation which invented that entity to study it. Of course there has been art before art history catalogued it. But art history as an organized discipline defined what it is and how it can be spoken of. In writing *Old Mistresses: Women, Art and Ideology* (1981) Rozsika Parker and I formulated the issue thus:

> To discover the history of women and art is in part to account for the way art history is written. To expose its underlying values, its assumptions, its silences and its prejudices is also to understand that the way women artists are recorded is crucial to the definition of art and artist in our society.[18]

Art history itself is to be understood as a series of representational practices which actively produce definitions of sexual difference and contribute to the present configuration of sexual politics and power relations. Art history is not just indifferent to women; it is a masculinist discourse, party to the social construction of sexual difference. As an ideological discourse it is composed of procedures and techniques by which a specific representation of art is manufactured. That representation is secured around the primary figure of the artist as individual creator. No doubt theories of the social production of art combined with the structuralist assassination of the author would also lead to a denunciation of the archaic individualism at the heart of art historical discourse. But it is only feminists who have nothing to lose with the desecration of Genius. The individualism of which the artist is a prime symbol is gender exclusive.[19] The artist is one major articulation of the contradictory nature of bourgeois ideals of masculinity.[20] The figure remains firmly entrenched in Marxist art history, witness the work of T.J. Clark, the Modern Art and Modernism course at the Open University, and even Louis Althusser on Cremonini.[21] It has become imperative to deconstruct the ideological manufacture of this privileged masculine individual in art historical discourse. In Essay 4 Deborah Cherry and I analyse the reciprocal positioning of masculine creator and passive feminine object in the art historical texts which form the continuing basis for studies of Pre-Raphaelitism. The point of departure was an attempt

11

to write Elizabeth Siddall and other women artists of the group back into art history. But they are already there, doing a specific job in their appointed guise. Any work on historical producers such as Elizabeth Siddall required at once a double focus. Initially it needed a critical deconstruction of the texts in which she is figured as the beloved inspiration and beautiful model of the fascinating Victorian genius Rossetti. Furthermore it involved a realization that her history lay right outside the discursive field of art history in feminist historical research which would not focus on individuals but on the social conditions of working women in London as milliners, models, in educational establishments, etc. In conjunction with an analysis derived from the model of Foucault's work we deployed the notion of woman as sign developed in an article by Elizabeth Cowie in 1978.[22] Cowie combined models from structural anthropology's analysis of the exchange of women as a system of communication with semiotic theory about signifying systems. Cowie's essay still provides one of the path-breaking theorizations of the social production of sexual difference.[23]

Complementing the task of deconstruction is feminist rewriting of the history of art in terms which firmly locate gender relations as a determining factor in cultural production and in signification. This involves feminist readings, a term borrowed from literary and film theory. Feminist readings involve texts often produced by men and with no conscious feminist concern or design which are susceptible to new understanding through feminist perceptions. In Essay 6 I offer psychoanalytically derived readings of representations of woman in selected texts by the Victorian painter D.G. Rossetti. Psychoanalysis has been a major force in European and British feminist studies despite widespread feminist suspicion of the sexist applications of Freudian theory in this century. As Juliet Mitchell commented in her important book challenging feminist critique, *Psychoanalysis and Feminism*, Freudian theory offers not a prescription for a patriarchal society but a description of one which we can use to understand its functionings. In her introduction she referred to the Parisian feminist group Psychoanalyse et Politique and explained their interest in psychoanalysis:

> Influenced, but critically, by the particular interpretation of Freud offered by Jacques Lacan, Psychoanalyse et Politique would use psychoanalysis for an understanding of the operations of the unconscious. Their concern is to analyse how men and women live as *men and women* within the material conditions of their existence – both general and specific. They argue that psychoanalysis gives us the concepts with which we can comprehend how ideology functions; closely connected with this, it further offers analysis of

the place and meaning of sexuality and gender differences within society. So where Marxist theory explains the historical and economic situation, psychoanalysis, in conjunction with notions of ideology already gained in dialectical materialism, is the way of understanding ideology and sexuality.[24]

Foucault has provided a social account of the discursive construction of sexuality *and* he argued that in some critical sense 'sexuality' is fundamentally bourgeois in origin. 'It was in the great middle classes that sexuality, albeit in a morally restricted and sharply defined form, first became of major ideological significance.'[25] Foucault identifies psychoanalysis as itself a product of the will to know, the construction and subjection of the sexualized body of the bourgeoisie.[26] The deployment of psychoanalytical theory by contemporary feminists is not a flight from historical analysis into some universalistic theory. Rooted historically as the mode of analysis (and a technique for relieving the extreme effects) of the social relations, practices and institutions which produced and regulated bourgeois sexuality, psychoanalysis makes its revelation of the making of sexual difference. Foucault speaks of class sexualities but these fundamentally involved gendered sexualities. The making of masculine and feminine subjects crucially involved the manufacture and regulation of sexualities, radically different and hardly complementary let alone compatible, between those designated men and women. But these terms were ideological abstractions compared to the careful distinctions maintained between ladies and women in class terms, and gentlemen and working-class men. The social definitions of class and of gender were intimately connected. But the issue of sexuality and its constant anxieties pressed with major ideological significance on the bourgeoisie. The case of Rossetti is studied not for an interest in this artist's particularity but in the generality of the sexual formation which provides the conditions of existence of these texts. To use Jacqueline Rose's phrase, we are dealing with bourgeois 'sexuality in the field of vision'.[27]

For through psychoanalytical theory we can recognize the specificity of visual performance and address. The construction of sexuality and its underpinning sexual difference is profoundly implicated in looking and the 'scopic field'. Visual representation is a privileged site (forgive the Freudian pun). Works by Rossetti are studied not as a secondary version of some founding social moment, but as part of a continuum of representations from and to the unconscious, as well as at the manifest level through which masculine sexuality and sexual positionality was problematically negotiated by the mid-nineteenth-century metropolitan bourgeoisie. Woman is the visual sign, but not a straightforward

signifier. If Marxist cultural studies rightly privilege ideology, feminist analyses focus on pleasure, on the mechanisms and managements of sexualized pleasures which the major ideological apparatuses organize, none more potently than those involved with visual representation. The works by Rossetti dramatize precisely the drives and impediments which overdetermine the excessive representation of woman at this period. The term 'regime of representation' is coined to describe the formation of visual codes and their institutional circulation as a decisive move against art history's patterns of periodization by style and movement, e.g. Pre-Raphaelitism, Impressionism, Symbolism, and so forth. In place of superficial stylistic differences, structural similarities are foregrounded.

In the final essay I consider the works of a group of feminist art producers in Britain in the 1970s and 1980s for whom psychoanalytical analyses of the visual pleasures is a major resource for their production of feminist interventions in artistic practice. There are significant continuities between feminist art practice and feminist art history, for those dividing walls which normally segregate artmaking from art criticism and art history are eroded by the larger community to which we belong as feminists, the women's movement. We are our own conversational community developing our paradigms of practice in constant interaction and supportive commentary. The political point of feminist art history must be to change the present by means of how we re-represent the past. That means we must refuse the art historian's permitted ignorance of living artists and contribute to the present day struggles of living producers.

There are other links which make it relevant to conclude this book with an essay on contemporary feminist art. If modernist art history supplies the paradigm which feminist art history of the modern period must contest, modernist criticism and modernist practice are the targets of contemporary practice. Modernist thought has been defined as functioning on three basic tenets: the specificity of aesthetic experience; the self-sufficiency of the visual; the teleological evolution of art autonomous from any other social causation or pressure.[28] Modernist protocols prescribe what is validated as 'modern art', i.e. what is relevant, progressing, and in the lead. Art which engages with the social world is political, sociological, narrative, demeaning the proper concerns of the artist with the nature of the medium or with human experience embodied in painted or hewn gestures. Feminist artistic practices and texts have intervened in alliance with other radical groups to disrupt the hegemony of modernist theories and practices even now still active in art education in so-called postmodernist culture. They have done this not merely to make a place for women artists within the

art world's parameters. The point is to mount a sustained and far reaching political critique of contemporary representational systems which have an overdetermined effect in the social production of sexual difference and its related gender hierarchy.

Equally importantly they are discovering ways to address women as subjects not masquerading as the feminine objects of masculine desire, fantasy and hatred. The dominative pleasures of the patriarchal visual field are deciphered and disrupted and, in the gaps between, new pleasures are being forged from political understandings of the conditions of our existence and psychological making. Questions about how women can speak/represent within a culture which defines the feminine as silenced other are posed at the end of the third essay, about Mary Cassatt and Berthe Morisot, using a quotation from an article by Mary Kelly whose work is the major focus of Essay 7. This connection not only indicates the contribution of feminist practitioners in art to the development of feminist art history but expresses my concern to do immediately for living women artists what we can only do belatedly for those in the past – write them into history.

The essays collected here represent a contribution to a diversified and heterogeneous range of practices which constitute the feminist intervention in art's history. This is not an abstraction but a historical practice conditioned by the institutions in which it is produced, the class, race and gender position of its producers. No doubt the focus of my concerns is conditioned by the conversational community within which I work and to which I have access through the magazines, conferences, exhibitions and educational institutions which form the social organization of radical intellectual production in Britain. This community is a mixed one in which alliances are forged under the umbrella of common purposes contesting the hegemony of the dominant paradigms. This fact has both advantages and disadvantages. For instance, collaborative work on analyses of the institutions and practices of modernism and modernist art history[29] and blindness towards gender issues evident in these enterprises has shaped my understanding of the objectives and political necessities of feminist interventions while giving me invaluable understanding of the dominant paradigms and their social bases which are indispensable to current feminist work. Moreover this work was not only Eurocentric but ethnocentric. The position of Black artists, men and women, past and present, in all the cultural and class diversity of their communities and countries needs to be analysed and documented. Race must equally be acknowledged as a central focus of all our analyses of societies which were and are not only bourgeois but imperialist, colonizing nations. This remains a shadowy concern within this body of writings. But confronted by those involved in struggles around this

issue, we must undergo self-criticism and change our practices.

The major community from which this book emerges and to which it is addressed is a dispersed one, composed of feminists working the world over researching, writing, talking with and for each other, in the construction of a radically new understanding of our world in all its horror and hope. The women who have inspired and supported me cannot be listed in their entirety. They are acknowledged throughout the texts which follow. This community is an academic one, benefiting from the privileged access to money and time to study and write. However compromised our activities sometimes seem within the bastions of power and privilege, and no doubt we are compromised and blinkered as a result, there remains a necessity for intellectual production in any political struggle. Some comfort can be gleaned from Christine Delphy's clear vision of feminist theory as a complement to the social movement of women:

> Materialist feminism is therefore an intellectual procedure whose advent is crucial for social movements and the feminist struggle and for knowledge. For the former it corresponds to the passage from utopian to scientific socialism and it will have the same implications for the development of feminist struggle. That procedure could not limit itself to women's oppression. It will not leave untouched any part of reality, any domain of knowledge, any aspect of the world. In the same way as feminism-as-a-movement aims at the revolution of social reality, so feminism-as-a-theory (and each is indispensable to each other) aims at a revolution in knowledge.[30]

Feminism-as-a-theory represents a diversified field of theorizations of at times considerable complexity. Their production and articulation is, however, qualified at all times by the political responsibility of working for the liberation of women.

What has art history to do with this struggle? A remote and limited discipline for the preservation of and research into objects and cultures of limited if not esoteric interest, art history might seem simply irrelevant. But art has become a growing part of big business, a major component of the leisure industry, a site of corporate investment. Take for instance the exhibition at the Tate Gallery in 1984, *The Pre-Raphaelites*, sponsored by a multinational whose interests involved not only mineral, banking and property concerns, but publishing houses, zoos and waxworks, as well as newspapers and magazines. What were they supporting – an exhibition which presented to the public men looking at beautiful women as the natural order of making beautiful things? Reviewing the exhibition Deborah Cherry and I concluded:

16

High Culture plays a specifiable part in the reproduction of women's oppression, in the circulation of relative values and meanings for the ideological constructs of masculinity and femininity. Representing creativity as masculine and Woman as the beautiful image for the desiring masculine gaze, High Culture systematically denies knowledge of women as producers of culture and meanings. Indeed High Culture is decisively positioned against feminism. Not only does it exclude the knowledge of women artists produced within feminism, but it works in a phallocentric signifying system in which woman is a sign within discourses on masculinity. The knowledges and significations produced by such events as *The Pre-Raphaelites* are intimately connected with the workings of patriarchal power in our society.[31]

There are many who see art history as a defunct and irrelevant disciplinary boundary. The study of cultural production has bled so widely and changed so radically from an object to a discourse and practice orientation that there is a complete communication breakdown between art historians working still within the normative discipline and those who are contesting the paradigm. We are witnessing a paradigm shift which will rewrite all cultural history. For these reasons I suggest that we no longer think of a feminist art history but a feminist intervention in the histories of art. Where we are coming from is not some other fledgling discipline or interdisciplinary formation. It is from the women's movement made real and concrete in all the variety of practices in which women are actively engaged to change the world. This is no 'new art history' aiming to make improvements, bring it up to date, season the old with current intellectual fashions or theory soup. The feminist problematic in this particular field of the social is shaped by the terrain – visual representations and their practices – on which we struggle. But it is ultimately defined within that collective critique of social, economic and ideological power which is the women's movement.

2

Vision, voice and power: feminist art histories and Marxism

This is a revised edition of a paper first published in English in
Block, 1982(6).

A (FEMINIST) SOCIAL HISTORY OF ART?

It ought to be clear by now that I'm not interested in the social
history of art as part of a cheerful diversification of the subject,
taking its place alongside other varieties – formalist, 'modernist',
sub-Freudian, filmic, feminist, 'radical', all of them hot-foot in
pursuit of the New. For diversification, read disintegration.
<div align="right">(T.J. Clark, 'On the conditions of artistic creation',

Times Literary Supplement, 24 May 1974, 562)</div>

In the essay from which this passage is cited, T.J. Clark described a crisis
in art history. He began by reminding his readers of a happier time,
early in the century, when art historians such as Dvořák and Riegl were
counted amongst the great and pioneering historians and when art
history was not reduced to its current curatorial role but participated in
the major debates in the study of human society. Since that time art
history has become isolated from the other social and historical sciences.
Within the discipline the dominant trends are positively anti-historical.
A review of the catalogue by one of the architects of modernist art
history, Alfred H. Barr, Jnr., for his exhibition *Cubism and Abstract Art*
(1936, Museum of Modern Art New York) published in 1937 by the
American Marxist art historian, Meyer Schapiro, provided a still pertin-
ent critique of modernist art history. Schapiro described the paradox of
Barr's book, which is largely an account of historical movements and yet

is itself essentially unhistorical. Barr, he suggested, provides a linear, evolutionary narrative of individual creators grouped together in styles and schools. History is replaced by mere chronology; the date of every stage in various movements is charted, enabling a curve to be plotted for the emergence of art year by year. Yet connections never are drawn between art and the conditions of the moment. Barr excludes as irrelevant to his story of art the *nature of the society* in which it arose, i.e. the character of the social structures and conflicts, the conditions of social life and exchange and thus the real arena of art's production and consumption. History, if it does make an appearance, is reduced to a series of incidents like a world war which may accelerate or obstruct art, an internal, immanent process amongst artists. Changes in style are explained by the popular theory of exhaustion, novelty and reaction.[1]

In opposition to this kind of art history which forms the backbone of the teaching of nineteenth- and twentieth-century history of art in much of America and Europe today, T.J. Clark has called for, and in his own books begun to lay the foundations for, a critical alternative.[2] The social history of art – informed by a Marxist analysis of society – constitutes a radically new body of art historical work which aims to contest the hegemony of bourgeois modernist art history. True there have been Marxist art historians before; but what is needed now is concerted effort to found a tradition, to produce a radically new kind of understanding of artistic production. Yet in 1974 Clark was fierce in his warnings against other tendencies currently on offer in art history. These he designated as merely pseudo-solutions; themselves proliferating symptoms of intellectual desperation. These novelties, reflecting fashions in related but necessarily distinct disciplines, include literary formalism, Freudianism, film theory and feminism.

As a feminist, I find myself awkwardly placed in this debate. I agree with Clark that one – and a very substantive one too – paradigm for the social history of art lies within Marxist cultural theory and historical practice. Yet in as much as society is structured by relations of inequality at the point of material production, so too is it structured by sexual divisions and inequalities. The nature of the societies in which art has been produced has been not only, for example, feudal or capitalist, but patriarchal and sexist. Neither of these forms of exploitation is reducible to the other. As Jean Gardiner has pointed out, a Marxist perspective which remains innocent of feminist work on sexual divisions cannot adequately analyse social processes: 'It is impossible to understand women's class position without understanding the way in which sexual divisions shape women's consciousness of class. . . . No socialist can afford to ignore this question.'[3] But it would be a mistake to see a solution in a simple extension of Marxism to acknowledge sexual politics

as an additional element. Domination and exploitation by sex are not just a supplement to a more basic level of conflict between class. Feminism has exposed new areas and forms of social conflict which demand their own modes of analysis of kinship, the social construction of sexual difference, sexuality, reproduction, labour and, of course, culture. Culture can be defined as those social practices whose prime aim is signification, i.e. the production of sense or making orders of 'sense' for the world we live in.[4] Culture is the social level in which are produced those images of the world and definitions of reality which can be ideologically mobilized to legitimize the existing order of relations of domination and subordination between classes, races and sexes. Art history takes an aspect of this cultural production, art, as its object of study; but the discipline itself is also a crucial component of the cultural hegemony by the dominant class, race and gender. Therefore it is important to contest the definitions of our society's ideal reality which are produced in art historical interpretations of culture.[5]

The project before us is therefore the development of art historical practices which analyse cultural production in the visual arts and related media by attending to the imperatives of both Marxism and feminism. This requires the mutual transformation of existing Marxist and recent feminist art history. Marxist art historians' prime concern with class relations is brought into question by feminist argument about the social relations of the sexes around sexuality, kinship, the family and the acquisition of gender identity. At the same time existing feminist art history is challenged by the rigour, historical incentive and theoretical developments of Marxists in the field. Feminist art history in this new form will not be a mere addition, a matter of producing a few more books about women artists. These can easily be incorporated and forgotten as were the many volumes on women artists published in the nineteenth century.[6] Alliance with the social history of art is necessary but should always be critical of its unquestioned patriarchal bias.

Why does it matter politically for feminists to intervene in so marginal an area as art history, 'an outpost of reactionary thought' as it has been called? Admittedly art history is not an influential discipline, locked up in universities, art colleges and musty basements of museums, peddling its 'civilizing' knowledge to the select and cultured. We should not, however, underestimate the effective significance of its definitions of art and artist to bourgeois ideology. The central figure of art historical discourse is the artist, who is presented as an ineffable ideal which complements the bourgeois myths of a universal, classless Man (*sic*).

Our general culture is furthermore permeated with ideas about the individual nature of creativity, how genius will always overcome social obstacles, that art is an inexplicable, almost magical sphere to be

20

venerated but not analysed. These myths are produced in ideologies of art history and are then dispersed through the channels of TV documentaries, popular art books, biographical romances about artists' lives like *Lust for Life* about Van Gogh, or *The Agony and the Ecstasy* about Michelangelo. 'To deprive the bourgeoisie not of its art but of its concept of art, this is the precondition of a revolutionary argument.'[7]

Feminist interrogations of art history have extended that programme to expose and challenge the prevailing assumptions that this 'creativity' is an exclusive masculine prerogative and that, as a consequence, the term artist automatically refers to a man. A useful reminder of this occurred in Gabhart and Broun's introductory essay to the exhibition they organized in 1972, *Old Mistresses: Women Artists of the Past:*

> The title of this exhibition alludes to the unspoken assumption in our language that art is created by men. The reverential term 'Old Master' has no meaningful equivalent; when cast in its feminine form, 'Old Mistresses', the connotation is altogether different, to say the least.[8]

Gabhart and Broun expose the relationship between language and ideology. But they do not ask *why* there is no place for women in the language of art history despite the fact that there have been so many women artists. In the light of my joint research with Rozsika Parker, I would reply that it is because the evolving concepts of the artist and the social definitions of woman have historically followed different and, recently, contradictory paths. Creativity has been appropriated as an ideological component of masculinity while femininity has been constructed as man's and, therefore, the artist's negative.[9] As the late-nineteenth-century writer clearly put it: 'As long as a woman refrains from unsexing herself let her dabble in anything. The woman of genius does not exist; when she does she is a man.'[10]

This is part of a larger question. What is the relationship between this pejorative view of women incapable of being artists – creative individuals – and their subordinated position as workers, the low pay, the unskilled and disregarded domestic labour to which they are so often restricted because such jobs are described as the 'natural' occupations of women? Another level of correspondence is the call to biology that is made to support the claim for men's inevitable greatness in art and women's eternal secondrateness. Men create art; women merely have babies. This false opposition has been frequently used to justify women's exclusion from cultural recognition. It is no coincidence that such appeals to 'biology' are utilized in many other spheres of women's endeavour to prejudice their equal employment, to lower their wages and to refuse social provision for child care. The sexual divisions

21

embedded in concepts of art and the artist are part of the cultural myths and ideologies peculiar to art history. But they contribute to the wider context of social definitions of masculinity and femininity and thus participate at the ideological level in reproducing the hierarchy between the sexes. It is this aspect of art history that Marxist studies have never addressed.

The radical critiques proposed by Marxist and feminist art history therefore stand in double and not necessarily coinciding opposition to bourgeois art history. Yet to date feminist art history has refused the necessary confrontation with mainstream art historical ideologies and practices. Instead feminists have been content to incorporate women's names in the chronologies and to include work by women in the inventories of styles and movements. Liberal policies within the art history establishment have allowed this unthreatening, 'additive' feminism a marginal place at its conferences as a diverting sideline or given it the space for a few odd articles in its academic journals. However, the critical implications of feminism for art history as a whole have been stifled and have not been allowed to change what is studied in art history, nor how it is studied and taught. It is useful to consider a perceptive essay written in 1949[11] in which the Marxist art historian, Friedrich Antal, pointed out what kind of challenges mainstream bourgeois art history can or cannot accept. He specifically mentioned some of the concessions to new – Marxist – ideals in art history which were then being made. These were accompanied, however, by a profound resistance to anything that posed a fundamental threat to the core of art history's ideology – the sanctity of the artist and the autonomy of art. Thus reference to literature on popular or semi-popular art was tolerated so long as this kind of art was segregated from the general history of stylistic development in the high arts. Discussion of subject matter was possible so long as it was limited to iconography and the reasons for the artist's choice of that subject matter were not given in terms of real, living history. Study of the working conditions of artists could be undertaken so long as it remained detached and its implications were not used in the analysis of the work of 'great' artists. Social and political background could even be mentioned so long as no real connection was drawn between it and art. Antal concluded that the last redoubt which would be held as long as possible was 'the most deep-rooted nineteenth-century belief, inherited from romanticism, of the incalculable nature of genius in art.'[12] Art history has its history as an ideological discourse. Antal's essay clearly specified the ways in which he saw the discipline responding to the challenge of Marxism thirty years ago and his reminder is timely:

22

The whole point of view of art historians, of whatever country or training, who have not yet even absorbed the achievements of Riegl, Dvorák, and Warburg (let alone tried to go beyond them) is conditioned by their historical place: they cling to older conceptions, thereby lagging behind some quarter of a century. And in the same way are conditioned their step by step retreat and the concessions they are willing to make – not too many and not too soon – to the new spirit. Their resistance is all the stronger, their will to give ground, all the less, the greater the consistency and novelty they encounter.[13]

Antal put his finger on the ways in which art history will accommodate what Clark has called a 'cheerful diversification'. Pluralism can be tolerated. What is refused and cannot coexist is not simply feminist approaches or reference to social context. It is that which fundamentally challenges the image of the world art history strives to create, offering a very different set of explanations of how history operates, what structures society, how art is produced, what kind of social beings artists are. We are involved in a contest for occupation of an ideologically strategic terrain. Feminist art history should see itself as part of the political initiative of the women's movement, not just as a novel art historical perspective, aiming to improve existing, but inadequate, art history. Feminist art history must engage in a politics of knowledge.

My own work on feminism and art history was initially undertaken in a collective of women artists, craftswomen, writers and historians. With Rozsika Parker I have written a book entitled *Old Mistresses: Women, Art and Ideology* (1981). The position from which we worked was in conflict with much existing feminist literature in art history. We do not think that the major issues for feminists in this discipline are the overcoming of the neglect of women artists by the Jansons and Gombrichs. Nor do we think that recording the obstacles such as discrimination against women as explanation of their absence from the history books provides the answers we want. As Rozsika Parker commented in a review of Germaine Greer's *The Obstacle Race* (1979): 'It is not the obstacles that Germaine Greer cites that really count, but the rules of the game which demand scrutiny.'[14]

We started from the premiss that women had always been involved in the production of art, but that our culture would not admit it. The question to be answered is: *Why is this so?* Why has it been necessary for art history to create an image of the history of past art as an exclusive record of masculine achievement. We discovered that it was only in the twentieth century, with the establishment of art history as an institutionalized academic discipline, that most art history systematically

obliterated women artists from the record. While most books do not refer at all to women artists, those that do make reference, do it only in order to remind us how inferior and insignificant women artists actually are. Our conclusion was therefore unexpected. Although women artists are treated by modern art history negatively, that is, ignored, omitted or when mentioned at all, derogated, women artists and the art they produced none the less play a structural role in the discourse of art history. In fact, to discover the history of women and art at all means accounting for the way art history is written. To expose its underlying assumptions, its prejudices and silences, is to reveal that the negative way in which women artists are recorded and dismissed is nevertheless crucial to the concepts of art and artists created by art history. The initial task of feminist art history is therefore a critique of art history itself.

Furthermore the art historical literature that does include references to women's art consistently employs a particular cluster of terms and evaluations, so consistently and unquestioningly that it can be called a 'feminine stereotype'. All that women have produced is seen to bear witness to a single sex-derived quality – to femininity – and thus to prove women's lesser status as artists. But what is the meaning of the equation of women's art with femininity and femininity with bad art? And, more significantly, why does the point have to be stressed so frequently? The feminine stereotype, we suggest, operates as a necessary term of difference, the foil against which a never-acknowledged masculine privilege in art can be maintained. We never say man artist or man's art; we simply say art and artist. This hidden sexual prerogative is secured by the assertion of a negative, an 'other', the feminine, as a necessary point of differentiation. The art made by women has to be mentioned and then dismissed precisely in order to secure this hierarchy.

Critically aware of the methods by which art history constructs an image for the artist which epitomizes bourgeois ideals of a masculine persona we can begin to map out a different kind of history for art. Initially we do need to retrieve a knowledge of the consistent but diverse record of women's artistic activity. Then we have to describe the historically specific positions from which women intervened in cultural practices as a whole, sometimes working in support of dominant social ideals, at other times critically resistant, often allied with other progressive forces. Always we need to map the changing definitions of the terms 'artist' and 'woman'. If we lack this sense of the ways in which women have heterogeneously *negotiated* their differential position as women in the changing class and patriarchal social relations, any historical account of women, art and ideology which we produce will be devoid of political significance. It will fall back on celebration of

individual success or failure, and, fatally, lack a theory of social and ideological transformation.

LESSONS AND PITFALLS OF MARXISM

In this section I want to look more closely at art history itself in relation to the feminist project and discuss some of the lessons to be learnt from related Marxist critiques of art history.

In a useful introduction to his programme for a Marxist art history in his book *L'Histoire de l'art et la lutte des classes* (1973) Nicos Hadjinicolaou identified the obstacles posed by the forms of current art history. These are art history as the history of artists (biography and monographs); art history as part of the history of civilizations (reflection of periods and their intellectual currents); and art history as the history of autonomous aestheticized objects.[15] However descriptively correct, it is hard none the less to characterize any of these methods as historical at all. They do embody, however, bourgeois *ideologies* about how history and thus society functions. In the representation of the historical development of human society which was manufactured after the revolutions of 1848, eighteenth-century arguments that history is a process of contradiction, discontinuity and transformation were replaced by mystifications and what amounted to a denial of history. The bourgeois order had to refute the fact of the drastic social upheavals of which it was born in order to protect its rule from subsequent proletarian challenge. Organic evolution, recurring cycles, or a continuity of the same, all these views serve to make the status quo seem inevitable. The image of the world figured in the bourgeois brain combines therefore both a repression of the real social conditions of its present role, and the necessary repression of any recognizable difference between itself and past societies. This can be accomplished firstly by 'modernizing' history, i.e. assuming a complete identity between the present and the past, and secondly by projecting back into the past the features of the present order so that they come to appear as universal, unchanged and *natural*. This has special significance for feminist analyses. Against women the fiction of an eternal, natural order of things is monolithically employed to ratify the continuing power of men over women. The justification for making women exclusively responsible for domestic work and child care is assumed to be the nature of women. Historically produced social roles are represented in bourgeois ideologies as timeless and biologically determined. Feminists have therefore a dual task, to challenge this substitution of nature for history and to insist on understanding that history itself is changing, contradictory, differentiated.

Furthermore art history belies historical scholarship in another way.

25

It often has nothing to do with history at all for it amounts only to art appreciation. Recent critiques of what literary criticism does to the history of literary production are helpful therefore in alerting us to similar historical tendencies in art history. The way in which literature is studied, as Macherey has usefully pointed out, does not explain how literature is produced. It aims to teach students how to consume the great fruits of the human spirit. In initiating students into the mysteries of aesthetic appreciation, submission to the inexplicable magic of creativity is instilled. But paradoxically, while literature is being presented as ineffable, the literary critic also strives to explain the hidden meanings and thus to 'translate' the work of literature. What usually happens in this operation is that the text is stripped naked, an apparently hidden nugget of meaning extracted through the exercise of sensitive, informed criticism and the whole 'translated' in the words of the critic who, while pretending merely to comment upon, in fact refashions the meanings of the work of art in his or her own ideological image (i.e. modernizes it). These dual procedures do not encourage students to ask the important questions – how and why an art object or text was made, for whom it was made, to do what kind of job it was made, within what constraints and possibilities it was produced and initially used? For, as Macherey states: 'In seeing how a book is made we also see what it is made *from*; this defect which gives it a history and a relation to the historical.'[16]

Literary appreciation and art-history-as-appreciation are concerned with quality – i.e. positive and negative evaluations of artefacts. Careful gradations and distinctions are established between the major and the minor, the good and the bad, the eternally valued and the fashionably momentary. This kind of evaluative judgement has particular implications for women. Women's art is consistently assessed as poor art. Take for instance Charles Sterling's explanation for reattributing a portrait thought to be by Jacques-Louis David to Constance Charpentier (1767–1849): 'Meanwhile the notion that our portrait may have been painted by a woman, is, let us confess, an attractive idea. Its poetry is literary rather than plastic, its very evident charms and its cleverly concealed weaknesses, its ensemble made up from a thousand subtle artifices, all seem to reveal the feminine spirit.'[17] And James Laver on the same painting: 'Although the painting is attractive as a period piece, there are certain weaknesses of which a painter of David's calibre would not have been guilty.'[18] Both Sterling and Laver have a norm of good art, against which the women are judged and found wanting. This establishes difference on a sexual axis and a different set of criteria for judging art made by women.

To counter this kind of criticism of women's art, feminists are easily

tempted to respond by trying to assert that women's art is just as good as men's; it has merely to be judged by yet another set of criteria. But this only creates an alternative method of appreciation – another way of consuming art. They attribute to women's art other qualities, claiming that it expresses a feminine essence, or interpret it saying that it tends to a central 'core' type of imagery derived from the form of female genitals and from female bodily experience. All too familiar formal or psychologistic or stylistic criteria are marshalled to estimate women's art. The effect is to leave intact that very notion of evaluating art, and of course the normative standards by which it is done. Special pleading for women's art to be assessed by different values ensures that women's art is confined within a gender-defined category, and, at the same time, that the general criterion for appreciating art remains that which is employed in discussing work by men. Men's art remains the supra-sexual norm precisely because women's art is assessed by what are easily dismissed as partisan or internally constructed values. Feminists thus end up reproducing Sterling's and Laver's hierarchy.

I am arguing that feminist art history has to reject all of this evaluative criticism and stop merely juggling the aesthetic criteria for appreciating art. Instead it should concentrate on historical forms of explanation of women's artistic *production*.[19] For literary and art historical appreciation can be seen as the complement of bourgeois tendencies to 'modernize' history. Both efface from the art work or text the signs of its having been *produced*. Stripped of its uniqueness and historical specificity as production, it is reclothed in the purely aesthetic values of the bourgeoisie. In one single movement both the historical character of the object and the historically determined ideology of the critic/art historian are conjured out of sight, and with them disappears the visibility of sexual position as a factor in both the production of art and its reception. Feminist art history can expose the derogatory evaluations of women's art, which are used to justify the omission of their art from serious scholarship, as symptoms of the antagonisms of a sexually divided society which masquerade, in this realm, as the exercise of pure judgement.

The insistence upon treating art as production invites us to consider the usefulness to feminist art history of Marxist paradigms. These are plural. There has been considerable development within Marxist cultural theory in the last decades particularly with regard to notions of ideology and representation.[20] But there are also elements of Marxist thinking about art and society to be avoided. In seeking for models of a social history of art within the Marxist tradition, feminist art history should be wary of reproducing its errors. The problems are these: treating art as a reflection of the society that produced it, or as an image of its class divisions; treating an artist as a representative of his/her class;

economic reductionism, that is, reducing all arguments about the forms and functions of cultural objects back to economic or material causes; ideological generalization, placing a picture because of its obvious content into a category of ideas, beliefs or social theories of a given society or period.

All these approaches strive, however crudely, to acknowledge the complex and inescapable relations between one specific social activity – art – and the totality of other social activities which constitute the 'society' in, for and even against which art is produced. The problem with reflection theory is that it is mechanistic, suggesting at once that art is an inanimate object which merely 'mirrors' a static and coherent thing called society. Reflection theory oversimplifies the process whereby an art product, consciously and ideologically manufactured from specifiable and selected materials, represents social processes which are themselves enormously complicated, mobile and opaque. A slightly more sophisticated version of reflection theory is that in which art is studied 'in its historical context'. History is, however, too often merely wheeled on as background to artistic production. History is conceived of as a lumpen entity, which can be swiftly sketched in as a story which provides clues to the picture's content.

The attempt to place the artist as a representative of a class outlook registers the need to recognize point of view and position in class society as a determination on the production of art. Even so, it involves considerable generalization. For instance in Nicos Hadjinicolaou's book we find the notion that paintings carry a visual ideology. Artists such as David or Rembrandt produced works which can be read as embodiments of the visual ideologies of a particular class or a section, a fraction of a class – art of the rising bourgeoisie at the end of the *ancien régime* for instance.[21] A whole oeuvre or group of works become unitary examples of the singular outlook of a social group via the service of the artist. Secondly this argument tends as a result to reinstate the artist as a special kind of spokesperson – visionary or seer – or 'ad-man' – with privileged access to and means of expression of the perspective and concerns of a class. To elaborate the inadequacies of this argument let us apply it to the case of women. Women artists are often treated in feminist art history virtually as representatives of their gender; their work expressing the visual ideology of a whole sex.

An example will illustrate this. I have taught a course on New York painting in the 1950s with special reference to the so-called abstract expressionists. First the general character of the movement and its art was established and then, in order to ensure some engagement with feminist art history, the work of one woman, Helen Frankenthaler, was taken up as a case study. This in effect meant that her work was made

to stand for women's point of view in the movement. So the individual producer becomes the representative of an entire sex in a way similar to that in which Hadjinicolaou and Antal placed artists in relation to a class. The individual woman's particular strategies and practices are reduced to a generalization of a sex – i.e. become non-specific and homogeneous. This is of course not to deny that one's position as a woman or within class society profoundly delimits and conditions the production of art.[22]

The third approach – economic reductionism – can be seen precisely as the attempt to insist upon the overall organization of social forces and relations as the determining factor in art-making. But to acknowledge a materialist basis in history, that is, that history is what real people do in concrete social relations, shaped by factors outside their individual control, is not the same thing as saying that knowing how factories are organized helps you to know why such an art is being produced. To know that society has been patriarchal and sexist means that you reject the idea that the oppression of women is divinely ordained, or biologically, psychologically inevitable. (To know that society is capitalist means that you reject the inevitability of wage labour capitalists' profits.) In studying art we want refined understanding of relation to and positions on that knowledge or social experience.

The danger is always of simply shifting your analysis from one set of *causes* to another, i.e. art is the way it is because of economic arrangements. Art is inevitably shaped and limited by the kind of society which produces it; but its particular features are not *caused* by economic structures or organization. They offer some of the conditions of the practice. In application to women the poverty of the argument is obvious since women's position in the basic economic organization of the workplace is easily shown to be mere complement to the kind of exploitation they experience in the home, in sexual relationships, child care, on the streets, as a result of sexual domination that is dispersed across a wide range of social practices.

The fourth problem – ideological generalization – is a response to the reductionism of the third. It is right to see relationships between one area of intellectual culture and others. It is suggested for instance that the historical coincidence of realism in art and positivism in philosophy is in some way a result of new forms of bourgeois ideology. But ideology is a process of basking contradictions; it is itself fractured and contradictory. Referring art to ideology does not sort anything out at all; it merely displaces the necessary study of what ideological work specific pieces of art are doing, and for whom. The parallel in the study of women and art is the way in which what women produce is placed in the category *women's art*. We are of course obliged to introduce the term if only to

29

make known the fact that there is art made by women. But underlying this tactical necessity may be the impulse to imagine that there is such a unitary ideological category as women's art. To treat work by women merely as exemplars of womanness is to reproduce a tautology which teaches us nothing about what being, doing like, thinking as a woman might be.

Whether it be class, race or gender, any argument that generalizes, reduces, typifies or suggests a reflection is refusing to deal with specificity of individual texts, artistic practitioners, historical moments. Art history – Marxist or feminist – must be primarily a historiographical exercise. Society is a historical process; it is not a static entity. History cannot be reduced to a manageable block of information; it has to be grasped itself as a complex of processes and relationships. I suggest that we have to abandon all the formulations such as 'art *and* society' or 'art *and* its social context', 'art *and* its historical background', 'art *and* class formation', 'art *and* gender relations'. All the real difficulty which is *not* being confronted resides in those '*ands*'.[23] What we have to deal with is the interplay of multiple histories – of the codes of art, of ideologies of the art world, of institutions of art, of forms of production, of social classes, of the family, of forms of sexual domination whose mutual determinations and independences have to be mapped together in precise and heterogeneous configurations.

FEMINIST THEORIES

What all these approaches have in common is a notion of the art object as a kind of vehicle for ideology, or history, or psychology, all of which are produced somehow and elsewhere. Not only do we have to grasp that art is a part of social production, but we also have to realize that it is itself productive, that is, it actively produces meanings. Art is constitutive of ideology; it is not merely an illustration of it. It is one of the social practices through which particular views of the world, definitions and identities for us to live are constructed, reproduced, and even redefined. How this kind of approach can be particularly relevant for feminists in cultural studies has been shown by Elizabeth Cowie in her article 'Woman as sign'.[24] Cowie surveys commonly held notions about the category, woman, and about the practice, film. For many feminists, woman is an unproblematic category. Woman is a given because of biological sex, because of anatomy. For others woman is not born, but made; conditioned by a series of socially prescribed roles. From these points of view, images of women in films are merely reflections, or at best representations, of those biological identities or social models. Films are to be judged therefore for the adequacy or distortedness of that representation in relation to lived

30

experience. It has, however, been argued that film has to be understood as a signifying practice, i.e. an organization of elements which *produce* meanings, construct images of the world, and strive to fix certain meanings, to effect particular ideological representations of the world. So instead of seeing films as vehicles for preformed meanings or reflectors of given identities, the practice has to be seen as an active intervention: 'Film is a point of production of definitions but it is neither unique and independent of, nor simply reducible to, other practices defining the position of women in society.'[25] As such, film is one of the practices which actively construct and secure the patriarchal definitions for the category, woman.

Cowie then argues that the term 'woman' and its meanings are not given in biology or in society but produced across a range of interrelating practices. Of course this does not mean that people of the female sex do not really exist. It merely means that 'woman' equals the significance attached in our culture to the fact of being non-male; it is constructed by concrete historical, social practices – for instance familial or kinship structures. Cowie draws on Lévi-Strauss's arguments about the exchange of women in kinship and the significance of that exchange.[26] For Lévi-Strauss the exchange of women between men is the foundation of sociality. For the exchange of objects which by the exchange are endowed with value, and thus acquire meaning, institutes the reciprocal relationships and duties which are the basis of cultural (i.e. social) organization as opposed to the natural state. All culture is therefore to be understood as exchange and therefore as communication. The most developed form of this is of course language. Language is composed of signifying elements ordered into meaning-producing relationships which establish positions for speakers and addressees. Woman as a category is a product of a network of relationships created in and through these exchanges of females as mothers, daughters, wives. The meaning of the term is also relative to all other terms in the social system. What woman means is composed of the positions in which female persons are placed, as mother, wife, daughter or sister, in relationship to a concurrent production of man as a category in positions such as father, son, husband, brother. Man, however, is positioned as exchanger, woman as a sign of the exchange as well as its object. If a woman is a sign, then the meaning of the sign will always have to be determined within a system of relationships, i.e. within the specific organization of kinship, reproduction and sexuality. Because it is a product of social relationships it can alter. Because it can alter, it must ceaselessly be reconstrued. The meaning of the term woman is effectively installed in social and economic positions and it is constantly produced in language, in representations made to those people in those social and economic positions – fixing an identity, social place and

sexual position and disallowing any other.

Furthermore woman as sign implies that woman signifies something other than female sex. When women are exchanged in marriage, for instance, the empirical signifying thing is a woman, a female person. The meaning carried through the exchange by that signifying element is not femaleness but the establishment and re-establishment of culture itself, i.e. of a particular order of socio-sexual relationships and powers:

> To talk of 'woman as sign' in exchange systems is no longer to talk of woman as the signified, but of a different signified, that of the establishment and re-establishment of kinship structure or culture. The form of the sign – in linguistic terms the signifier – may empirically be woman, but the signified (i.e. the meaning) is not woman.[27]

Woman as a sign signifies social order; if the sign is misused it can threaten disorder. The category woman is of profound importance to the order of a society. It is therefore to be understood as having to be produced ceaselessly across a range of social practices and institutions and the meanings for it are constantly being negotiated in those signifying systems of culture, for instance film or painting. To understand the precise disposition of meanings for the terms man and woman and the social order based upon them we have always to attend to the specific work that is done within and by a particular text, film or painting. At the same time this formulation allows us to recognize the centrality and critical importance of the representation of woman in patriarchal culture. And hence to grasp the radical potential of its analysis and subversion.

Cowie's work was generated within the women's movement but it reflects a theoretical tendency that is by no means general. There are several feminisms. Take for instance three quite distinct political definitions of patriarchy. A quote from Kate Millett's book *Sexual Politics* (1971) will illustrate the idea that patriarchy is about the exclusive possession of instrumental social power:

> Our society . . . is a patriarchy. The fact is evident at once if one recalls that the military, industry, technology, universities, science, political offices, finances – in short every avenue of power within society, including the coercive force of the police, is in entirely male hands.[28]

In her article, 'The unhappy marriage of Marxism and feminism', Heidi Hartman offered her contribution to the definition of a patriarchy as a hierarchy of relations between men in order to dominate women:

> We can usefully define patriarchy as a set of social relations between men, which have a material base, and which though hierarchical, establish and create interdependence and solidarity among men that enable them to dominate women. Though patriarchy is hierarchical and men of different classes, races or ethnic groups have different places in the patriarchy, they are also united in the shared relationship of dominance over their women; they are dependent on each other to maintain that domination The material base upon which patriarchy rests lies most fundamentally in men's control over women's labor power. Men maintain control by excluding women from access to some essential productive resources (in capitalist societies, for example, jobs that pay living wages) and by restricting women's sexuality.[29]

Hartman thus lays stress on the interrelationships between men across other social divisions which unite them in subordinating women. She also points to two crucial areas of its enactment, exclusion from equality in work and submission through sexuality. She usefully therefore reminds us that power is not just a matter of coercive force but a network of relationships, of inclusions and exclusions, of domination and subordination. In recent years another formulation has been advanced which shifts the attention from sociologically defined sexual divisions in society based on given gender categories, men and women, to the idea that sexual divisions are the result of the construction of 'sexual difference' as a socially significant axis of meaning. Difference in English means a state of being unlike. The word distinction conveys the correct meaning more precisely. Distinction is the result of an act of differentiation, drawing distinctions, a process of definition of categories. Thus masculinity and femininity are not terms which designate a *given* and separate entity, men and women, but are simply two terms of difference. In this sense patriarchy does not refer to the static, oppressive domination by one sex over another, but to a web of psycho-social relationships which institute a socially significant difference on the axis of sex which is so deeply located in our very sense of lived, sexual, identity that it appears to us as natural and unalterable. To oppose this powerful web we have to develop a theory of how gender is actually produced, how sexuality is socially organized into the categories of masculinity and femininity, lived out through social positions as wives, mothers, daughters, fathers, sons, etc. These positions are produced initially in those social institutions around child care and socialization, family relations, school and the acquisition of language. But they have constantly to be reinforced by representations that are made to us in the range of ideological practices that we call

culture. Pictures, photographs, films, etc., are addressed to us as their viewers and work upon us by means of winning our identification with those versions of masculinity and femininity which are represented to us. It is a process of constantly binding us into a particular – but always unstable – regime of sexual difference.

FEMINIST ART HISTORIES

The work of feminist art historians has been influenced both by their attitude to art history and their conception of feminism. I want now to consider several texts by feminist writers to indicate how these differing perceptions of the feminist project inform and constrain the art history they have produced. One of the first and influential essays which initiated the renewed efforts of feminists in art history in Britain and America was Linda Nochlin's 'Why have there been no great women artists?'[30] The title pointed to the kind of questions feminists were facing in the given conditions of widespread ignorance about women artists. Nochlin insisted that it was a false question for it invited a negative answer, 'Because women are incapable of greatness.'[31] It tended to encourage feminists to dig up many women artists from the basements of galleries and argue that, for instance, Berthe Morisot was a better artist and not quite as dependent on Manet as we have been told. They fall into the trap of providing alternative criteria for appreciation (see pages 26–7). None the less Nochlin believes that there have not been great women artists. She herself therefore subscribes to the evaluative category. She proceeds to provide a basically sociological type of explanation for this 'failure'. The fault does not lie in women's wombs but in society's institutions and education. To support her case Nochlin demolishes as myth the common notion of an innate nugget of genius which will always win through, and shows that art-making is dependent on favourable social and cultural conditions. Women as artists had unfavourable conditions. They were excluded from training in the nude at the anatomy classes of the academies, and were restricted by social ideologies which preached at women a femininity based on accomplishment in place of professional ambition and dedication to excellence. Women's past artistic poverty is explicable in terms of restrictions and discrimination. The future, however, is open and thus Nochlin concludes:

> What is important is that women face up to the reality of their history and of their present situation, without making excuses or puffing mediocrity. Disadvantage may be indeed an excuse; it is not, however, an intellectual position. Rather using their situation

as underdogs in the realm of grandeur and outsiders in the realm of ideology as a vantage point, women can reveal institutional and intellectual weakness in general and, at the same time, that they destroy false consciousness, take part in the creation of institutions in which clear thought – and true greatness – are challenges open to anyone, man or woman, courageous enough to take the necessary risk, the leap into the unknown.[32]

So Nochlin requires that we face up to the unrelievedly dismal character of women's history. We must forget the past, buckle to and exploit the underdog position to act as a gadfly on the patriarchal body and liberate it from false consciousness towards women. Institutional pressures and social ideologies are reduced magically to a matter of mistaken understanding and bad faith. Constraint thus effortlessly dispelled, a vista will open for women who will be able to transcend sexual divisions and society and attain true greatness.

Nochlin's work made a critical intervention in the early 1970s and directed the argument fruitfully into social explanations of women's position in art. Yet for her, art is still a category to be discussed in terms of greatness, risks, leaps into the unknown. The political vantage point is liberal, equal rights feminism in which discrimination against women is admitted to have taken place but, at the gates of future freedom, issues of sexual identity and social gender evaporate before the dream of bourgeois humanism. There is a residual idealism in the piece too in that the social is presented only in terms of obstacles placed around the individual's freedom of action and these obstacles, the result of false consciousness, can be dispelled by an act of will alone. While Nochlin is willing to acknowledge that femininity is a social concept – something that was preached at women by nineteenth-century writers – woman in general is an unquestioned category. For Nochlin, women can escape from the merely social obstruction of feminine role models, only however in order to join men in a sexually neutral utopia jumping into the unknown. In effect Nochlin reinforces the patriarchal definition of man as the norm of humanity, woman as the disadvantaged other whose freedom lies in becoming like man. Individualism, humanism and voluntarism prescribe the limits of this liberal bourgeois argument, which, as such, is unhistorical. For what is evacuated, notably in the conclusion I have quoted, is history, i.e. the social processes, the concrete struggles within real social relations. This occurs because the *present* is in fact absented. Women artists have the burden of the past – discrimination in the eighteenth century, Victorian social mores in the nineteenth. They have the hope of a better future. But what is never specified is the present conjuncture which is the only moment of

35

potential transformation. Finally any argument that deals exclusively in terms of discrimination is mistaking symptom for cause. Discrimination is but a symptom of a liberal bourgeois society which proclaims itself the society of liberty and equality for all while it none the less prevents the enjoyment of equal rights through structural constraints, economically and socially – and psychologically through the agencies of consciousness like education and the media. Visible discrimination is merely the exposed nerve, a revealed point of contradiction between the dominant and privileged social or sexual groups in society and those they oppress and exploit. It is not a cause and therefore cannot be an explanation.

In 1976 Linda Nochlin collaborated with Ann Sutherland Harris to produce a large exhibition on *Women Artists 1550–1950* and the catalogue was published as a book with the same title. In the concluding paragraph of her introductory essay Sutherland Harris stated:

> Slowly these women must be integrated into their art historical context. For too long they have either been omitted altogether, or isolated, as even in this exhibition, and discussed only as women artists, and not simply as artists, as if in some strange way they were not part of their culture at all. This exhibition will be a success if it helps to remove once and for all the justification of any future exhibitions with this theme.[33]

For integration here read incorporation and, indeed, loss of the real issues posed by women's art and its exclusion. Sutherland Harris does not grasp the difference between historically analysing the special features which have shaped the art made by women, because they made art in a society structured around sexual difference, and, on the other hand, imagining a future in which the particular interpretation of the significance of the sex of the artist will not be oppressive to women. The fact of sex and possible constructive differences between people who bear babies and those who don't will not vanish; the ways in which sexuality and social relations between men and women are organized can, and we hope will, be changed. The ambition should not be to avoid mentioning the sex of the maker, but that the sex of the maker should not automatically penalize women artists and celebrate men artists in the specific ways it does now.

Sutherland Harris wants to demonstrate that there have been women artists, to prove that they can be discussed in exactly the same formalist or iconographic terms used for men's work in mainstream art history and then hope that this will provide the passport for women's assimilation into existing histories of art. So women artists are to be integrated into present ways of understanding the history of art; their work will not be permitted to transform our conception of art, of history or the modes

36

of art historical research and explanation. The catalogue format allows its authors to discuss individual works of art by women painters. In addition to standard methodologies for inserting pictures into stylistic chronologies and movements, there are examples in the catalogue/book of the tendency to modernize history and to make intuitive analogies between content and gender. Take for instance this discussion of *The proposition* (1631, The Hague, the Mauritshuis) by the Dutch seventeenth-century painter Judith Leyster (1609–60). 'The proposition' was a common subject in the sixteenth and seventeenth centuries in the Low Countries; often presentation stressed a whorishness in the female figures and included an older woman as the procuress. Sutherland Harris contrasts these other, 'boisterous and vulgar' treatments of the theme with Leyster's work which she argues is unusual in portraying a woman who has not invited such a proposition and intends to refuse it (a suspicion here that prostitutes deserve what they get!):

> The woman shown here is not a whore. She is a housewife engaged in a domestic chore, and her intense concentration on her sewing as she tries to ignore the man who touches her arm and extends a palm full of coins will instantly engage the sympathy of any woman who has been similarly approached by a man who stubbornly refused to believe that his attentions were unwelcome. . . . Leyster's proposition is a uniquely personal interpretation with feminist overtones.[34]

Sutherland Harris differentiates Leyster's painting of the subject by appealing to a shared experience between women, i.e. by a common gender consciousness. This is accomplished by a paradoxical manoeuvre. On one hand the picture is set in an art historical context, compared iconographically with other examples of the genre in Dutch seventeenth-century art. But it is simultaneously removed and placed in a transhistorical category, representing woman's point of view. Sutherland Harris assumes a shared consciousness between women irrespective of differences of class, nationality and historical period. This transhistorical unity arises not from an argued reading of the painting nor from a case being made for the overriding determinations of gender on production and reception of art, but in the catalogue author's own twentieth-century feminist projections on to the picture. A veneer of art historicalism coupled with *ad feminam* appeal masks a more subtle form of historicism.

Of course there are important questions to be asked about why Leyster has treated the subject in this way. The answers cannot, however, lie in a transhistorical concept of woman. They will be found in careful attention to the way in which Leyster has transformed or

engaged with precise and historically specific materials and debates. In my own limited knowledge of Dutch seventeenth-century art I can only raise two points of possible investigation. I am tempted to consider what relationship there might be between the kind of domestic treatment of solicitation and the debates about the status and role of women which were evolving, on the one hand, amongst the proliferating Protestant religious sects like the egalitarian Labadists, for instance, to which Maria Sibylla Merian (1657–1717) and her daughters later belonged, or, on the other, in the evolving seventeenth-century bourgeois ideologies of domesticity and female amateur domestic labour. Moreover recent scholarship has overturned the predominantly realist interpretations of Dutch genre painting and suggested that many pictures of seemingly ordinary domestic life should in fact be read as allegories, and indeed as political allegory which was part of a bitter struggle between different factions in Holland over the continuation or ending of the War of Independence with Spain. It has been noted that in the symbolism used in coins, political prints and broadsheets of the period, the city of Amsterdam was represented as a housewife, dressed in white, carefully taking care of the household and not being swayed by the promises of merchant gold. I have mentioned these two possible lines of enquiry in order to point out what a great disservice we do to women's art by refusing to treat women artists as social and political subjects. In addition to the specific conflicts around gender with which they may or may not have engaged, women were often also involved in contemporary class and ideological struggles. Equally vital is it to remember that sexuality has a history, as does the family and the other institutions through which the identities of masculinity and femininity were produced. Anything that has a history has probably been very different in the past.

There have on the other hand been some useful initiatives to wrench the history of women's art from the straitjacket of academic bourgeois art history. But at what price? Karen Wilson and J. J. Petersen, in *Women Artists, Recognition and Reappraisal from the Early Middle Ages to the Twentieth Century* (1976), do not want to annex women to existing schema of the history of art but to provide women in general with the new information about the heritage of women artists. They argue for a new way of seeing this recovered tradition and attack the art world for traditionally ignoring the issues of sex, class and race and, quoting from Lise Vogel, add:

> Moreover it is assumed that a single human norm exists, one that is universal, ahistorical and without sex, class or race, although it is in fact clearly male, upper-class and white.[35]

They mount a commendable attack on the way art history predisposes

us to look at only a certain kind of fine art and ignore the rest – like weaving for instance – to study only certain named artists which are chosen by biased criteria. But I am not convinced that the alternative should be a total refusal of any kind of art historical analysis and a rejection of every kind of examination of the meanings of paintings and the contexts of their production.

What their book offers in the end is illustrated biography without any assessment of the pictures as images or as cultural products. They admit they are not art historians and could not provide such an analysis if they wanted to. Yet the sentimental celebration of heroic individual women who have struggled and overcome the odds against them in fact reproduces one of the central myths of art history – the artist. In addition a book which chronicles the lives of women artists down the ages without reference to the rest of art history, or to history itself, turns out to be not very different from the 'separate but unequal' format of Victorian writing about women artists, as for example Walter Sparrow's *Women Painters of the World* (1905). Such chivalrous texts, willing to acknowledge the existence and indeed special characteristics of women artists, managed none the less to consign women's art to a radically separate sphere. Nineteenth-century distinction between the art produced by men and by women was based on bourgeois concepts of domestic and maternal femininity; twentieth-century feminists like Petersen and Wilson effect a comparably categorical severance of women from the rest of art and construct an insulated linear chronology which links women throughout history by virtue of biological sex alone. They efface the fact that although women as a sex have been oppressed in most societies, their oppression, and the way they have lived it or even resisted, has varied from society to society, and period to period, from class to class. This historicity of women's oppression and resistance disappears when all women are placed in a homogeneous category based on the commonest and most unhistoricized denominator.

Germaine Greer's *The Obstacle Race* (1979) is an exception, initially, to these two trends towards sociologism and biologism. Her book was undertaken as a study of creativity and sexuality rather than a straight history of women and art. She wanted to explore the relationship between art-making and the psychic structures of masculinity and femininity. Yet on closer scrutiny Greer's book is not so different from the other feminist texts I have been discussing. Like Sutherland Harris, she unquestioningly employs the standard formalist type of art history combined with a well-educated 'connoisseurship'. Like Petersen and Wilson, Greer treats woman as a transhistorical and unitary category. Like Nochlin, Greer discusses the obstacles that have been laid in the path of women in art. *The Obstacle Race* of the title is, however, a more

mixed course than Nochlin's; some are social and institutional, the family for instance; others are results of lived experience of psychological constraints. These latter are in fact an extension of the thesis for which Greer became famous, put forward in her book *The Female Eunuch* (1971). There Greer had argued that in a patriarchal society women lived as castrates, as the damaged 'other' of men, psychically deformed, alienated from their own libidos. In contrast to the bourgeois ideal of free individual versus discriminating society which informs Nochlin's text, Greer rightly addresses the interface of social forms and subjectivity, stressing the psychological level on which oppression is lived, for it is built into our very sense of self. The danger, however, is that without a developed theory of ideology and the careful adaptation of psychoanalytic theory which feminists have recently used to help explain the social production of a sexed subjectivity, Greer's book merely inverts Nochlin's stress on external constraints such as discrimination and places the emphasis on the internal restrictions of damaged egos.

Why does Greer turn to art history for this argument about women as castrates in society? Because she sees the artist as the archetypal masculine personality structure, egomaniacal, posturing, overidentified with sexual prowess, sacrificing everything and everyone for something called his art. Painting in particular is quintessential masculine activity – a matter of making monuments to self. Here lies another paradox of the book.

Greer delivers a mighty blow against the mythic ideal of the artist, revealing it as a socially tolerated form of obsessive neurosis. Yet she confirms the absolute masculinity of the activity of art. 'Western art', she writes, 'is largely neurotic . . . but the neurosis of the artist is of a very different kind from the self-destructiveness of women.'[36] For Greer does not undertake the study of women painters in order to gain knowledge about the history of culture, the meanings and ideological operations of art in the past, but in order to illustrate the pathology of oppression. Women artists are the mirror image of men artists in the sense that the male artist is his sex's archetype, the female artist, incompetent and obstructed from without and within, is an illustration of woman in patriarchy. Greer therefore effects a dangerous confusion. Women may and often do experience themselves through the images of women and ideas about women which are presented to us by the society in which we live. Woman in patriarchal culture is represented as the negative of man, the non-male, the mutilated other, castrated. But that does not make women castrated; nor does it ensure that women see themselves only in those terms. Women have struggled against the given definitions and ideologies of femininity, negotiated their varying

situations at different periods and in different cultures. They have resisted what is represented to them. Moreover, as I argued above, artistic representations are not produced as passive reflections. In the ceaselessly necessary attempts to keep in place dominant ideologies about women is registered the constant resistance they have evoked. Women, art and ideology have to be studied as a set of varying, and unpredictable, relationships.

SOME CASE STUDIES – DEBATES WITHIN FEMINIST ART HISTORIES

In *Old Mistresses: Women, Art and Ideology*, Rozsika Parker and I tried to construct a conceptual framework to provide ways of connecting the specific histories of artists who were women with the ideological and social formations which shaped their interventions in artistic practice. In place of the traditional survey, we studied women's history in its discontinuities and specificities. Three examples develop the ideas drawn from that initial essay in feminist art history.

The Artist and Social Class: Sofonisba Anguissola (1535/40 – 1625)

And even if Sofonisba Anguissola's contribution to Renaissance portraiture does not earn her a place in a Renaissance chapter, her historical impact as the first woman artist to become a celebrity and therefore open the profession to women certainly does.[37]

There are several points to remark in this quotation. Anguissola is being given a red star for initiative, for being the first woman in a profession, for starting a linear sequence of women artists. Yet she is being presented to us as an exception – unusual as an artist by virtue of her sex. As such she is being evaluated by special criteria reserved for women for it is only her sex and novelty that can merit her an otherwise undeserved place in Renaissance art history. We know a lot about Anguissola. She was discussed by Vasari in a chapter on several women artists in Volume III of his book on his most famous contemporaries, *The Lives of the Most Prominent Painters, Sculptors, and Architects* (1568). Why did he include her? As a novelty perhaps. That would be typical of an emerging strategy amongst men writing about women in art in the Renaissance. In an earlier text by the Italian poet Boccaccio, *On Famous Women* (1370), we find the paradox of an author who mentions the names of several women artists – in his case from antiquity – but only in order to represent them as atypical of their sex – to create the idea that women and art are incompatible. Boccaccio states:

41

I thought these achievements worthy of some praise, for art is much alien to the mind of women, and these things cannot be accomplished without a great deal of talent which in women is usually very scarce.

There are women artists, but Boccaccio handles this fact by conjuring up for us the idea that it is remarkable. The effect is the same as that it is remarkable. The effect is the same as that in Sutherland Harris's text. Celebrity, novelty, exceptionalness are the myths made up by a masculine-dominated culture to 'frame' the facts of women's unbroken participation in artistic production. But I do not think this explains entirely Vasari's chapter on the artist Anguissola.

Some evidence may be gleaned from a *Self portrait* by Anguissola of 1561 (?) (Althorp, the Spencer Collection). The artist presents herself at a musical instrument accompanied by her chaperone. She does not stress her artistic skills but the cultured accomplishments which signify her class position. Anguissola, an Italian, was the daughter of a noble family of Cremona and was at the time of the portrait employed as lady in waiting and painter to the Queen of Spain. Artists from the nobility were uncommon in this period; but the attributes of the aristocratic classes and their circles – learning, knowledge and accomplishment – were coveted by artists wishful of severing themselves from the artisan class and becoming members of the educated and learned communities. Such aspirations were supported by a growing literature on the artist. For instance, Alberti fabricated the story that artists of classical antiquity came from elevated social classes in order to underwrite contemporary artists' ambition.[38] In this context it should not surprise us that one of the most celebrated and still most famous artists of the Renaissance, Michelangelo was descended from a patrician family and attempted to invent noble claims for his family. In contemporary discourses and practices which manoeuvred the shift in the social status of the artist from craftsperson to member of the intellectual classes, images of nobility were highly significant.

This shift away from the conditions and class base of medieval art production had somewhat adverse effects on the practice of many women who had been hitherto involved in art production through households, convents, workshops and family connections. Women's participation in family businesses and craftwork was further undermined in the new tradesmen's families where, in imitation of aristocratic fashions, women were withdrawn from commerce and supposed instead to be occupied with leisured, i.e. unpaid, activities in and for the home. But at the same time, in some circles within the aristocracy new and favourable attitudes towards women's education were being

encouraged within the literature of new ideals of the courtier. These included training daughters of the nobility in several accomplishments, amongst them painting and drawing. It was in this context that Anguissola was able to exploit a complex of circumstances and make of her painting an occupation that gained her patrons and a place at the Spanish court. She exploited the situation which was therefore different from that of women traditionally becoming artists and indeed from men currently entering the profession. Her *Self portrait* is legible against this field of shifting forces. She presents herself as a member of the cultured élite; the chaperone and dress, the musical instrument and her playing signify the class whose attributes coincided at that period with the evolving ideologies of the new artist. It was therefore her class position that rendered her activity as an artist both possible and indeed worthy of notice and comment. Significantly, of the other women artists whom Vasari chose to record in his highly motivated eulogies on the new ideals of the artist, Properzia de' Rossi (c. 1490–1530) was also a noblewoman. Furthermore a careful reading of what Vasari selects to mention about women artists shows his concentration on precisely those features of their social position which accorded with the elevated concept of the artist he was attempting to secure.

This favourable coincidence for some women artists between class and artistic discourses was a historically determined conjuncture. It was compromised, however, by concurrent claims for an almost divine status for the artist, as second only to the prime creator – in Judaeo-Christian mythology a definitively masculine persona. Moreover at another historical moment in the late nineteenth century aristocratic and even haut-bourgeois connections were a positive disadvantage to women artists as both Marie Bashkirtseff (1859–84) and Berthe Morisot (1841–95) found.[39] By then the relations between femininity and class were such as to bind women to the domestic performance of social duties in the drawing-room in ways that were radically opposed to the public, professional sphere in which artistic activity was pursued. These two women's practice as artists was facilitated not by their class but by a quite different constellation of forces around the institutions of art training and exhibition – the impressionist and independent movements for instance. However, the purpose of this discussion of Anguissola has been to stress the necessity for seeking out and understanding the conditions which favoured women's art-making as much as those which limited it and for seeing these conditions in real historical terms.

Academies of Art: Naked Power

Feminist art historians have misunderstood the nature and effects of the constraints placed upon women artists in the heyday of the academies in the eighteenth and nineteenth centuries. The restricted access to academic art education has been represented as a major obstacle, an effective form of discrimination which prevented women from being able to participate in all genres of art. Admittedly the fact that women were excluded from the life class did prevent them from officially being able to study human anatomy from the live human model. For almost three hundred years from the Renaissance to the late nineteenth century the nude human figure was the basis of the most highly regarded forms of art, what academic theories called history painting and placed at the summit of artistic achievement. The simple fact of prevention of study of the nude constrained many women to practise exclusively in the genres of still life, portraiture and landscape. These genres were less prestigious and thought to demand less skill or intellect. By association, women artists specializing in these 'lesser' genres were themselves regarded as artists of lesser talent. Yet in cases where men, Joshua Reynolds (1723–92) or Chardin (1699-1779) for instance, practised them, their abilities as artists were never questioned. However, from the point of view from which women artists have been assessed then and since, their concentration in these areas signified their inferiority. Take for instance this comment by Martin Grant in *Flower Painting through Four Centuries* (1952):

> Flower painting demands no genius of a mental or spiritual kind, but only the genius of taking pains and supreme craftsmanship. . . . In all three hundred years of the production the total practitioners of flowers down to 1880 is less than seven hundred . . . whilst only a very small proportion are artists of the highest or even high merit. Actually more than 200 of these are of the late eighteenth and nineteenth centuries *and at least half of them are women*. (my italics)[40]

What we can discern is again a discursive strategy for distinguishing between good and bad art, *vis-à-vis* men and women. Women's exclusion from the necessary training to become a history painter – which did not of course prevent all women from working in that area – was probably an inconvenience to them. More importantly, it functioned as a stratagem by which the academic establishment could differentiate women's and men's spheres of activity. This institutionally constructed segregation was then represented as proof of an innate inequality of talent.

The academies actively resisted and restricted women's participation in the full production of art by the device of refusal of the study of the nude. But that had even more far-reaching significance. Empirically women often could hire a nude model unofficially, or get a friend or husband to pose, but it was not officially acknowledged that women were involved in the making of major history painting. That meant they were prevented from contributing to what those history paintings pictured. It was the men of the academy and the ideologues who determined what images were produced in the most prestigious and ideologically significant arenas of high cultural production.[41] Control over access to the nude was instrumental in the exercise of power over what meanings were constructed by an art based upon an ideal of the human body. Official exclusion from the nude model ensured that women had no means to determine the language of high art or to make their own representations of the world, from their point of view, and thus to resist and contest the hegemony of the dominant class or gender. Concurrently, in the late eighteenth century another development can be traced which was to create an even more rigid set of sexual divisions in art. Johann Zoffany's 1772 group portrait of the British *Academicians of the Royal Academy* (Royal Collection) depicts the assembled company of artists as gentlemen and as men of learning. They are gathered together in the life room surrounded by examples of classical art and in the company of a nude model striking a heroic pose. They are there to discuss with each other their art and its ideals. The official portrait fulfils the necessity both of document – we can identify all the sitters through the skilful record of face and feature – and of the ideal. The picture is 'of' the Royal Academicians, but the painting is *about* the ideal of the academic artist. It is *about* eighteenth-century notions of the persona of the artist and of how art should be pursued and practised – learnedly, with reason, and by men. For there were two female academicians at the time, Angelica Kauffmann (1741–1807) and Mary Moser (1744–1819). These two women are included in Zoffany's picture, but only by small face portraits on the wall. In the interests of historical accuracy they could not have been omitted from the group portrait; but in the interests of the men – masked by pleading decency and propriety – they could not be seen to have access to the nude model. They are therefore excluded also at another level – from the idea of the artist. As paintings on the wall, treated with somewhat less detail and accuracy than their fellows, they can easily be mistaken for part of the studio furniture. They become material for the men to discuss and utilize like the classical statues around them. Woman is thus represented as object for art rather than producer of it. Indeed close scrutiny of other, written texts in which women artists of the period are represented reveals a growing discourse

45

on the woman artist who is not the embodiment of reason and learning, but the spectacle of beauty, sexually desirable, an artistic inspiration – a muse.[42] In considering the conditions of women's practice in the late eighteenth century, I would stress that it is far too simplistic to argue that women were left out or discriminated against. Rather the evidence suggests the active construction of difference, of separate spheres for men's and women's work, distinct identities for the artist who was a man – the artist, and the artist who was a woman – the woman artist. The category woman artist was established and the sexual discourse in art constructed around the growing hegemony of men in institutional practices and in the language of art itself.

Revolutionary Defeat: the Bourgeois Order of Things

> Finally no biography will do her justice that does not take into account the historical context of her career, a gradually disintegrating aristocratic society of which she was an ardent supporter and for which her work, both written and painted, provides an incomparable record.[43]

Elisabeth Vigée Lebrun (1755–1842), about whom Sutherland Harris writes above, provides my final example. The passage I have quoted exemplifies the kind of pitfalls I discussed in a previous section in which history is mere background and art is treated as a social document. It is indeed necessary to treat Vigée Lebrun as the historically interesting figure she was, instead of the characteristic dismissal of her work as sentimental and sickly sweet to be found in so many art history books that deign to comment upon her at all. But her relationship to the events of the 1780s and 1790s is not so clear and simple.

Vigée Lebrun was employed by Marie Antoinette to paint portraits for her, and through the royal connection many of Vigée Lebrun's patrons were members of the aristocratic circle around the court. In the violent struggles attendant on the revolution of 1789 that class and the tastes it employed its artists to service were momentarily shaken. Vigée Lebrun's flight from France on the eve of the revolution in 1789 announced not so much her political loyalties as her fear of what would become of her professional and financial connections with the court of Marie Antoinette, and after the initial upheavals, a petition was signed in France by artists and friends requesting that her name be removed from the list of proscribed émigrés. Vigée Lebrun's career raises important questions about the artist's relationship to social change. For artists do not passively reproduce dominant ideology; they participate in its

46

construction and alteration. Artists work in but also on ideology. Vigée Lebrun's practice as an artist was shaped by the conflicting ideologies emerging in a period of radical social upheaval in which not only was the structure of political power in society dramatically shifted but, more relevantly, within the new class formation, women's roles were transformed.

Vigée Lebrun painted many self portraits and portraits of fellow artists. Comparison of her painting of herself, *Self portrait* (London, National Gallery) dressed in a silk dress and a hat bedecked with flowers which match the array of colours on her unused and very decorative palette, with her painting of *Hubert Robert* is instructive (Paris, Musée du Louvre, 1788). In the *Hubert Robert* portrait Vigée Lebrun presents us with the image of the Romantic ideal of the artist, casually dressed in workmanlike clothes, unmoved by the creases in his jacket or the lumpiness of the quickly knotted cravat. It shows neither the studied casualness of the eighteenth-century domestic portrait of 'les philosophes' for which, for instance, Diderot sat without his wig, swathed in a comfortable dressing-gown. At the same time it displays none of the respectful formality of public dress. Robert does not look towards the viewer, but gazes off to some unseen point of real or imaginary inspiration. He holds his palette and used brushes with easy confidence. At work and in privacy, the artist, self-generated, self-absorbed, dressed only to suit his convenience and work, is being represented as someone apart whose behaviour is directed by the exigencies of artistic creation. Vigée Lebrun's image of herself as artist constructs a totally different set of concerns. Her dress is social, outdoor and fashionable. Her hair-style, her decorations have been faithfully set down. They add up to a picture of a beautiful woman, an overlapping notion of beauty and femininity that is entangled in dress, hair, skin texture, fabric and the carefully organized interplay of artifice and nature. Moreover she gazes at us, not asserting her look over ours, but rather inviting us to look at her. Everything from the shadow of the hat to the sweep of her welcoming hand combines to signify her existence for us, her presentation of herself as a spectacle for us. In the gulf that separates the two paintings of artists lies what was to become in bourgeois society an insuperable distance between the notion of the artist and the notion of woman.

In a fascinating article on late-eighteenth-century genre painting, Carol Duncan charted the emergence of a new, moralistic, emotionally charged representation of family life in which domesticity and the relationships between parent and children were presented as not only pleasant but blissful.[44] Responsible for this new treatment of mothers, children and the family, she argues, was the development of new,

bourgeois institutions of the family and childhood which replaced the *ancien régime's* idea of family as dynasty with an affectionate bond between parents and children living in a nuclear unit. The clearly differentiated roles for father and mother, the insistence on gratifying emotional feelings between members of this social unit were all constituent elements of what was, at that date, progressive bourgeois ideology. One of its most salient novelties was the cult of the happy mother, the woman fulfilled by her own child-bearing and child-rearing. However symptomatic of emerging bourgeois ideas this insistence on family and motherhood, it was not restricted to that class, nor only celebrated in the domestic genre often associated with its patronage. Note for instance the portrait of Marie Antoinette and her children by Elisabeth Vigée Lebrun (1787, Versailles) in which the Queen is portrayed dandling a lively baby on her knee, while a daughter leans affectionately against her, and the heir to the throne plays with the baby's cradle. In another *Self portrait* (Paris, Musée du Louvre) painted in 1789, Vigée Lebrun showed herself and her daughter. The portrait is articulated across this ideological shift. The novelty of the painting lies in its secular displacement of the image of the Madonna with male child for a double female portrait – mother and daughter. In her presentation of self, the artist doubly stresses the contemporary conception of woman. Partly revealed, smooth-limbed and beautiful, 'naturally' coiffed, she also engages with a position as a mother, and an affectionate one. The bourgeois notion that woman's place is in the home and that woman's only genuine fulfilment lies in child-bearing – the 'You won't be an artist; you'll just have babies' – is anticipated in this maternal rather than professional presentation of the artist. Moreover the painting links the two females in a circular embrace. The child is a smaller version of the adult woman. The mother is to be fulfilled through her child; the child will grow up to a future role identical to her mother's. The compositional device inscribes into the painting the closing circle of women's lives in the bourgeois society that was to be established after the revolution. By the nineteenth century, with the consolidation of a patriarchal bourgeoisie as the dominant social class, women were increasingly locked into place in the family; the category woman was limited to those familial positions and where women lived and worked beyond them they were penalized for it and treated as unnatural, unwomanly, unsexed. Femininity was exclusively domestic and maternal. At the same time the bourgeois notions of the artist evolved associating the creator with everything that was anti-domestic, whether it was the Romantic ideal of outsiderness and alliance with sublime Nature or Bohemian models of free living, sexually energetic, socially alienated outcasts. As bourgeois femininity was to be lived out in rigidly

enforced reproductive and prescribed supportive roles, a profound contradiction was established between the ideological identities of the artist and of woman. (Art history today, i.e. modernizing bourgeois art history, masks that historically created division as natural fact.)

The categorical differences of identity between terms such as artist and woman thus were historically produced within the social formation of the bourgeois order. The bourgeois revolution was in many ways a historic defeat for women and it created the special configuration of power and domination with which we as women now have to contend. It is the history of its consolidation, i.e. of bourgeois social relations and of their dominant ideological forms, that we need to analyse and subvert. Hence the relationship of Marxism and feminist art history is not a 'marriage' (Hartman), not a cobbling together. It must be the fruitful raiding of Marxism for its explanatory instruments, for its analysis of the operations of bourgeois society and of bourgeois ideologies in order to be able to identify the specific configurations of bourgeois femininity and the forms of bourgeois mystification which mask the reality of social and sexual antagonisms and, denying us vision and voice, deprive us of power.

3

Modernity and the spaces of femininity

Investment in the look is not as privileged in women as in men.
More than other senses, the eye objectifies and masters. It sets at
a distance, and maintains a distance. In our culture the predomin-
ance of the look over smell, taste, touch and hearing has brought
about an impoverishment of bodily relations. The moment the look
dominates, the body loses its materiality.
(Luce Irigaray (1978). Interview in M.- F. Hans and G. Lapouge
(eds) *Les Femmes, la pornographie et l'érotisme,* Paris, p. 50)

INTRODUCTION

The schema which decorated the cover of Alfred H. Barr's catalogue for
the exhibition *Cubism and Abstract Art* at the Museum of Modern Art, New
York, in 1936 is paradigmatic of the way modern art has been mapped
by modernist art history (Figure 3.1). Artistic practices from the late nine-
teenth century are placed on a chronological flow chart where movement
follows movement connected by one-way arrows which indicate influence
and reaction. Over each movement a named artist presides. All those
canonized as the initiators of modern art are men. Is this because there
were no women involved in early modern movements? No.[1] Is it
because those who were, were without significance in determining the
shape and character of modern art? No. Or is it rather because what
modernist art history celebrates is a selective tradition which normalizes,
as the *only* modernism, a particular and gendered set of practices? I would
argue for this explanation. As a result any attempt to deal with artists
in the early history of modernism who are women necessitates a
deconstruction of the masculinist myths of modernism.[2]

50

3.1 Cover design for exhibition catalogue: *Cubism and Abstract Art* (1936)
New York Museum of Modern Art

These are, however, widespread and structure the discourse of many
counter-modernists, for instance in the social history of art. The recent
publication *The Painting of Modern Life: Paris in the Art of Manet and his
Followers*, by T. J. Clark,[3] offers a searching account of the social
relations between the emergence of new protocols and criteria for paint-
ing – modernism – and the myths of modernity shaped in and by the
new city of Paris remade by capitalism during the Second Empire.
Going beyond the commonplaces about a desire to be contemporary in
art, 'il faut être de son temps',[4] Clark puzzles at what structured the

51

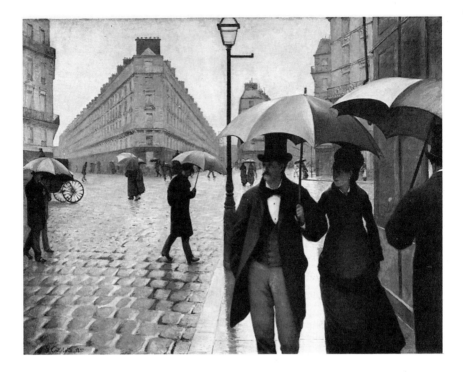

3.2 Gustave Caillebotte, *Paris, a rainy day* (1877)

notions of modernity which became the territory for Manet and his followers. He thus indexes the impressionist painting practices to a complex set of negotiations of the ambiguous and baffling class forma-tions and class identities which emerged in Parisian society. Modernity is presented as far more then a sense of being 'up to date' – modernity is a matter of representations and major myths – of a new Paris for recreation, leisure and pleasure, of nature to be enjoyed at weekends in suburbia, of the prostitute taking over and of fluidity of class in the popular spaces of entertainment. The key markers in this mythic territory are leisure, consumption, the spectacle and money. And we can reconstruct from Clark a map of impressionist territory which stretches from the new boulevards via Gare St Lazare out on the suburban train to La Grenouillère, Bougival or Argenteuil. In these sites, the artists lived, worked and pictured themselves[5] (Figure 3.2). But in two of the four chapters of Clark's book, he deals with the problematic of sexuality in bourgeois Paris and the canonical paintings are *Olympia* (1863, Paris, Musée du Louvre) and *A bar at the Folies-Bergère* (1881–2, London, Courtauld Institute of Art) (Figure 3.3).

It is a mighty but flawed argument on many levels but here I wish to

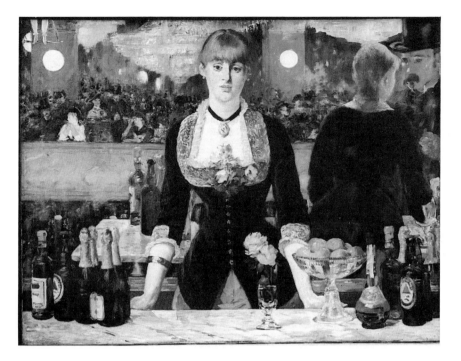

3.3 Edouard Manet, *A bar at the Folies-Bergère* (1881–2)

attend to its peculiar closures on the issue of sexuality. For Clark the founding fact is class. Olympia's nakedness inscribes her class and thus debunks the mythic classlessness of sex epitomized in the image of the courtesan.[6] The fashionably blasé barmaid at the Folies evades a fixed identity as either bourgeois or proletarian but none the less participates in the play around class that constituted the myth and appeal of the popular.[7]

Although Clark nods in the direction of feminism by acknowledging that these paintings imply a masculine viewer/consumer, the manner in which this is done ensures the normalcy of that position leaving it below the threshold of historical investigation and theoretical analysis.[8] To recognize the gender specific conditions of these paintings' existence one need only imagine a female spectator and a female producer of the works. How can a woman relate to the viewing positions proposed by either of these paintings? Can a woman be offered, in order to be denied, imaginary possession of Olympia or the barmaid? Would a woman of Manet's class have a familiarity with either of these spaces and its exchanges which could be evoked so that the painting's modernist job of negation and disruption could be effective? Could Berthe

53

Morisot have gone to such a location to canvass the subject? Would it enter her head as a site of modernity as she experienced it? Could she as a woman experience modernity as Clark defines it at all?*

For it is a striking fact that many of the canonical works held up as the founding monuments of modern art treat precisely with this area, sexuality, and this form of it, commercial exchange. I am thinking of innumerable brothel scenes through to Picasso's *Demoiselles d'Avignon* or that other form, the artist's couch. The encounters pictured and imagined are those between men who have the freedom to take their pleasures in many urban spaces and women from a class subject to them who have to work in those spaces often selling their bodies to clients, or to artists. Undoubtedly these exchanges are structured by relations of class but these are thoroughly captured within gender and its power relations. Neither can be separated or ordered in a hierarchy. They are historical simultaneities and mutually inflecting.

So we must enquire why the territory of modernism so often is a way of dealing with masculine sexuality and its sign, the bodies of women – why the nude, the brothel, the bar? What relation is there between sexuality, modernity and modernism. If it is normal to see paintings of women's bodies as the territory across which men artists claim their modernity and compete for leadership of the avant-garde, can we expect to rediscover paintings by women in which they battled with their sexuality in the representation of the male nude? Of course not; the very

* While accepting that paintings such as *Olympia* and *A bar at the Folies-Bergère* come from a tradition which invokes the spectator as masculine, it is necessary to acknowledge the way in which a feminine spectator is actually implied by these paintings. Surely one part of the shock, of the transgression effected by the painting *Olympia* for its first viewers at the Paris Salon was the presence of that 'brazen' but cool look from the white woman on a bed attended by a black maid in a space in which women, or to be historically precise bourgeois ladies, would be presumed to be present. That look, so overtly passing between a seller of woman's body and a client/viewer signified the commercial and sexual exchanges specific to a part of the public realm which should be invisible to ladies. Furthermore its absence from their consciousness structured their identities as ladies. In some of his writings T. J. Clark correctly discusses the meanings of the sign woman in the nineteenth century as oscillating between two poles of the *fille publique* (woman of the streets) and the *femme honnête* (the respectable married woman). But it would seem that the exhibition of *Olympia* precisely confounds that social and ideological distance between two imaginary poles and forces the one to confront the other in that part of the public realm where ladies do go – still within the frontiers of femininity. The presence of this painting in the Salon – not because it is a nude but because it displaces the mythological costume or anecdote through which prostitution was represented mythically through the courtesan – transgresses the line on my grid derived from Baudelaire's text, introducing not just modernity as a manner of painting a pressing contemporary theme, but the spaces of modernity into a social territory of the bourgeoisie, the Salon, where viewing such an image is quite shocking because of the presence of wives, sisters and daughters. The understanding of the shock depends upon our restoration of the female spectator to her historical and social place.

54

suggestion seems ludicrous. But why? Because there is a historical asymmetry – a difference socially, economically, subjectively between being a woman and being a man in Paris in the late nineteenth century. This difference – the product of the social structuration of sexual difference and not any imaginary biological distinction – determined both what and how men and women painted.

I have long been interested in the work of Berthe Morisot (1841–96) and Mary Cassatt (1844–1926), two of the four women who were actively involved with the impressionist exhibiting society in Paris in the 1870s and 1880s who were regarded by their contemporaries as important members of the artistic group we now label the Impressionists.[9] But how are we to study the work of artists who are women so that we can discover and account for the specificity of what they produced as individuals while also recognizing that, as women, they worked from different positions and experiences from those of their colleagues who were men?

Analysing the activities of women who were artists cannot merely involve mapping women on to existing schemata even those which claim to consider the production of art socially and address the centrality of sexuality. We cannot ignore the fact that the terrains of artistic practice and of art history are structured in and structuring of gender power relations.

As Roszika Parker and I argued in *Old Mistresses: Women, Art and Ideology* (1981), feminist art history has a double project. The historical recovery of data about women producers of art coexists with and is only critically possible through a concomitant deconstruction of the discourses and practices of art history itself.

Historical recovery of women who were artists is a prime necessity because of the consistent obliteration of their activity in what passes for art history. We have to refute the lies that there were no women artists, or that the women artists who are admitted are second-rate and that the reason for their indifference lies in the all-pervasive submission to an indelible femininity – always proposed as unquestionably a disability in making art. But alone historical recovery is insufficient. What sense are we to make of information without a theorized framework through which to discern the particularity of women's work? This is itself a complicated issue. To avoid the embrace of the feminine stereotype which homogenizes women's work as determined by natural gender, we must stress the heterogeneity of women's art work, the specificity of individual producers and products. Yet we have to recognize what women share – as a result of nurture not nature, i.e. the historically variable social systems which produce sexual differentiation.

This leads to a major aspect of the feminist project, the theorization

and historical analysis of sexual difference. Difference is not essential but understood as a social structure which positions male and female people asymmetrically in relation to language, to social and economic power and to meaning. Feminist analysis undermines one bias of patriarchal power by refuting the myths of universal or general meaning. Sexuality, modernism or modernity cannot function as given categories to which we add women. That only identifies a partial and masculine viewpoint with the norm and confirms women as other and subsidiary. Sexuality, modernism or modernity are organized by and organizations of sexual difference. To perceive women's specificity is to analyse historically a particular configuration of difference.

This is my project here. How do the socially contrived orders of sexual difference structure the lives of Mary Cassatt and Berthe Morisot? How did that structure what they produced? The matrix I shall consider here is that of space.

Space can be grasped in several dimensions. The first refers us to spaces as locations. What spaces are represented in the paintings made by Berthe Morisot and Mary Cassatt? And what are not? A quick list includes:

dining-rooms
drawing-rooms
bedrooms
balconies/verandas
private gardens (See Figures 3.4–3.11.)

The majority of these have to be recognized as examples of private areas or domestic space. But there are paintings located in the public domain, scenes for instance of promenading, driving in the park, being at the theatre, boating. They are the spaces of bourgeois recreation, display and those social rituals which constituted polite society, or Society, Le Monde. In the case of Mary Cassatt's work, spaces of labour are included, especially those involving child care (Figure 3.10). In several examples, they make visible aspects of working-class women's labour within the bourgeois home.

I have previously argued that engagement with the impressionist group was attractive to some women precisely because subjects dealing with domestic social life hitherto relegated as mere genre painting were legitimized as central topics of the painting practices.[10] On closer examination it is much more significant how little of typical impressionist iconography actually reappears in the works made by artists who are women. They do not represent the territory which their colleagues who were men so freely occupied and made use of in their works, for instance bars, cafés, backstage and even those places which Clark has seen as participating in the myth of the popular – such as the bar at the

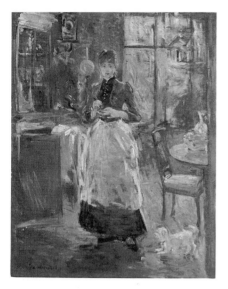
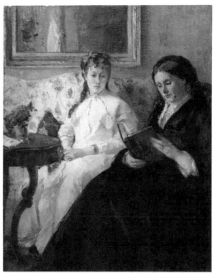

3.4 Berthe Morisot
 In the dining room (1886)

3.5 Berthe Morisot
 Two women reading (1869–70)

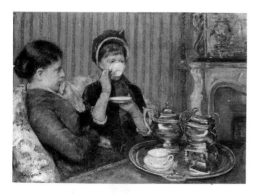

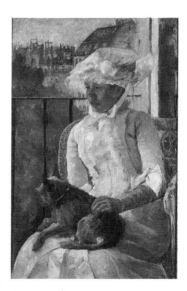

3.6 Mary Cassatt
 Five o'clock tea (1880)

3.7 Mary Cassatt
 Susan on a balcony (1883)

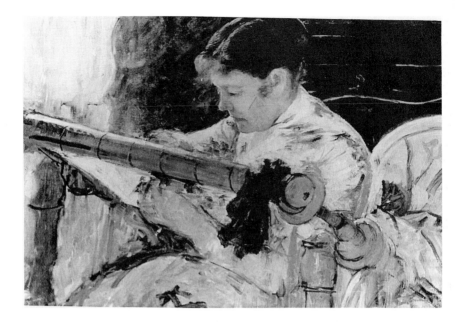

3.8 Mary Cassatt *Lydia at a tapestry frame* (*c.* 1881)

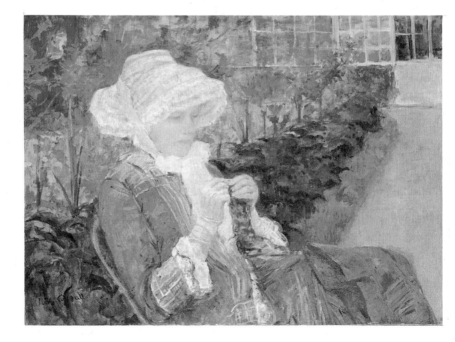

3.9 Mary Cassatt *Lydia crocheting in the garden* (1880)

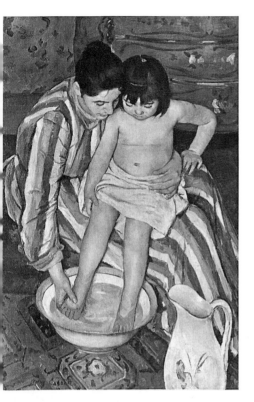

3.10 Mary Cassatt
The bath (1892)

3.11 Berthe Morisot
On a summer's day (1880)

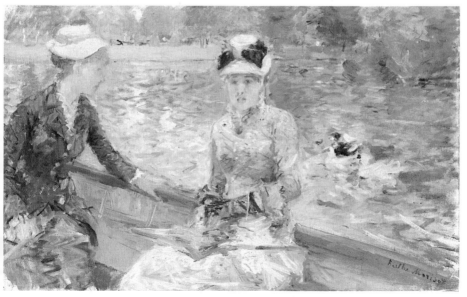

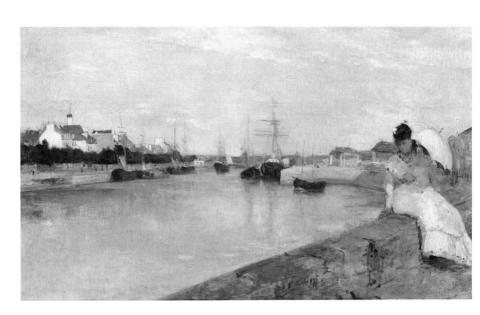

3.12 Berthe Morisot *The harbour at Lorient* (1869)

3.13 Berthe Morisot *On the terrace* (1874)

3.14 Berthe Morisot
On the balcony (1872)

3.15 Claude Monet
The garden of the princess (1867)

Folies-Bergère or even the Moulin de la Galette. A range of places and subjects was closed to them while open to their male colleagues who could move freely with men and women in the socially fluid public world of the streets, popular entertainment and commercial or casual sexual exchange.

The second dimension in which the issue of space can be addressed is that of the spatial order within paintings. Playing with spatial structures was one of the defining features of early modernist painting in Paris, be it Manet's witty and calculated play upon flatness or Degas's use of acute angles of vision, varying viewpoints and cryptic framing devices. With their close personal contacts with both artists, Morisot and Cassatt were no doubt party to the conversations out of which these strategies emerged and equally subject to the less conscious social forces which may well have conditioned the predisposition to explore spatial ambiguities and metaphors.[11] Yet although there are examples of their using similar tactics, I would like to suggest that spatial devices in the work of Morisot and Cassatt work to a wholly different effect.

A remarkable feature in the spatial arrangements in paintings by Morisot is the juxtaposition on a single canvas of two spatial systems – or at least of two compartments of space often obviously boundaried by some device such as a balustrade, balcony, veranda or embankment whose presence is underscored by facture. In *The harbour at Lorient*, 1869 (Figure 3.12), Morisot offers us at the left a landscape view down the estuary represented in traditional perspective while in one corner, shaped by the boundary of the embankment, the main figure is seated at an oblique angle to the view and to the viewer. A comparable composition occurs in *On the terrace*, 1874 (Figure 3.13), where again the foreground figure is literally squeezed off-centre and compressed within a box of space marked by a heavily brushed-in band of dark paint forming the wall of the balcony on the other side of which lies the outside world of the beach. In *On the balcony*, 1872 (Figure 3.14), the viewer's gaze over Paris is obstructed by the figures who are none the less separated from that Paris as they look over the balustrade from the Trocadéro, very near to her home.[12] The point can be underlined by contrasting the painting by Monet, *The garden of the princess*, 1867 (Figure 3.15), where the viewer cannot readily imagine the point from which the painting has been made, namely a window high in one of the new apartment buildings, and instead enjoys a fantasy of floating over the scene. What Morisot's balustrades demarcate is not the boundary between public and private but between the spaces of masculinity and of femininity inscribed at the level of both what spaces are open to men and women and what relation a man or woman has to that space and its occupants.

In Morisot's paintings, moreover, it is as if the place from which the painter worked is made part of the scene creating a compression or immediacy in the foreground spaces. This locates the viewer in that same place, establishing a notional relation between the viewer and the woman defining the foreground, therefore forcing the viewer to experience a dislocation between her space and that of a world beyond its frontiers.

Proximity and compression are also characteristic of the works of Cassatt. Less often is there a split space but it occurs, as in *Susan on a balcony*, 1883 (Figure 3.7). More common is a shallow pictorial space which the painted figure dominates *Young woman in black: portrait of Mrs Gardner Cassatt*, 1883 (Figure 3.16). The viewer is forced into a confrontation or conversation with the painted figure while dominance and familiarity are denied by the device of the averted head of concentration on an activity by the depicted personage. What are the conditions for this awkward but pointed relation of the figure to the world? Why this lack of conventional distance and the radical disruption of what we take as the normal spectator-text relations? What has disturbed the 'logic of the gaze?'

In a previous monograph on Mary Cassatt I tried to establish a correspondence between the social space of the represented and the pictorial space of the representation.[13] Considering the painting *Lydia, at a tapestry frame*, 1881 (Figure 3.8), I noted the shallow space of the painting which seemed inadequate to contain the embroidery frame at which the artist's sister works. I tried to explain its threatened protrusion beyond the picture's space into that of the viewer as a comment on the containment of women and read the painting as a statement of resistance to it. In *Lydia crocheting in the garden*, 1880 (Figure 3.9), the woman is not placed in an interior but in a garden. Yet this outdoor space seems to collapse towards the picture plane, again creating a sense of compression. The comfortable vista beyond the figure, opening out to include a view and the sky beyond as in Caillebotte's *Garden at Petit Gennevilliers with dahlias*, 1893, is decisively refused.

I argued that despite the exterior setting the painting creates the intimacy of an interior and registers the garden, a favoured topic with impressionist artists, not as a piece of private property but as the place of seclusion and enclosure. I was searching for some kind of homology between the compression of pictorial space and the social confinement of women within the prescribed limits of bourgeois codes of femininity. Claustrophobia and restraint were read into the pressurized placement of figures in shallow depth. But such an argument is only a modified form of reflection theory which does not explain anything (though it does have the saving grace of acknowledging the role of signifiers in the active production of meaning).

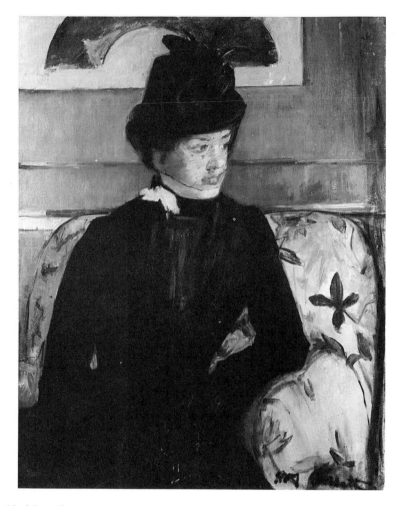

3.16 Mary Cassatt *Young woman in black: portrait of Mrs Gardner Cassatt* (1883)

In the case of Mary Cassatt I would now want to draw attention to the disarticulation of the conventions of geometric perspective which had normally governed the representation of space in European painting since the fifteenth century. Since its development in the fifteenth century, this mathematically calculated system of projection had aided painters in the representation of a three-dimensional world on a two-dimensional surface by organizing objects in relation to each other to produce a notional and singular position from which the scene is intelligible. It establishes the viewer as both absent from and indeed independent of the scene while being its mastering eye/I.

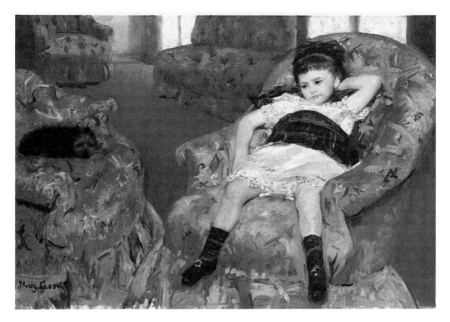

3.17 Mary Cassatt *Young girl in a blue armchair* (1878)

It is possible to represent space by other conventions. Phenomenology has been usefully applied to the apparent spatial deviations of the work of Van Gogh and Cézanne.[14] Instead of pictorial space functioning as a notional box into which objects are placed in a rational and abstract relationship, space is represented according to the way it is experienced by a combination of touch, texture, as well as sight. Thus objects are patterned according to subjective hierarchies of value for the producer. Phenomenological space is not orchestrated for sight alone but by means of visual cues refers to other sensations and relations of bodies and objects in a lived world. As experiential space this kind of representation becomes susceptible to different ideological, historical as well as purely contingent, subjective inflections.

These are not necessarily unconscious. For instance in *Young girl in a blue armchair*, 1878 (Figure 3.17) by Cassatt, the viewpoint from which the room has been painted is low so that the chairs loom large as if imagined from the perspective of a small person placed amongst massive upholstered obstacles. The background zooms sharply away indicating a different sense of distance from that a taller adult would enjoy over the objects to an easily accessible back wall. The painting therefore not only pictures a small child in a room but evokes that child's sense of the space of the room. It is from this conception of the

65

possibilities of spatial structure that I can now discern a way through my earlier problem in attempting to relate space and social processes. For a third approach lies in considering not only the spaces represented, or the spaces *of* the representation, but the social spaces from which the representation is made and its reciprocal positionalities. The producer is herself shaped within a spatially orchestrated social structure which is lived at both psychic and social levels. The space of the look at the point of production will to some extent determine the viewing position of the spectator at the point of consumption. This point of view is neither abstract nor exclusively personal, but ideologically and historically construed. It is the art historian's job to re-create it – since it cannot ensure its recognition outside its historical moment.

The spaces of femininity operated not only at the level of what is represented, the drawing-room or sewing-room. The spaces of femininity are those from which femininity is lived as a positionality in discourse and social practice. They are the product of a lived sense of social locatedness, mobility and visibility, in the social relations of seeing and being seen. Shaped within the sexual politics of looking they demarcate a particular social organization of the gaze which itself works back to secure a particular social ordering of sexual difference. Femininity is both the condition and the effect.

How does this relate to modernity and modernism? As Janet Wolff has convincingly pointed out, the literature of modernity describes the experience of men.[15] It is essentially a literature about transformations in the public world and its associated consciousness. It is generally agreed that modernity as a nineteenth-century phenomenon is a product of the city. It is a response in a mythic or ideological form to the new complexities of a social existence passed amongst strangers in an atmosphere of intensified nervous and psychic stimulation, in a world ruled by money and commodity exchange, stressed by competition and formative of an intensified individuality, publicly defended by a blasé mask of indifference but intensely 'expressed' in a private, familial context.[16] Modernity stands for a myriad of responses to the vast increase in population leading to the literature of the crowds and masses, a speeding up of the pace of life with its attendant changes in the sense and regulation of time and fostering that very modern phenomenon, fashion, the shift in the character of towns and cities from being centres of quite visible activities – manufacture, trade, exchange – to being zoned and stratified, with production becoming less visible while the centres of cities such as Paris and London become key sites of consumption and display producing what Sennett has labelled the spectacular city.[17]

All these phenomena affected women as well as men, but in different

ways. What I have described above takes place within and comes to define the modern forms of the public space changing as Sennett argues in his book significantly titled *The Fall of Public Man* from the eighteenth century formation to become more mystified and threatening but also more exciting and sexualized. One of the key figures to embody the novel forms of public experience of modernity is the flâneur or impassive stroller, the man in the crowd who goes, in Walter Benjamin's phrase, 'botanizing on the asphalt'.[18] The flâneur symbolizes the privilege or freedom to move about the public arenas of the city observing but never interacting, consuming the sights through a controlling but rarely acknowledged gaze, directed as much at other people as at the goods for sale. The flâneur embodies the gaze of modernity which is both covetous and erotic.

But the flâneur is an exclusively masculine type which functions within the matrix of bourgeois ideology through which the social spaces of the city were reconstructed by the overlaying of the doctrine of separate spheres on to the division of public and private which became as a result a gendered division. In contesting the dominance of the aristocratic social formation they were struggling to displace, the emergent bourgeoisies of the late eighteenth century refuted a social system based on fixed orders of rank, estate and birth and defined themselves in universalistic and democratic terms. The pre-eminent ideological figure is MAN which immediately reveals the partiality of their democracy and universalism. The rallying cry, liberty, equality and fraternity (again note its gender partiality) imagines a society composed of free, self-possessing male individuals exchanging with equal and like. Yet the economic and social conditions of the existence of the bourgeoisie as a class are structurally founded upon inequality and difference in terms both of socio-economic categories and of gender. The ideological formations of the bourgeoisie negotiate these contradictions by diverse tactics. One is the appeal to an imaginary order of nature which designates as unquestionable the hierarchies in which women, children, hands and servants (as well as other races) are posited as naturally different from and subordinate to white European man. Another formation endorsed the theological separation of spheres by fragmentation of the problematic social world into separated areas of gendered activity. This division took over and reworked the eighteenth-century compartmentalization of the public and private. The public sphere, defined as the world of productive labour, political decision, government, education, the law and public service, increasingly became exclusive to men. The private sphere was the world, home, wives, children and servants.[19] As Jules Simon, moderate republican politician, explained in 1892:

What is man's vocation? It is to be a good citizen. And woman's? To be a good wife and a good mother. One is in some way called to the outside world, the other is *retained* for the interior.[20] (my italics)

Woman was defined by this other, non-social space of sentiment and duty from which money and power were banished.[21] Men, however, moved freely between the spheres while women were supposed to occupy the domestic space alone. Men came home to be themselves but in equally constraining roles as husbands and fathers, to engage in affective relationships after a hard day in the brutal, divisive and competitive world of daily capitalist hostilities. We are here defining a mental map rather than a description of actual social spaces. In her introduction to the essays on *Women in Space*, Shirley Ardener has, however, emphasized that

> societies have generated their own culturally determined ground rules for making boundaries on the ground and have divided the social into spheres, levels and territories with invisible fences and platforms to be scaled by abstract ladders and crossed by intangible bridges with as much trepidation and exultation as on a plank over a raging torrent.[22]

There was none the less an overlap between the purely ideological maps and the concrete organization of the social sphere. As social historians, Catherine Hall and Lee Davidoff have shown in their work on the formation of the British middle class in Birmingham, the city was literally reshaped according to this ideal divide. The new institutions of public governance and business were established as being exclusively masculine preserves and the growing separation of work and home was made real by the building of suburbs such as Edgbaston to which wives and daughters were banished.[23]

As both ideal and social structure, the mapping of the separation of the spheres for women and men on to the division of public and private was powerfully operative in the construction of a specifically bourgeois way of life. It aided the production of the gendered social identities by which the miscellaneous components of the bourgeoisie were helped to cohere as a class, in difference from both aristocracy and proletariat. Bourgeois women, however, obviously went out in public, to promenade, go shopping, or visiting or simply to be on display. And working-class women went out to work, but that fact presented a problem in terms of definition as woman. For instance Jules Simon categorically stated that a woman who worked ceased to be a woman.[24] Therefore, across the public realm lay another, less often studied map

which secured the definitions of bourgeois womanhood – femininity – in difference from proletarian women.

For bourgeois women, going into town mingling with crowds of mixed social composition was not only frightening because it became increasingly unfamiliar, but because it was morally dangerous. It has been argued that to maintain one's respectability, closely identified with femininity, meant *not* exposing oneself in public. The public space was officially the realm of and for men; for women to enter it entailed unforeseen risks. For instance in *La Femme* (1858–60) Jules Michelet exclaimed

> How many irritations for the single woman! She can hardly ever go out in the evening; she would be taken for a prostitute. There are a thousand places where only men are to be seen, and if she needs to go there on business, the men are amazed, and laugh like fools. For example, should she find herself delayed at the other end of Paris and hungry, she will not dare to enter into a restaurant. She would constitute an event; she would be a spectacle: All eyes would be constantly fixed on her, and she would overhear uncomplimentary and bold conjectures.[25]

The private realm was fashioned for men as a place of refuge from the hurly-burly of business, but it was also a place of constraint. The pressures of intensified individuality protected in public by the blasé mask of indifference, registered in the equally socially induced roles of loving husband and responsible father, led to a desire to escape the overbearing demands of masculine domestic personae. The public domain became also a realm of freedom and irresponsibility if not immorality. This, of course, meant different things for men and for women. For women, the public spaces thus construed were where one risked losing one's virtue, dirtying oneself; going out in public and the idea of disgrace were closely allied. For the man going out in public meant losing oneself in the crowd away from both demands of respectability. Men colluded to protect this freedom. Thus a woman going out to dine at a restaurant even with her husband present was scandalous whereas a man dining out with a mistress, even in the view of his friends, was granted a fictive invisibility.[26]

The public and private division functioned on many levels. As a metaphorical map in ideology, it structured the very meaning of the terms masculine and feminine within its mythic boundaries. In practice as the ideology of domesticity became hegemonic, it regulated women's and men's behaviour in the respective public and private spaces. Presence in either of the domains determined one's social identity and therefore, in objective terms, the separation of the spheres problematized women's relation to the very activities and experiences

we typically accept as defining modernity.

In the diaries of the artist Marie Bashkirtseff, who lived and worked in Paris during the same period as Morisot and Cassatt, the following passage reveals some of the restraints:

> What I long for is the freedom of going about alone, of coming and going, of sitting in the seats of the Tuileries, and especially in the Luxembourg, of stopping and looking at the artistic shops, of entering churches and museums, of walking about old streets at night; that's what I long for; and that's the freedom without which one cannot become a real artist. Do you imagine that I get much good from what I see, chaperoned as I am, and when, in order to go to the Louvre, I must wait for my carriage, my lady companion, my family?[27]

These territories of the bourgeois city were however not only gendered on a male/female polarity. They became the sites for the negotiation of gendered class identities and class gender positions. The spaces of modernity are where class and gender interface in critical ways, in that they are the spaces of sexual exchange. The significant spaces of modernity are neither simply those of masculinity, nor are they those of femininity which are as much the spaces of modernity for being the negative of the streets and bars. They are, as the canonical works indicate, the marginal or interstitial spaces where the fields of the masculine and feminine intersect and structure sexuality within a classed order.

THE PAINTER OF MODERN LIFE

One text above all charts this interaction of class and gender. In 1863 Charles Baudelaire published in *Le Figaro* an essay entitled 'The painter of modern life'. In this text the figure of the flâneur is modified to become the modern artist while at the same time the text provides a mapping of Paris marking out the sites/sights for the flâneur/artist. The essay is ostensibly about the work of a minor illustrator Constantin Guys but he is only a pretext for Baudelaire to weave an elaborate and impossible image of his ideal artist who is a passionate lover of crowds, and incognito, a man of the world.

> The crowd is his element as the air is that of birds and water of fishes. His passion and profession are to become one flesh with the crowd. For the perfect flâneur, for the passionate spectator, it is an immense joy to set up house in the heart of the multitude, amid the ebb and flow of movement, in the midst of the fugitive and the

infinite. To be away from home and yet feel oneself everywhere at home; to see the world and to be the centre of the world and yet remain hidden from the world – such are a few of the slightest pleasures of those independent, passionate, impartial natures which the tongue can but clumsily define. The spectator is a *prince* and everywhere rejoices in his incognito. The lover of life makes the whole world his family.[28]

The text is structured by an opposition between home, the inside domain of the known and constrained personality and the outside, the space of freedom, where there is liberty to look without being watched or even recognized in the act of looking. It is the imagined freedom of the voyeur. In the crowd the flâneur/artist sets up home. Thus the flâneur/artist is articulated across the twin ideological formations of modern bourgeois society – the splitting of private and public with its double freedom for men in the public space, and the pre-eminence of a detached observing gaze, whose possession and power is never questioned as its basis in the hierarchy of the sexes is never acknowledged. For as Janet Wolff has recently argued, there is no female equivalent of the quintessential masculine figure, the flâneur; there is not and could not be a female flâneuse. (See note 15.)

Women did not enjoy the freedom of incognito in the crowd. They were never positioned as the normal occupants of the public realm. They did not have the right to look, to stare, scrutinize or watch. As the Baudelairean text goes on to show, women do not look. They are positioned as the *object* of the flâneur's gaze.

Woman is for the artist in general . . . far more than just the female of man. Rather she is divinity, a star . . . a glittering conglomeration of all the graces of nature, condensed into a single being; an object of keenest admiration and curiosity that the picture of life can offer to its contemplator. She is an idol, stupid perhaps, but dazzling and bewitching. . . . Everything that adorns women that serves to show off her beauty is part of herself . . .

No doubt woman is sometimes a light, a glance, an invitation to happiness, sometimes she is just a word.[29]

Indeed woman is just a sign, a fiction, a confection of meanings and fantasies. Femininity is not the natural condition of female persons. It is a historically variable ideological construction of meanings for a sign W*O*M*A*N which is produced by and for another social group which derives its identity and imagined superiority by manufacturing the spectre of this fantastic Other. *WOMAN* is both an idol and nothing but a word. Thus when we come to read the chapter of Baudelaire's essay

71

titled 'Women and prostitutes' in which the author charts a journey across Paris for the flâneur/artist, where women appear merely to be there as spontaneously visible objects, it is necessary to recognize that the text is itself constructing a notion of WOMAN across a fictive map of urban spaces – the spaces of modernity.

The flâneur/artist starts his journey in the auditorium where young women of the most fashionable society sit in snowy white in their boxes at the theatre. Next he watches elegant families strolling at leisure in the walks of a public garden, wives leaning complacently on the arms of husbands while skinny little girls play at making social class calls in mimicry of their elders. Then he moves on to the lowlier theatrical world where frail and slender dancers appear in a blaze of limelight admired by fat bourgeois men. At the café door, we meet a swell while indoors is his mistress, called in the text 'a fat baggage', who lacks practically nothing to make her a great lady except that practically nothing is practically everything for it is distinction (class). Then we enter the doors of Valentino's, the Prado or Casino, where against a background of hellish light, we encounter the protean image of wanton beauty, the courtesan, 'the perfect image of savagery that lurks in the heart of civilization'. Finally by degrees of destitution, he charts women, from the patrician airs of young and successful prostitutes to the poor slaves of the filthy stews.

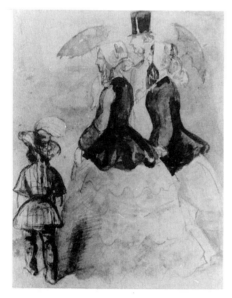

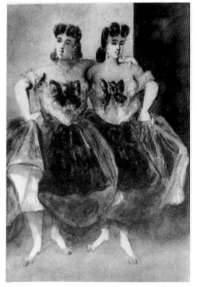

3.18 Constantin Guys
A family walking in the park

3.19 Constantin Guys
Two courtesans

Attempting to match the drawings by Guys to this extraordinary spectacle will disappoint. In no way are the drawings as vivid, for their project is less ideological and altogether more mundane as in the manner of the fashion plate.

None the less they provide some interest in revealing how differently the figures of females are actually represented according to location. The respectable women chaperoned or accompanied by husbands in the park pass by fused almost with their clothing so that, decorporealized, their dress defines their class position and meaning. In spaces marked out for visual and notional sexual consumption the bodies are in evidence, laid out, opened up and offered to view while drapery functions to reveal a sexualized anatomy (Figures 3.18 and 3.19).

Baudelaire's essay maps a representation of Paris as the city of women. It constructs a sexualized journey which can be correlated with impressionist practice. Clark has offered one map of impressionist painting following the trajectories of leisure from city centre by suburban railway to the suburbs. I want to propose another dimension of that map which links impressionist practice to the erotic territories of modernity. I have drawn up a grid using Baudelaire's categories and mapped the works of Manet, Degas and others on to this schema.[30]

GRID I

LADIES	THEATRE (LOGE)	debutantes; young women of fashionable society	RENOIR	CASSATT
	PARK	matrons, mothers, children, elegant families	MANET	CASSATT MORISOT
FALLEN WOMEN	THEATRE (BACKSTAGE)	DANCERS	DEGAS	
	CAFES	mistresses and kept women	MANET RENOIR DEGAS	
	FOLIES	THE COURTESAN 'protean image of wanton beauty'	MANET DEGAS GUYS	
	BROTHELS	'poor slaves of filthy stews'	MANET GUYS	

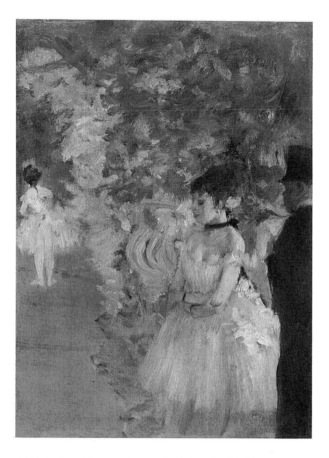

3.20 Edgar Degas *Dancers backstage* (c. 1872)

From the loge pieces by Renoir (admittedly not women of the highest society) to the *Musique aux Tuileries* of Manet, Monet's park scenes and others easily cover this terrain where bourgeois men and women take their leisure. But then when we move backstage at the theatre we enter different worlds, still of men and women but differently placed by class. Degas's pictures of the dancers on stage and rehearsing are well known. Perhaps less familiar are his scenes illustrating the backstage at the Opéra where members of the Jockey Club bargain for their evening's entertainment with the little performers (Figure 3.20). Both Degas and Manet represented the women who haunted cafés and as Theresa Ann Gronberg has shown these were working-class women often suspected of touting for custom as clandestine prostitutes.[31]

Thence we can find examples sited in the Folies and cafés-concerts as well as the boudoirs of the courtesan. Even if *Olympia* cannot be situated

in a recognizable locality, reference was made in the reviews to the café Paul Niquet's, the haunt of the women who serviced the porters of Les Halles and a sign for the reviewer of total degradation and depravity.[32]

WOMEN AND THE PUBLIC MODERN

The artists who were women in this cultural group of necessity occupied this map but partially. They can be located all right but in spaces above a decisive line. *Lydia at the theatre*, 1879 and *The loge*, 1882 (Figure 3.21) situate us in the theatre with the young and fashionable but there could hardly be a greater difference between these paintings and the work by Renoir on this theme, *The first outing*, 1876 (London, National Gallery of Art), for example.

The stiff and formal poses of the two young women in the painting by Cassatt were precisely calculated as the drawings for the work reveal. Their erect posture, one carefully grasping an unwrapped bouquet, the other sheltering behind a large fan, create a telling effect of suppressed excitement and extreme constraint, of unease in this public place, exposed and dressed up, on display. They are set at an oblique angle to the frame so that they are not contained by its edges, not framed and made a pretty picture for us as in *The loge* (Figure 3.22) by Renoir where the spectacle at which the scene is set and the spectacle the woman herself is made to offer, merge for the unacknowledged but presumed masculine spectator. In Renoir's *The first outing* the choice of a profile opens out the spectator's gaze into the auditorium and invites her/him to imagine that she/he is sharing in the main figure's excitement while she seems totally unaware of offering such a delightful spectacle. The lack of self-consciousness is, of course, purely contrived so that the viewer can enjoy the sight of the young girl.

The mark of difference between the paintings by Renoir and Cassatt is the refusal in the latter of that complicity in the way the female protagonist is depicted. In a later painting, *At the opera*, 1879 (Figure 3.23), a woman is represented dressed in daytime or mourning black in a box at the theatre. She looks from the spectator into the distance in a direction which cuts across the plane of the picture but as the viewer follows her gaze another look is revealed steadfastly fixed on the woman in the foreground. The picture thus juxtaposes two looks, giving priority to that of the woman who is, remarkably, pictured actively looking. She does not return the viewer's gaze, a convention which confirms the viewer's right to look and appraise. Instead we find that the viewer outside the picture is evoked by being as it were the mirror image of the man looking in the picture.

This is, in a sense, the subject of the painting – the problematic of

women out in public being vulnerable to a compromising gaze. The witty pun on the spectator outside the painting being matched by that within should not disguise the serious meaning of the fact that social spaces are policed by men's watching women and the positioning of the spectator outside the painting in relation to the man within it serves to indicate that the spectator participates in that game as well. The fact that the woman is pictured so actively looking, signified above all by the fact that her eyes are masked by opera glasses, prevents her being objectified and she figures as the subject of her own look.

Cassatt and Morisot painted pictures of women in public spaces but these all lie above a certain line on the grid I devised from Baudelaire's text. The other world of women was inaccessible to them while it was freely available to the men of the group and constantly entering

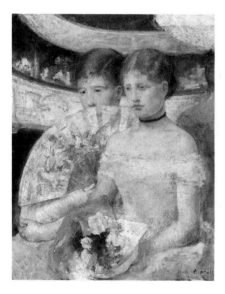

3.21 Mary Cassatt *The loge* (1882)

3.22 Auguste Renoir *The loge* (1874)

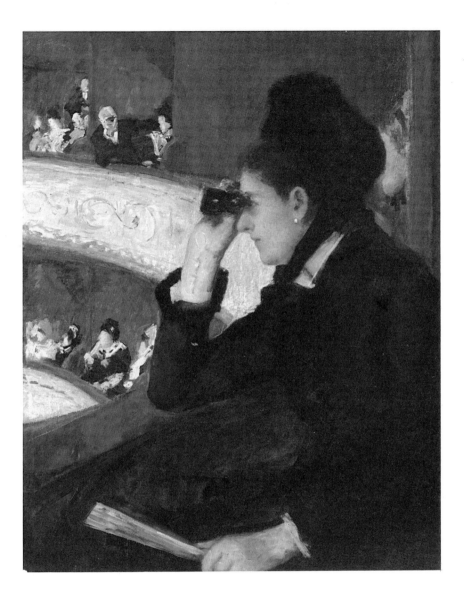

3.23 Mary Cassatt *At the opera* (1879)

representation as the very territory of their engagement with modernity. There is evidence that bourgeois women did go to the cafés-concerts but this is reported as a fact to regret and a symptom of modern decline.[33] As Clark points out, guides for foreigners to Paris such as Murray's clearly wish to prevent such slumming by commenting that respectable people do not visit such venues. In the journals Marie Bashkirtseff records a visit she and some friends made to a masked ball where behind the disguise daughters of the aristocracy could live dangerously, playing with sexual freedom their classed gender denied them. But given both Bashkirtseff's dubious social position, and her condemnation of the standard morality and regulation of women's sexuality, her escapade merely reconfirms the norm.[34]

To enter such spaces as the masked ball or the café-concert constituted a serious threat to a bourgeois woman's reputation and therefore her femininity. The guarded respectability of the lady could be soiled by mere visual contact for seeing was bound up with knowing. This other world of encounter between bourgeois men and women of another class was a no-go area for bourgeois women. It is the place where female sexuality or rather female bodies are bought and sold, where woman becomes both an exchangeable commodity and a seller of flesh, entering the economic domain through her direct exchanges with men. Here the division of the public and private mapped as a separation of the masculine and feminine is ruptured by money, the ruler of the public domain, and precisely what is banished from the home.

Femininity in its class-specific forms is maintained by the polarity virgin/whore which is mystifying representation of the economic exchanges in the patriarchal kinship system. In bourgeois ideologies of femininity the fact of the money and property relations which legally and economically constitute bourgeois marriage is conjured out of sight by the mystification of a one-off purchase of the rights to a body and its products as an effect of love to be sustained by duty and devotion.

Femininity should be understood therefore not as a condition of women but as the ideological form of the regulation of female sexuality within a familial, heterosexual domesticity which is ultimately organized by the law. The spaces of femininity – ideologically, pictorially – hardly articulate female sexualities. That is not to accept nineteenth-century notions of women's asexuality but to stress the difference between what was actually lived or how it was experienced and what was officially spoken or represented as female sexuality.[35]

In the ideological and social spaces of femininity, female sexuality could not be directly registered. This has a crucial effect with regard to the use artists who were women could make of the positionality represented by the gaze of the flâneur – and therefore with regard to

modernity. The gaze of the flâneur articulates and produces a masculine sexuality which in the modern sexual economy enjoys the freedom to look, appraise and possess, is deed or in fantasy. Walter Benjamin draws special attention to a poem by Baudelaire, 'A une passante' ('To a passer-by'). The poem is written from the point of view of a man who sees in the crowd a beautiful widow; he falls in love as she vanishes from sight. Benjamin's comment is apt: 'One may say that the poem deals with the function of the crowd not in the life of a citizen but in the life of an erotic person.'[36]

It is not the public realm simply equated with the masculine which defines the flâneur/artist but access to a sexual realm which is marked by those interstitial spaces, the spaces of ambiguity, defined as such not only by the relatively unfixed or fantasizable class boundaries Clark makes so much of but because of cross-class sexual exchange. Women could enter and represent selected locations in the public sphere – those of entertainment and display. But a line demarcates not the end of the public/private divide but the frontier of the spaces of femininity. Below this line lies the realm of the sexualized and commodified bodies of women, where nature is ended, where class, capital and masculine power invade and interlock. It is a line that marks off a class boundary but it reveals where new class formations of the bourgeois world restructured gender relations not only between men and women but between women of different classes.*

MEN AND WOMEN IN THE PRIVATE SPHERE

I have redrawn the Baudelairean map to include those spaces which are absent – the domestic sphere, the drawing-room, veranda or balcony, the garden of the summer villa and the bedroom (Grid II). This listing

* I may have overstated the case that bourgeois women's sexuality could not be articulated within these spaces. In the light of recent feminist study of the psychosexual psychology of motherhood, it would be possible to read mother-child paintings by women in a far more complex way as a site for the articulation of female sexualities. Moreover in paintings by Morisot, for instance of her adolescent daughter, we may discern the inscription of yet another moment at which female sexuality is referred to by circling around the emergence from latency into an adult sexuality prior to its strict regulation within marital domestic forms. More generally it would be wise to pay heed to the writings of historian Carroll Smith-Rosenberg on the importance of female friendships. She stresses that from our post-Freudian vantage point it is very difficult to read the intimacies of nineteenth-century women, to understand the valencies of the terms of endearment, often very physical, to comprehend the forms of sexuality and love as they were lived, experienced and represented. A great deal more research needs to be done before any statements can be made without the danger of feminists merely rehearsing and confirming the official discourse of masculine ideologues on female sexualities. (C. Smith-Rosenberg 'Hearing women's words: a feminist reconstruction of history', in her book *Disorderly Conduct: Visions of Gender in Victorian America*, New York, Knopf, 1985.)

produces a markedly difference balance between the artists who are women and men from that on the first grid. Cassatt and Morisot occupy these new spaces to a much greater degree while their colleagues are less apparent, but importantly, not totally absent.

GRID II

LADIES			MANET CAILLEBOTTE	MORISOT CASSATT	BEDROOM
			RENOIR CAILLEBOTTE	MORISOT CASSATT	DRAWING ROOM
			BAZILLE CAILLEBOTTE	CASSATT MORISOT	VERANDA
			MONET	CASSATT MORISOT	GARDEN
	THEATRE (LOGE)	debutantes	RENOIR	CASSATT	THEATRE
	PARK	elegant families	MANET	CASSATT MORISOT	PARK
FALLEN WOMEN	THEATRE (BACKSTAGE)	dancers	DEGAS		
	CAFES	mistresses and kept women	MANET RENOIR DEGAS		
	FOLIES	THE COURTESAN 'protean image of wanton beauty'	MANET DEGAS GUYS		
	BROTHELS	'poor slaves of filthy stews'	MANET GUYS		

By way of example, we could cite Renoir's portrait of *Madame Charpentier and her children*, 1878 (New York, Metropolitan Museum) or Bazille's *Family reunion*, 1867 (Paris, Musée d'Orsay) or the painting of Camille in several poses and different dresses painted by Claude Monet in 1867, *Woman in the garden* (Paris, Musée d'Orsay).

These paintings share the territory of the feminine but they are painted from a totally different perspective. Renoir entered Madame Charpentier's drawing-room on commission; Bazille celebrated a particular, almost formal occasion and Monet's painting was devised as

an exercise in open-air painting.[37] The majority of works by Morisot and Cassatt deal with these domestic spaces: for instance *Two women reading*, 1869-70 (Figure 3.5) and *Susan on a balcony*, 1883 (Figure 3.7). These are painted with a sureness of knowledge of the daily routine and rituals which not only constituted the spaces of femininity but collectively trace the construction of femininity across the stages of women's lives. As I have argued previously, Cassatt's oeuvre may be seen to delineate femininity as it is induced, acquired and ritualized from youth through motherhood to old age.[38] Morisot used her daughter's life to produce works remarkable for their concern with female subjectivity especially at critical turning-points of the feminine. For instance, her painting *Psyché* shows an adolescent woman before a mirror, which in France is named a 'Psyché' (Figure 3.24). The classical, mythological figure Psyche was a young mortal with whom Venus's son Cupid fell in love and it was the topic of several paintings in the neo-classical and romantic period as a topos for awakening sexuality.[39]

Morisot's painting offers the spectator a view into the bedroom of a bourgeois woman and as such is not without voyeuristic potential but at the same time, the pictured woman is not offered for sight so much as caught contemplating herself in a mirror in a way which separates the woman as subject of a contemplative and thoughtful look from woman as object – a contrast may make this clearer; compare it with Manet's painting of a half-dressed woman looking in a mirror in such a way that her ample back is offered to the spectator as merely a body in a working room, *Before the mirror*, 1876–7 (New York, Solomon R. Guggenheim Museum).

But I must stress that I am in no way suggesting that Cassatt and Morisot are offering us a truth about the spaces of femininity. I am not suggesting that their intimacy with the domestic space enabled them to escape their historical formation as sexed and classed subjects, that they could see it objectively and transcribe it with some kind of personal authenticity. To argue that would presuppose some notion of gendered authorship, that the phenomena I am concerned to define and explicate are a result of the fact that the authors/artists are women. That would merely tie the women back into some transhistorical notion of the biologically determined gender characteristics, what Rozsika Parker and I labelled in *Old Mistresses* as the feminine stereotype.

None the less the painters of this cultural group were positioned differently with regard to social mobility and the type of looking permitted them according to their being men or women. Instead of considering the paintings as documents of this condition, reflecting or expressing it, I would stress that the practice of painting is itself *a site for the inscription of sexual difference*. Social positionality in terms of both class and gender

3.24 Berthe Morisot *Psyché* (1876)

determine – that is, set the pressure and prescribe the limits of – the work produced. But we are here considering a continuing process. The social, sexual and psychic construction of femininity is constantly produced, regulated, renegotiated. This productivity is involved as much in the practice of making art. In manufacturing a painting, engaging a model, sitting in a room with someone, using a score of known techniques, modifying them, surprising oneself with novel and unexpected effects both technical and in terms of meanings, which result from the way the model is positioned, the size of the room, the nature of the contract, the experience of the scene being painted and so forth – all these actual procedures which make up part of the social practice of making a painting, function as the modes by which the social and psychic positionality of Cassatt and Morisot not only structured their pictures, but reciprocally affected the painters themselves as they found, through the making of images, their world represented back to them.

It is here that the critique of authorship is relevant – the critique of the notion of a fully coherent author subject previous to the act of creation, producing a work of art which then becomes merely a mirror or, at best, a vehicle for communicating a fully formed intention and a consciously grasped experience. What I am proposing is that on the one hand we

consider the social formation of the producer within class and gender relations, but also recognize the working process or practice as the site of a crucial social interaction between producer and materials. These are themselves economically and culturally determined be they technical – the legacy of conventions, traditions and procedures – or those social and ideological connotations of subject. The product is an inscription of those transactions and produces positions for its viewers.

I am not suggesting that the meaning is therefore locked into the work and prescribed. The death of the author has involved the emphasis on the reader/viewer as the active producer of meaning for texts. But this carries with it an excessive danger of total relativism; any reader can make any meanings. There is a limit, an historical and ideological limit which is secured by accepting the death of the mythic figure of the creator/author but not the negation of the historical producer working within conditions which determine the productivity of the work while never confining its actual or potential field of meanings. This issue becomes acutely relevant for the study of cultural producers who are women. Typically within art history they are denied the status of author/creator (see Barr's chart, Figure 3.1). Their creative personality is never canonized or celebrated. Moreover they have been the prey of ideological readings where without regard to history and difference, art historians and critics have confidently proclaimed the meanings of the work by women, meanings which always reduce back to merely stating that these are works by women. Thus Mary Cassatt has been most often indulged as a painter of typical feminine subjects, the mother and child, while the following enthusiastic review by the Irish painter and critic George Moore speaks volumes about his problem with praising an artist who genuinely impressed him but was a woman:

> Madame Lebrun painted well, but she invented nothing, she failed to make her own of any special manner of seeing and rendering things; she failed to create a style. Only one woman did this, and that woman is Madame Morisot, and her pictures are the only pictures painted by a woman that could not be destroyed without creating a blank, a hiatus in the history of art. True that hiatus would be slight – insignificant if you will – but the insignificant is sometimes dear to us; and though nightingales, thrushes and skylarks were to sing in King's Bench Walk, I should miss the individual chirp of the pretty sparrow. Madame Morisot's note is perhaps as insignificant as a sparrow's, but it is an unique and individual note. She has created a style, and has done so by investing her art with all her femininity; her art is no dull parody of ours; it is all womanhood – sweet and gracious, tender and wistful womanhood.[40]

Thus it becomes especially necessary to develop means by which we can represent women as cultural producers within specific historical formations, while at the same time dealing with the centrality of the issue of femininity in structuring their lives and work. Yet femininity must not be presented as the founding cause of their work. This involves moving away from stressing the social construction of femininity as taking part in privileged social practices such as the family prior to the making of art which then becomes a merely passive mirroring of that social role or psychic condition. By stressing the working process – both as manufacture and signification – as the site of the inscription of sexual difference I am wanting to emphasize the active part of cultural practices in producing the social relations and regulations of femininity. They can also conceivably be a place for some qualification or disruption of them. The notion springs women from the trap of circularity. Socially shaped within the feminine, their art is made to confirm femininity as an inescapable condition understood perpetually from the ideological patriarchal definition of it. There is no doubt that femininity is an oppressive condition yet women live it to different purposes and feminist analyses are currently concerned to explore not only its limits but the concrete ways women negotiate and refashion that position to alter its meanings.

How sexual difference is inscribed will be determined by the specificity of the practice and the processes of representation. In this essay I have explored two axes on which these issues can be considered – that of space and that of the look. I have argued that the social process defined by the term modernity was experienced spatially in terms of access to the spectacular city which was open to a class and gender-specific gaze. (This hovers between the still public figure of the flâneur and the modern condition of voyeur.) In addition, I have pointed to a coincidence between the spaces of modernity and the spaces of masculinity as they intersect in the territory of cross-class sexual exchange. Modifying therefore the simple conceit of a bourgeois world divided by public and private, masculine and feminine, the argument seeks to locate the production of the bourgeois definition of woman defined by the polarity of bourgeois lady and proletarian prostitute/ working woman. The spaces of femininity are not only limited in relation to those defining modernity but because of the sexualized map across which woman is separated, the spaces of femininity are defined by a different organization of the look.

Difference, however, does not of necessity involve restriction or lack. That would be to reinscribe the patriarchal construction of woman. The features in the paintings by Mary Cassatt and Berthe Morisot of proximity, intimacy and divided spaces posit a different kind of viewing

84

relation at the point of both production and consumption.

The difference they articulate is bound to the production of femininity as both difference and as specificity. They suggest the particularity of the female spectator – that which is completely negated in the selective tradition we are offered as history.

WOMEN AND THE GAZE

In an article entitled 'Film and the masquerade: theorizing the female spectator', Mary Ann Doane uses a photograph by Robert Doisneau titled *An oblique look*, 1948 to introduce her discussion of the negation of the female gaze (Figure 3.25) in both visual representations and on the streets.[41] In the photograph a petit bourgeois couple stand in front of an art dealer's window and look in. The spectator is hidden voyeur-like inside the shop. The woman looks at a picture and seems about to comment on it to her husband. Unbeknownst to her, he is fact looking elsewhere, at the proffered buttocks of a half-naked female figure in a painting placed obliquely to the surface/photo/window so the spectator can also see what he sees. Doane argues that it is his gaze which defines the problematic of the photograph and it erases that of the woman. She looks at nothing that has any meaning for the spectator. Spatially central she is negated in the triangulation of looks between the man, the picture of the fetishized woman and the spectator, who is thus enthralled to a masculine viewing position. To get the joke, we must be complicit with his secret discovery of something better to look at. The joke, like all dirty jokes, is at the woman's expense. She is contrasted iconographically to the naked woman. She is denied the picturing of her desire; what she looks at is blank for the spectator. She is denied being the object of desire because she is represented as a woman who actively looks rather than returning and confirming the gaze of the masculine spectator. Doane concludes that the photograph almost uncannily delineates the sexual politics of looking.

I have introduced this example to make somewhat plainer what is at stake in considering the female spectator – the very possibility that texts made by women can produce different positions within this sexual politics of looking. Without that possibility, women are both denied a representation of their desire and pleasure and are constantly erased so that to look at and enjoy the sites of patriarchal culture we women must become nominal transvestites. We must assume a masculine position or masochistically enjoy the sight of woman's humiliation. At the beginning of this essay I raised the question of Berthe Morisot's relation to such modern sights and canonical paintings of the modern as *Olympia* and *A bar at the Folies-Bergére*, both of which figure within the sexual politics of

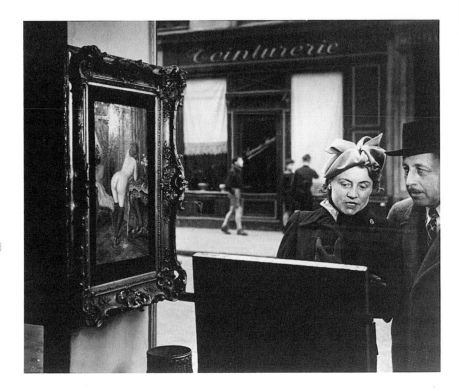

3.25 Robert Doisneau *An oblique look* (1948).

looking – a politics at the heart of modernist art and modernist art history's version of it. Since the early 1970s, modernism has been critically challenged nowhere more purposely than by feminist cultural practitioners.

In a recent article titled 'Desiring images/imaging desire', Mary Kelly addresses the feminist dilemma wherein the woman who is an artist sees her experience in terms of the feminine position, that is as object of the look, while she must also account for the feeling she experiences as an artist occupying the masculine position as subject of the look. Different strategies have emerged to negotiate this fundamental contradiction, focusing on ways of either re-picturing or refusing the literal figuration of the woman's body. All these attempts centre on the problem: 'How is a radical, critical and pleasurable positioning of the woman as spectator to be done?' Kelly concludes her particular pathway through this dilemma (which is too specific to enter into at this moment) with a significant comment:

Until now the woman as spectator has been pinned to the surface of the picture, trapped in a path of light that leads her back to the features of a veiled face. It seems important to acknowledge that the masquerade has always been internalized, linked to a particular organization of the drives, represented through a diversity of aims and objects; but without being lured into looking for a psychic truth beneath the veil. To see this picture critically, the viewer should neither be too close nor too far away.[42]

Kelly's comment echoes the terms of proximity and distance which have been central to this essay.* The sexual politics of looking function around a regime which divides into binary positions, activity/passivity, looking/being seen, voyeur/exhibitionist, subject/object. In approaching works by Cassatt and Morisot we can ask: Are they complicit with the dominant regime?[43] Do they naturalize femininity in its major premisses? Is femininity confirmed as passivity and masochistic or is there a critical look resulting from a different position from which femininity is appraised, experienced and represented? In these paintings by means of distinctly different treatments of those protocols of painting defined as initiating modernist art – articulation of space, re-positioning the viewer, selection of location, facture and brushwork – the private sphere is invested with meanings other than those ideologically produced to secure it as the site of femininity. One of the major means by which femininity is thus reworked is by the rearticula-tion of traditional space so that it ceases to function primarily as the space of sight for a mastering gaze, but becomes the locus of relationships. The gaze that is fixed on the represented figure is that of equal and like and this is inscribed into the painting by that particular proximity which I suggested characterized the work. There is little extraneous space to distract the viewer from the inter-subjective encounter or to reduce the figures to objectified staffage, or to make them the objects of a voyeuristic gaze. The eye is not given its solitary freedom. The women depicted func-tion as subjects of their own looking or their activity, within highly specified locations of which the viewer becomes a part.

The rare photograph of Berthe Morisot at work in her studio serves to represent the exchange of looks between women which structure these

* In earlier drafts of this chapter I explore the possibilities of co-ordinating the historical perspectives on the spaces of modernity and femininity with those of feminist psychoanalytical writing on femininity (Cixous, Irigaray and Montrelay) between which there was tantalizing coincidence on the issues of the look, the body and the tropes of distance and proximity in the construction and feminine negotiation of sexual difference under a patriarchal system. The use of a statement by Luce Irigaray as introit, and the citation from Mary Kelly, marks the possibility of that reading which could not be undertaken here without massively enlarging this chapter.

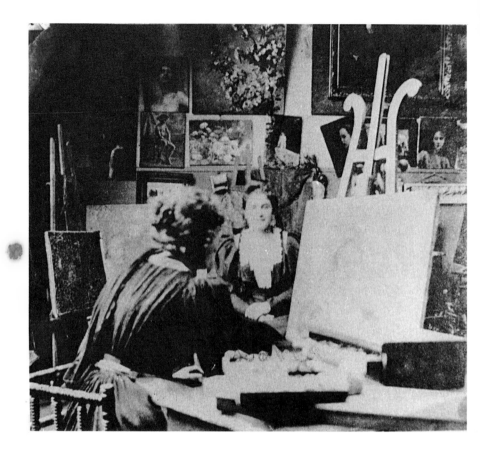

3.26 Berthe Morisot in her studio

works (Figure 3.26). The majority of women painted by Cassatt or
Morisot were intimates of the family circle. But that included women
from the bourgeoisie and from the proletariat who worked for the
household as servants and nannies. It is significant to note that the
realities of class cannot be wished away by some mythic ideal of
sisterhood amongst women. The ways in which working-class women
were painted by Cassatt, for example, involve the use class power in
that she could ask them to model half-dressed for the scenes of women
washing. None the less they were not subject to the voyeuristic gaze of
those women washing themselves made by Degas which, as Lipton has
argued, can be located in the maisons-closes or official brothels of
Paris.[44] The maid's simple washing stand allows a space in which
women outside the bourgeoisie can be represented both intimately and
as working women without forcing them into the sexualized category of

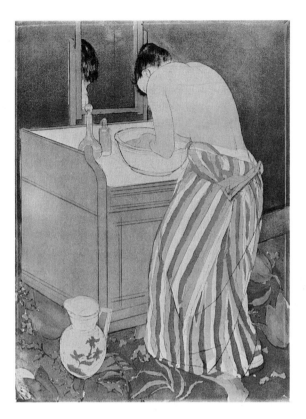

3.27 Mary Cassatt *Woman bathing* (1891)

the fallen woman. The body of woman can be pictured as classed but not subject to sexual commodification (Figure 3.27).

I hope it will by now be clear that the significance of this argument extends beyond issues about impressionist painting and parity for artists who are women. Modernity is still with us, ever more acutely as our cities become in the exacerbated world of postmodernity, more and more a place of strangers and spectacle, while women are ever more vulnerable to violent assault while out in public and are denied the right to move around our cities safely. The spaces of femininity still regulate women's lives – from running the gauntlet of intrusive looks by men on the streets to surviving deadly sexual assaults. In rape trials, women on the street are assumed to be 'asking for it'. The configuration which shaped the work of Cassatt and Morisot still defines our world. It is relevant then to develop feminist analyses of the founding moments of

modernity and modernism, to discern its sexualized structures, to discover past resistances and differences, to examine how women producers developed alternative models for negotiating modernity and the spaces of femininity.

4

Woman as sign in Pre-Raphaelite literature: the representation of Elizabeth Siddall

This essay by Deborah Cherry and Griselda Pollock was first published in *Art History*, 1984. It has been revised by Griselda Pollock.

The feminist critique of art history began by berating the discipline for its discriminatory exclusion of women artists. This was a necessary but limited tactic. For art history as discourse actively produces its meanings by exclusion, repression and subordination of its Other. The feminine is located by the textual strategies and ideological formations of art history as the passive, beautiful or erotic object of a creativity exclusively tied to the masculine. Therefore feminist deconstruction of art historical texts and their highly political effects is a fundamental necessity as a preliminary for developing appropriate strategies for analysing women as cultural producers.

In 1975 I was invited to give a short paper at the second conference of the newly founded Association of Art Historians. I was offered the token space of speaking about 'Women in Victorian art'. Instead of attempting to catalogue the many women active as artists in the period or itemize their specialities, I chose to consider the complex issues raised by the case of Elizabeth Eleanor Siddall (1829–62). Well known in art history books as the beloved model and later wife of the leading Pre-Raphaelite artist Dante Gabriel Rossetti (1828–82), Siddall attracted feminist attention because she too produced paintings and drawings as well as poetry. Her case epitomized the contradictions of woman as muse for, and object of, art celebrated by art historians and woman as ignored producer. This drama had been played out at a moment of considerable historical significance in the history of women. The art

91

works for which it is said that Elizabeth Siddall modelled negotiate and articulate emerging bourgeois definitions of masculine sexuality through representations of 'femininity'. Poems and pictures made by this woman moreover intervened in this field of meanings from a distinct class as well as a gender position. In the paper I struggled to discover a means to grasp the specificity of this woman's life and work while dealing with the structural relations, social, sexual and ideological within which that particular life and activity alone would make sense.

Shortly thereafter I made contact with Deborah Cherry and finding a common interest in Elizabeth Siddall and the issues raised in this study we agreed to collaborate. Over several years we undertook exhaustive research compiling as full a documentation as was possible. It soon became clear, however, that the major primary sources used in Pre-Raphaelite scholarship – memoirs, diaries, letters by members of the Pre-Raphaelite circle, especially those edited by Siddall's brother-in-law, William Michael Rossetti – were deeply implicated in nineteenth-century ideologies of class and gender, of the artist and romance.

At that stage we did not yet have a historical framework within which to handle the material we had amassed, especially its fissures, inconsistencies, differences. Instead of being able to use it to piece together a jigsaw from which a complete picture of Elizabeth Siddall would emerge we found ourselves forced into confrontation with the textual activities of the so-called documents. In the interim the work of Michel Foucault became more widely known to us and more accepted within the cultural community in which we worked. Foucault's analyses of historical writing, of discursive formations and their practical institutionalization, provided a necessary instrument for feminist probing of the archive, of evidence, of the selective resources of historical research which secure masculine hegemony in the recirculation by one generation of a previous generation's ideological structurings of knowledge. The other major theoretical resource we used is a text written for the first edition of *M/F* in 1978, 'Woman as sign' by Elizabeth Cowie. This text helped us to understand the recurring and insistent patterns of the representations to which Elizabeth Siddall had been subjected in Pre-Raphaelite literature both in the 1880s and the contemporary period.

This extract from a popular monograph, *Dante Gabriel Rossetti* (1975), typical of the Pre-Raphaelite literature of the 1970s, rehearses the common knowledge about Elizabeth Eleanor Siddall (1829–62).[1]

Elizabeth Siddal was a girl of quite remarkable beauty with whom Rossetti fell totally in love. Already obsessed by the life and writings of Dante his namesake, it would have been surprising if he had not responded positively to a girl who seemed ideally suited

to become his own Beatrice. Discovered one day in 1850 by Rossetti's friend Walter Deverell in a milliner's shop off Leicester Square she was soon sitting for all the Brotherhood and their friends as well. But after 1851 she only sat to Rossetti with whom she developed an increasingly close relationship, and from whose paintings of the next ten years her features are seldom absent. We know what she looked like, both from her presence as a model in a dozen or more paintings, and also from the large number of surviving portraits which Rossetti made of her over the years until her death in 1862. Extraordinarily moving and poignant as these drawings are, and I would argue that taken together they comprise Rossetti's most individual and personal artistic achievement, without precedent or parallel, they still leave Lizzie's character an enigma, and the exact nature of their relationship a puzzle. That Rossetti's drawings do not exaggerate or distort her beauty is clear when we consider contemporary paintings or description of her by others: 'Tall, finely formed, with a lofty neck, and regular yet somewhat uncommon features, greenish blue unsparkling eyes, large perfect eyelids, brilliant complexion, and a lavish wealth of coppery golden hair.' But she was consumptive and her health was to become a constant cause of concern. The frail and melancholy personality that so many of Rossetti's obsessive drawings evoke. . . . One cannot help relating the interminably unhappy love affair and the pathos of the beautiful yet melancholic and fatally ill Lizzie to the dominant features of the paintings that Rossetti was to produce through the 1850s.

It is necessary first of all to note the deliberate misspelling of the name. Siddall, a historical individual, is persistently represented in Pre-Raphaelite literature as 'Siddal' – a difference whose significance we shall carefully elaborate. The passage quoted above reproduces the fixed parameters within which this 'Siddal' functions as a sign of the genius of Dante Gabriel Rossetti. 'Siddal'/Lizzie is constructed as fatally ill, consumptive, as an enigma and yet with a specifiable melancholy personality, as a beautiful model, and as the beloved of Rossetti. There is no history outside the Pre-Raphaelite circle and beyond a relation with Rossetti. We are told that Siddall was 'discovered' one day in 1850; the term 'discovered' is redolent of those imperialist enterprises in which the existence of a people or a country is acknowledged only when seen in a colonial relation to the master race, class, gender. Such relativity is further secured by the assertion that Siddall is knowable because of her presence in Rossetti's drawings. The text states confidently that 'we know what she looked like'. Drawings, said to be of Siddall, are

represented as truthful mirrors of her beautiful appearance. Complex representational practices are thus misrecognized as reflections of reality, as is the ideological work of these drawings in the historically specific construction of femininity. This passage, like the monograph itself, has, however, ideological effects. One of the most significant of these is the definition of individual artistic creativity as masculine. The drawings and paintings supposedly from the model Elizabeth Siddall are said to comprise the artist's 'most individual and personal artistic achievement'. His individuality and his stature as an artist are erected on the negation of the female model whose appearance is appropriated as a signifier of his artistry and his personality.

Monographs such as *Dante Gabriel Rossetti* (1975) have much in common with illustrated biography. Both fabricate and celebrate individuality in the focus on a single main character. Both share the narrative drive to chart a linear progress from birth to death which produces a coherent subject, an author for an oeuvre. The predominantly biographical impulse of art history has structured the ways in which Pre-Raphaelitism is constituted and studied;[2] it has overdetermined the image of Elizabeth Siddall in specific ways. 'Siddal' is constructed as a creature relative to Rossetti: she is said to appear transparently on the surface of his drawings. In effect 'Siddal' becomes a cipher for masculine creativity inspired by and fulfilled in love for a beautiful feminine face.

There is nothing exceptional about the version of the story given in *Dante Gabriel Rossetti* (1975) and its emphases. It is familiar to the point of tedium in its elaboration of the topos of the romantic artist, inspired to produce great art through the thwarted love for a beautiful, unattainable woman. In Pre-Raphaelite literature Rossetti is fitted to the paradigm of the romantic artist by virtue of his use of the Dante and Beatrice motif. Rossetti's conceit of an artist inspired by a beautiful woman in his many deployments of the Dante material or in the essay 'Hand and soul' published in *The Germ* in 1850 has been taken literally by art historians: art and life are collapsed together in the fabrication of a twentieth-century love-story. The conflation of art and life is imputed to Rossetti. The elisions are, however, produced in art historical texts which claim to describe and record what Rossetti felt and did.

We have been warned in other texts on Pre-Raphaelitism of the temptation to read off Rossetti's life from his art, or vice versa, the tendency to fantasy biography:

> Rossetti, for a hundred years, has been victimised by critics who have relied mainly on biographical data to explicate the poetry and by biographers who have poached on the poetry for 'evidence' to document their biographical assumptions.[3]

This writer's insistence on critical distance did not preserve Siddall from being entangled in the web of Rossetti's art, for the same text continues:

> It is tempting to say that Elizabeth Siddal was, after all, the only Pre-Raphaelite. In a grim way, she stood for what it all meant; and she combined in her fragile beauty and in her tragic life the legendary aspect that inspired the movement's art and poetry.[4]

The role of 'Siddal' is here massively enlarged: she is presented as a symbol of the whole movement. As in most accounts Siddall's name is rendered Siddal. An historical personage is thus transformed into a construct of Pre-Raphaelite literature. Elizabeth Siddall's entry into the Pre-Raphaelite circle was secured by the loss of her family name: she became Lizzie, Liz, Guggums, Guggum, Gug, The Sid, Miss Sid, Miss Siddal, Ida. Although it was a characteristic habit among members of this cultural fraction to use pet names for each other, the variety of those used for Elizabeth Siddall indicate the refashioning which this working-class woman underwent, and their recirculation in modern texts works to secure the signification of 'Siddal'.

For historians the absence of a fixed name presents problems, especially when attempting to corroborate Siddall's historical position by reference to documentation outside the confines of Pre-Raphaelitism and art history. Can we trace this person in the censuses and directories without a consensus on the spelling of the name? Can we trace and identify the members of her family? Can we be sure that all the references within the Pre-Raphaelite literature refer to our topic?

'Siddal' functions as a sign. More than the name of an historical personage it does not simply refer to a woman, or even Woman. Its signified is masculine creativity. Our argument here is loosely derived from the work of Elizabeth Cowie's article 'Woman as sign'.[5] Cowie argues for a decisive shift in the analysis of the origins and effects of the representations of women in cultural systems away from the notion that images of women reflect pre-existent, real or socially produced categories. Cowie stresses the necessity to recognize that a system of representation is a point of production for definitions which is neither unique and independent of, nor simply reducible to, other practices defining the position of women in society. Attention is to be focused on the signifying practices in which woman is produced as a sign whose signified is not, however, 'woman'. In her analysis of Lévi-Strauss's work on kinship structures, exogamy and the exchange of women, Cowie indicates that within a particular signifying system, kinship, woman is produced as a sign, which can be differentiated from the positioning of women as the objects of exchange. She argues:

It is therefore possible to see 'woman' not as a given, biologically or psychologically, but as a category produced in signifying practices. . . . To talk of 'woman as sign' in exchange systems is no longer to talk of woman as the signified, but of a different signified, that of: establishment/re-establishment of kinship structures or culture. The form of the sign – the signifier in linguistic terms – may empirically be woman, but the signified is not 'woman'.[6]

We are mobilizing this formulation of the notion of 'woman as sign' to different effects. To identify 'Siddal' as a sign in art historical discourse drives a theoretical wedge between the historical individual of the name Elizabeth Eleanor Siddall and a set of signifieds articulated by the signifier 'Siddal' in art history. Thus art history is treated as a system of representations, a signifying system, a point of production of definitions and meanings which can be seen both in their particularity and in their relations to other mutually reinforcing discursive and institutional practices across whose varying processes woman/femininity and man/masculinity are produced, renegotiated and fixed in relative hierarchies. The meaning of 'Siddal' as sign, therefore, is not of Siddall, and does not refer us to such a person. Rather it renders the altered name 'Siddal' a signifier in and for a discourse about the establishment of masculine dominance/feminine subordination.

This signification is secured by constructing a series of related values for the term 'Siddal' which congeal around visual appearance and physical condition. Passivity is the dominant trope; beauty renders those so designated an object of another's desiring gaze; illness – suggested in terms such as 'fragile', 'tragic life' – implies dependency, incapacity, inactivity, suffering. These texts construct a recognizable historical and ideological position, femininity, which operated in its generative nineteenth-century discourses as the negative, the foil to the masculine usurpation of activity, productivity, creativity, health.[7]

In patriarchal ideologies of art the role ascribed to the feminine position is either as art's object, the model, or as its muse by virtue of a romantic affiliation with an artist. In Pre-Raphaelite literature 'Siddal' functions as both. Recognition of woman's active part in culture as producer is thus eroded. The notion that art is made from that 'natural' condition of men looking at lovely women effaces from art history consideration of how art is socially produced. Instead it offers merely the hagiography of individual male artists, the celebration of masculine creativity and its collateral, the aesthetic autonomy of art. 'Siddal' therefore articulates the informing ideologies of art history about the personal process of artistic creation and its natural disposition between the sexes.

There are several ways to counter these problems. The first impulse is to challenge the dominant knowledge system by providing more information about the artistic activities of Elizabeth Siddall, attempting thereby to position her as a creative individual by reassembling an oeuvre, and producing an authorial identity for it. There is evidence that Siddall was caught up in the cult of art as expressive genius unfettered by formal training which was proclaimed by Rossetti and Ruskin. From 1852 to 1861 she worked as an artist and poet, producing over 100 works including oil-paintings such as her *Self portrait*, 1853–4 (private collection), water-colours such as *Lady Clare* (private collection), *Clerk Saunders*, 1857 (Cambridge, Fitzwilliam Museum), *Sir Patrick Spens*, 1856 and *Lady affixing a pennant to a knight's spear* (London, Tate Gallery), *Madonna and child with an angel* (Wilmington, Delaware Art Museum), *The haunted wood*, 1856 and *St Agnes Eve* (Wolverhampton, Wightwick Manor), and *The quest of the holy grail* (London, Tate Gallery) (made with D. G. Rossetti), finished drawings such as *The Lady of Shalott* (J. S. Maas Collection) and *Pippa passes*, 1854 (Oxford, Ashmolean Museum) and sketches.[8] A collection of her poems, with reproductions of many of these works, has recently been published.[9]

In the cases in which recognition is awarded to Siddall's art, however, it is usually defined exclusively in relation to Rossetti's.

Under Rossetti's influence she made drawings and wrote verses, but she seems to have had no original creative power: she was as the moon to his sun, merely reflecting his light.[10]

The attempt, therefore, simply to annex a woman artist to the existing canon of art history does not, indeed cannot, shift its masculinist paradigm. The woman artist is framed in a relative, secondary position by the patriarchal discourses of art history and their celebration of heroic individual creativity, art history's brand of bourgeois individualism.[11] The artist is constructed by art historical practices as a being transcendent of history, a free creative agent, independent of social relations. The history of art consists of a glittering sequence of Great Individual Men, a category which structures the relativity of women artists. Attempting to restore Elizabeth Siddall in this empirical and monographic manner cannot effect the necessary alteration of the gendered discourses of art history.

There is another approach to the problem, but this also encounters serious difficulties. This second strategy involves a more sophisticated scrutiny and cross-referencing of all the available documentary material which might reconstitute a history of Elizabeth Siddall both inside and beyond the Pre-Raphaelite circle. It is possible to collate material from the Pre-Raphaelite literature of diaries, letters, journals and memoirs

with records such as censuses, post office directories, parish records, the registers of births, marriages and deaths, articles in parliamentary papers, contemporary newspapers and journals, etc.[12] This project is based on the assumption that the accumulation of a more extensive range of documentation will itself be sufficient to dispel the enigma of 'Siddal' and reveal, hidden from history, a more complete identity for this working-class woman who became a painter and poet. Research of this kind does undermine many of the common assumptions offered as fact about Elizabeth Siddall in art history books. But such a project does not necessarily produce an alternative version of 'Siddal' by virtue of amassing different facts; indeed it may well reproduce the character of the melancholy, fatally ill, wife of Rossetti.[13] To make sense of this more extended range of historical materials needs that they be placed in a theoretically informed framework of the social, economic and ideological practices of mid-nineteenth-century London.

From census returns, post office directories, parish records, birth, marriage and death certificates a family Siddall can be traced comprising Charles Siddall, cutler (born Sheffield 1800, died London 1859), Elizabeth Eleanor Evans Siddall, and their children Charles, Ann, Elizabeth Eleanor, Mary, Lydia, Clara, James and Henry.[14] This family becomes historically meaningful only when situated at the intersections of a network of practices. Historical investigation shifts away from individuals forming the family unit, momentarily abstracted and defined by the taxonomies of public population records, and towards the complex and shifting histories of Sheffield and London, the trades of cutlery, ironmongery and millinery, and the social topography of South London between 1820 and 1860.[15] The addresses of workplace and residence (sometimes coinciding) of Charles Siddall over several decades indicate the fluctuating fortunes of the cutlery trades and these occurred within broader patterns of social and economic movement in this period. These records offer no more than the trace of a history whose meanings reside in the social collectivities of class and gender, not isolatable individuals. It is important to note a crucial distinction between the isolatable individual as the ideological figure of bourgeois individualism, produced in and by empiricist accounts of history, and the historical individual whose particularity of life and experience feminist and socialist historians reclaim precisely by insisting upon the formation of the individual subject in the historically specific material practices of the social relations of class and of gender difference.[16]

Furthermore, the archive, that is the resources for historical research, is itself historically formed. The archive is part of a system of representation by means of which the past seems to be left deposit in the present; it is a fissured, uneven, contradictory monument of the past.[17]

The materials for producing a history of Elizabeth Siddall are intricated in class and gender power relations which have determined who is recorded, how, and by whom – and who is not. Moreover the proliferating literatures of social documentation which emerged in the early and mid-nineteenth century – the census returns, statistical information, directories, the reports of parliamentary commissions, and the social inquirers – involved a variety of discursive strategies and ideological effects. They were part of the complex practices of surveillance, classification and regulation of the population which occurred in the process of the consolidation of the capitalist state. These texts formed specific knowledges of the social body and its constituent individuals.[18] They should not therefore be used by the historian as a transparent window to the past, as primary or privileged access to the individual, for the individual as a category is formed in and by these texts, as it is also differently formed in and by the texts of the memoirs, biographies and monographs produced from the 1880s onwards. All these texts offer differing registers of historical statement, and the products of the 1850s are to be marked off from those of the 1880s–1900s which have their own historical formation and specificities.

In this essay, however, the purpose is not to undertake that task of providing a historical framework within which to situate the historical individual Elizabeth Siddall. The chapter undertakes the preliminary task of analysing the textual terrain on which 'Siddal' was constructed from the 1880s to the present. The project is to investigate how a certain order of knowledge about Elizabeth Siddall was, and is, produced and incessantly recirculated in art history, to examine why it partakes of certain constituents and how a regime of truth about 'Siddal' was installed and secured. Knowledge is related to and enmeshed in the workings of power. The production of truth is linked to the systems of power operative in society which produce and maintain regimes of truth. 'Truths' circulated about female artists and femininity are produced for and maintain simultaneously produced 'truths' about male artists and masculinity. It is to the network of power and knowledge that this analysis attends.

The major resources upon which modern historians of Pre-Raphaelitism and Rossetti in particular rely are the historically mediated writings of the artist's brother William Michael Rossetti.[19] The constant acknowledgement of these texts revives their authority and confers upon them a pre-eminent status as historical record. The 'authority' of W. M. Rossetti is based upon several interlocking claims. As author he claims the power to speak truth, because he was there; he positions himself as a participant and an eye-witness who provides direct, personal knowledge of people and events. For example, in introducing

99

an 'express biographic record' of Elizabeth Siddall in the *Burlington Magazine* of 1903 it is stated, 'I need hardly say that I myself knew her and remember her very well.'[20] In addition the author makes his statements from within the privileged site of the family: he writes of 'my brother' and assures readers that he has intimate and comprehensive knowledge of that brother's private, affective and creative life. As author W. M. Rossetti constructed himself as a careful, pedantic recorder who will 'endeavour to compile with care and fullness and to present the results with precision and perspicuity'.[21] He possessed letters, diaries and manuscript notes which are offered as if they provide direct access to and are the authentic voices of the protagonists of his narratives: 'The letters, such as they are, shall be left to speak for themselves.'[22] The documents have, however, been wrenched from the field of their production and exchange. They are reframed within an attenuated chronological sequence, the effect of which is to produce ideologically that which the reader consumes as a coherent centre of the texts, the individual subject. The artist 'Rossetti' is not the pre-text but the result of the workings of the text.

The W. M. Rossetti texts belonged to and indeed serve as major examples of a type of literature which emerged in the later nineteenth century, the artist's biography.[23] *The Life and Letters* . . . format, when applied to the artist, secures an image of the artist as a creative individual who is both amenable to understanding and yet fascinatingly different. The narration of the life is interspersed with those details of the 'difference' of artistic life – sudden deaths, obsessive pursuits, erratic business activities and social hours, unusual dwellings, special languages, coteries and friendships, drugs – which consolidate and distinguish the artistic temperament and life-style. W. M. Rossetti's texts strive to fashion an image of D. G. Rossetti as a grand old master of art complete with romantic temperament and entertaining life-style.

W. M. Rossetti's texts cannot be treated as evidence. As historically specific forms of literature they were, moreover, written several decades after the events which they claim to describe in such vivid detail. They have to be examined carefully, subjected to a symptomatic reading as the material and product of history. No one writes without inscribing a point of view on that which is written: language is an ideological practice of representation. These general comments can be specified by analysing one particular chapter, chapter seventeen of *Dante Gabriel Rossetti: His Family Letters with a Memoir* (1895), which is entitled 'Miss Siddal'. The chapter heading is footnoted. Although the family spelt the name Siddall 'my brother always spelled the name thus'. 'Siddal' is thus claimed for Rossetti – there is possession in naming – and indeed the chapter opens with his name.[24]

Dante Rossetti – though there was nothing of the Puritan in his feelings, nor in his demeanour or conversation – had no juvenile amours, *liaisons*, or flirtations. In 1850 he fell seriously in love. (I, 181)

Elizabeth Siddall is not mentioned, nor is she named for several paragraphs. But a space is prepared for the introduction of Rossetti's true love. Any other women in his life are disposed of without precluding Rossetti's capacity for a healthy masculine passion. The reference to the Puritan stalls connotations of excessive sensuality which might attach to the bohemian artist and which had been generated in connection to Rossetti in 1871/2 in the public debate after the publication of his *Poems*.[25] In her absence 'Siddal' is placed in a reciprocal relation to Rossetti: he the active lover, she the as yet *undiscovered* object. The construction of masculinity is made in opposition and in precedence to absent femininity.

The next paragraph is long and complex; its theme is a story which begins as do most fairy-tales:

One day – early in 1850, if not in 1849 – Deverell accompanied his mother to a bonnet-shop in Cranbourne Alley (now gone – close to Leicester Square); and among the shop-assistants he saw a young woman who lifted down a bandbox or what not. . . . Deverell got his mother to enquire whether he might be privileged to have sittings from this beauty and the petition was granted. (I, 171)

A vivid scene is created for us, the veracity of which is heightened by the topographical aside. In the article in the *Burlington Magazine* of 1903 there are significant differences:

One day, which may have been in the latter part of 1849, he accompanied his mother to a bonnet-shop in Cranbourne Alley. Looking from the shop through an open door into a back room, he saw a very young woman working with the needle. (274)

In *Dante Gabriel Rossetti: His Family Letters with a Memoir* (1895) the episode of the discovery is amplified with a lengthy passage of apparent description which, despite the authoritative use of the historical mode of writing, inscribes a specific viewpoint:

She was a most beautiful creature, with an air between dignity and sweetness, mixed with something which exceeded modest self-respect, and partook of disdainful reserve: tall, finely formed, with

a lofty neck, and regular yet somewhat uncommon features, greenish-blue unsparkling eyes, large perfect eyelids, brilliant complexion, and a lavish wealth of coppery-golden hair. (I, 171)

It will be remembered that the assertion in *Dante Gabriel Rossetti* (1975) that 'we know what she looked like' was supported by quotation of part of the above passage. But conflicting accounts of Siddall's appearance have survived in Pre-Raphaelite memoirs. If W. M. Rossetti wrote of her eyes as 'greenish-blue', Swinburne deemed them a 'luminous grey green', and Georgiana Burne-Jones recalled eyes of 'golden brown, agate colour, and wonderfully luminous'.[26] In the passage cited above from *Dante Gabriel Rossetti: His Family Letters with a Memoir* the shop assistant is represented chiefly by reference to physical features. Discomfort breaks through the surface of the narrative, however, when the passively beautiful object threatens to emerge as a characterful subject. Smoothly endorsing the woman as good to look at, the prose baulks at the unspeakable excess of feminine pride. The W. M. Rossetti texts constantly register 'Siddal' as a problem woman because, as was stated in *Some Reminiscences* (1906), 'her inner personality did not float upon the surface of her speech or bearing, to me it remained, if not strictly enigmatic, still mainly undivulged.'[27] 'Siddal' as aloof, withdrawn, mysterious stands in relation to the author as the truthful eye-witness. This insistence on the enigmatic quality of 'Siddal' has functioned powerfully. The equally decisive account of a witty, intelligent, charming and courageous woman given by A. C. Swinburne has been overlooked. Indeed it was politely and firmly discounted in *Dante Gabriel Rossetti: His Family Letters with a Memoir* by the introduction of a quotation from Swinburne's letter to the *Academy* of 24 December 1892 with the remark: 'When one wants chivalrous generosity, one goes to Algernon Swinburne for it' (I, 174). W. M. Rossetti's now hegemonic picture of 'Miss Siddal' was determined within nineteenth-century bourgeois ideologies of femininity, a positive ideal of which can be discerned within his representation of his mother, Frances Polidori Rossetti, in the opening chapter of *Dante Gabriel Rossetti: His Family Letters with a Memoir*:

Mrs. Rossetti was well bred and well educated, a constant reader, full of clear perception and sound sense on a variety of subjects, and perfectly qualified to hold her own in society; a combination of abnormal modesty of self-estimate (free, however, from the silliness or insincerity of self-disparagement), and of retirement and repose of character, and of devotion to home duties, kept her back. The idea of 'making an impression' never appeared to present itself to her mind. . . . Perfect simplicity of thought, speech

and manner characterised her always; – I venture to think it was dignity under another name. (I, 21)

In patriarchal discourses on woman feminine beauty is transitory; in the case of Elizabeth Siddall it appears to have been fatal. In *Dante Gabriel Rossetti: His Family Letters with a Memoir* her end is soon prefigured:

All this fine development, and this brilliancy of hue, were only too consistent with a consumptive taint in the constitution.[28]

Beauty and death coalesce. Pulmonary consumption, a disease contracted and suffered fatally under specifiable social and economic conditions, is represented as a weakness of the feminine body, a representation determined by the ideological suture between female mortality from tuberculosis and femininity as an inferior, tainted, body type.[29] (It should be stressed, of course, that there is no evidence of Siddall having suffered from this or any other disease.)

Thus far chapter seventeen of *Dante Gabriel Rossetti: His Family Letters with a Memoir* has been preamble, for 'she' has yet to be introduced. And by the time the name is provided complex significations have been established:

This milliner's girl was Elizabeth Eleanor Siddal. When Deverell first saw her, she was, I believe, not fully seventeen years of age. (I, 172)

A footnote explains that at her death D. G. Rossetti thought Siddall was 29 years old and that her sister told them that she was then 28. Modern publications have erroneously tended to follow W. M. Rossetti's assertion in the *Burlington Magazine* of 1903 that Siddall was six years younger than D. G. Rossetti.[30] It is possible that no one, including Siddall herself, knew her age. But recent consultation of public records has revealed that Siddall was born in July 1829, one year after Rossetti, and that she was 32 years old when she died in 1862.[31] The discovery of the baptism certificate is but one example of how historical investigation outside Pre-Raphaelite literature has challenged the regime of truth fabricated about Siddall, and specifically of her youth. Her youthfulness was, however, an important constituent in the construction of the tragic life of a frail invalid who died young, while it compounds with notions of femininity as virginal and vulnerable. Gender differentiation is marked in the texts in the positioning of Rossetti and 'Siddal' in terms of the contrasts of age/youth, tutor/pupil, artist/model, health/sickness.

In the Pre-Raphaelite literature there is considerable confusion and contradiction about Siddall's class and social origins. Ruskin and F. G.

Stephens both considered her father to be a watchmaker; W. M. Rossetti identified him as a cutler.[32] In the post office directories for the 1830s, 1840s and 1850s Charles Siddall is listed as a cutler, as he is in the census returns for 1841 and 1851, though he also appears as ironmonger on occasions, as on his daughter's baptismal record. However, on Elizabeth's marriage certificate of 1860 his occupation is given as optician.[33] In the Pre-Raphaelite memoirs Elizabeth Siddall herself is variously said to be a 'milliner's girl', a 'shop-assistant' or apprentice in a bonnet shop, a needlewoman in a back room.[34] No contemporary evidence survives of Elizabeth Siddall's employment in the millinery business. According to public records two of her sisters worked in the clothing trades: Clara Siddall is listed as a mantlemaker in the 1861 census and as a dressmaker in the 1871 census, and Mary as a dressmaker in the 1861 census. Recognition of this material can lead us to site Siddall in family patterns of employment in the skilled working class and, together with an investigation of the clothing trades, within a network of employment undertaken almost exclusively by women. It is therefore not sufficient to indicate that contemporaries were mistaken about her origins, or that later biographers misremembered her occupation. We must recognize the historically situated anxieties negotiated by the representations in and by which 'Siddal's' social persona was fabricated in the later nineteenth century.

In *Dante Gabriel Rossetti: His Family Letters with a Memoir* Siddall's class position has to be negotiated in relation to that of Rossetti whose beloved she is to become. Having mentioned several details which pass for family background, the author imagines a toddling Elizabeth 'Siddal' assisted across a muddy road by a local trader known, indeed notorious, to the reading public for a murder he later committed. Laconically the author comments: 'Such is the difference in "the environment"' (I, 173). Difference from whom? The unspoken divide is between those who mingle with criminal traders in Newington Butts and the imagined reader positioned in and by the text. For the middle-class readership of these artistic biographies, 'Siddal' has to become compatible with the role for which she is destined in the story: 'Miss Siddal – let me say here once for all – was a graceful lady-like person, knowing how to behave in company' (I, 173). Significant ambiguities remain in this text, which more recent writings do not pause to resolve, ignoring the complexity of nineteenth-century class relations.[35] The invisibility of class is assisted once again by the romantic topos which is the central concern. For example, in *Dante Gabriel Rossetti* (1975) Siddall has no history other than her relation to Rossetti, no characteristics other than beauty, melancholy, illness. By contrast nineteenth-century writings were greatly concerned with her class, with degrees of refinement and

gentility, signified by a beautiful appearance.

Siddall was one of several working-class women drawn into a select circle of artists whose bohemianism none the less bore the stamp of the bourgeoisie from which most of them came and which they served. Over and over again we find male artists of this circle searching out working-class women as models, lovers and wives, desiring them for their difference, persistently re-forming them and always experiencing some anguished conflict over the role and place of these women in the Society into which the artists had dragged them. Women like Siddall, Emma Hill (Madox Brown), Annie Miller, Jane Burden (Morris) who were elevated from models to proposed wives were subjected to a programme of drastic re-education. This process required in particular an induction into that social role and psychic condition called femininity – silence, pleasant appearance, deferential manners, self-sacrifice. In W. M. Rossetti's texts 'Siddal' is pure, refined, feminine: 'one could not have *seen* a woman in whose demeanour maidenly and feminine purity was more markedly apparent'.[36] Siddall is represented as remodelled in terms of bourgeois femininity, a transformation which qualifies her for her role as Rossetti's principal model.

In romantic novels the first meeting of the lovers is an important event. That of Rossetti and 'Siddal' is, however, also problematic. In *Dante Gabriel Rossetti: His Family Letters with a Memoir* it is stated:

> Not long after Miss Siddal had begun to sit for Deverell, Dante Rossetti saw her, admired her enormously, and was soon in love with her, *how* soon I cannot exactly say. . . . I do not know at what date a definite engagement existed between Miss Siddal and my brother – very probably before or not long after the close of 1851. (I, 173)

Claims are made here for an immediate affective relationship, but the chronology is systematically imprecise, and there is no consistency in the multitude of texts which tell the tale.[37] Despite the excessive attention awarded to it, the first encounter and its date are not historically significant issues. They become meaningful only in the fabrication of a romantic biography in which man meets woman, and where love at first sight is followed by courtship, betrothal and marriage. The function of the presentation of the 'event' in *Dante Gabriel Rossetti: His Family Letters with a Memoir* is to negotiate and discount other possibilities in the professional and social relations between a bourgeois male artist and a female working-class model, and to equate the meeting with the inception of respectable courtship.

Siddall supposedly encountered the Pre-Raphaelite artists when several of them were preparing pictures for which they fancied a red-

haired model. According to *Dante Gabriel Rossetti: His Family Letters with a Memoir* Siddall was initially employed by Deverell and Hunt but not by Rossetti, then at work on *Ecce Ancilla Domini!* (London, Tate Gallery). The author tries to deal with this paradox:

> She had a face and demeanour very suitable indeed for a youthful Madonna: but I presume the head of the Virgin in the *Annunciation* picture had been painted before he knew her – and, under any circumstances, he would perhaps have taken this head from Christina [Rossetti, the artist's sister], to keep the work in harmony with *The Girlhood of Mary Virgin*. (I, 173)

In the *P.R.B. Journal* (edited by W. M. Rossetti) D. G. Rossetti is recorded as painting the Virgin's head in December 1849, searching for a red-haired model in early March 1850, and later that month repainting the head; on 29 March Miss Love sat for the Virgin's hair. Work on the head continued in April and December 1850.[38]

But 'Siddal's' modelling to Rossetti is an important element in the artistic love-story: it conflates the themes of love and art in their ordained sexual hierarchy. In *Dante Gabriel Rossetti: His Family Letters with a Memoir* the author suggests – and most art historians have repeated it as if proven – that 'the first painting in which I find the head of Miss Siddal is the rich little water-colour of 1850', *Rossovestita* (Birmingham City Museum and Art Gallery). He adds, 'This is not greatly like Lizzie, but it can hardly have been from any one else' (I, 173). There is no evidence to support this, nothing of a documentary kind, and none from the drawing itself. Contemporary manuscripts indicate that there were other possibilities for the model.[39] In *Dante Gabriel Rossetti: His Family Letters with a Memoir*, as in later writings, 'Siddal' is installed as Rossetti's favoured and exclusive model. The art then signifies the relation of inspired masculine creativity and its loved object – passive feminine beauty. The trope of Dante and Beatrice is next invoked:

> Soon followed a true likeness in the water-colour, *Beatrice at a Marriage Feast Denies Dante her Salutation*, which was exhibited in the winter of 1852–53. Here Beatrice is Miss Siddal, and *every* other Beatrice he drew for some years following is also, I think, from her – likewise the Virgin in a water-colour of the *Annunciation*, 1852. (I, 173)

'Siddal' becomes Beatrice, the beautiful, adored, and yet unattainable image for the masculine artist inspired by her beauty, a beauty which he fabricates in the 'beautiful' drawings he makes.

In W. M. Rossetti's texts the romanticization of the relationship between Rossetti and 'Siddal' is read off and read into the drawings said

to represent her. W. M. Rossetti stressed that her face often appeared in his brother's pictures; he provided a list of such occurrences in the *Burlington Magazine* of 1903. In *Dante Gabriel Rossetti: His Family Letters with a Memoir* he wrote:

> In these years, 1850 to 1854, Dante Rossetti was so constantly in the company of Lizzie Siddal that this may have even conduced towards the break-up of the P.R.B. as as a society of comrades. He was constantly painting or drawing from her. (I, 175)

The drawings became a testimony to and evidence of a close love relationship between the artist and his model, a couple, it is said, who were not only devoted to each other but who spent most of their time together.

It is generally asserted in the Pre-Raphaelite literature, both nineteenth- and twentieth-century, that the Pre-Raphaelite artists employed their models in a peculiar and original manner, giving in their works not only fidelity to the appearance of the model but also to the model's character. In his article 'Dante Rossetti and Elizabeth Siddal' the author W. M. Rossetti provides what has become the authoritative declaration of Pre-Raphaelite policy in the matter:

> A leading doctrine with the Pre-Raphaelites (and I think it a very sound one) was that it is highly inexpedient for a painter, occupied with an ideal or poetical subject, to portray his personages from the ordinary hired models; and that on the contrary he ought to look out for living people who, by refinement of character and aspect, may be supposed to have some affinity with those personages – and, when he has found such people to paint from, he ought, with substantial though not slavish fidelity, to represent them as they are.[40]

This passage is usually taken at face value and circulated as a truth about Pre-Raphaelite paintings although it does not easily accord with accounts in letters and journals of the 1850s of the numerous models employed for the rendition of a certain face or figure. The passage quoted above is furrowed by complex issues of class and gender. It prefaced the discussion of 'Siddal's' modelling to Rossetti, and as such pertains particularly to the representation of woman. Distinctions are drawn between 'ordinary hired models', those who worked for their living, and 'living people' with 'refinement of character and aspect', by implication middle-class, who had 'affinity', with the personages depicted in paintings of 'an ideal of poetical subject'.

The working class is marked off from the middle class on economic, social and ideological levels, a differentiation critical in the nineteenth-

century construction of bourgeois femininity. The purity, virtue, spirituality, gentility and refinement of bourgeois femininity was constructed in gender contrast to the definitions of masculinity, and against the impurity, animality and work of the working-class woman. This passage suggests that the privileged qualities of the bourgeois woman will be transferred into the picture for which she modelled, that her 'femininity' will guarantee the ideological soundness of the picture. These claims for the equivalence between the representation of woman in art and the historical individual represented are sustained against the repressed representation of the working-class women whose presence as model could, it is feared, taint a high-minded picture.

The texts of W. M. Rossetti insist that 'Siddal' was Rossetti's favoured model for 'all the leading female personages'.[41] 'Siddal' is therefore positioned in these texts as refined and genteel, a woman of 'maidenly and feminine purity', and considerable emphasis is given to her withdrawal from that working-class, popular, street culture which was perceived as different from and threatening to bourgeois culture. The imputed purity and refinement of the model should anchor the purity of the pictures for which the feminine woman modelled. This sustains the probity of the artist, and this reflexivity adds another dimension to the ways in which 'Siddal' historically functions as a sign for masculine creativity.

Modern writings have recirculated these major tropes of W. M. Rossetti's texts, as the first example shows. They tend to construct an intimate relationship between artist and model using it as an explanation of the drawings Rossetti made and to assert that the drawings are faithful portraits of the model's face and disposition. The strategies are at work in Dante Gabriel Rossetti (1975), and earlier in The Pre-Raphaelites (1970) by Timothy Hilton, which explains the drawings and water-colours produced in the 1850s (years in which Rossetti was 'pursuing a very individual path') in terms of the familiar biographical paradigm:

> Rossetti and Lizzy, alone, lived together, slept together, and created together, for Rossetti taught her to draw and encouraged her enthusiasm for writing verse. The enclosed world of love, the égoisme à deux, this self-protective concentricity, is expressed in many of the pictures of these Chatham Place years. There are, first of all, a very large number of portrait drawings, some of them claiming a place as the most beautiful works that Rossetti ever produced. . . . The reciprocity of the artist-model relationship is now that between lover and beloved, and is dramatised in drawings like Rossetti sitting to Miss Siddal, and one of Lizzy by an easel in front of a window. . . . The twin inspirations of Dante and Lizzy enabled Rossetti to dig deeply into a totally new and deeply personal field of art.[42]

Later, in a discussion of Beata Beatrix, 1863 (London, Tate Gallery),

historical individuals – D. G. Rossetti and E. E. Siddall – are confused with representations of Dante and Beatrice:

> In 1863, he painted what is perhaps his best picture, *Beata Beatrix*, nominally a painting about Dante's Beatrice but actually a picture about Lizzy. It is Rossetti's tombstone to his wife. And so it is easier to understand the achievement of this painting, and its very un-English quality, if we think of it as a monument rather than as a painting about Dante. The urge to commemorate the dead is a basic human impulse. . . .
>
> Rossetti paints powerfully here. He revivifies as he mourns, testifying his belief in undying art as he grieves for the mortal. The ground had already been well prepared for the basic theme of this painting, in Rossetti's long-standing identification of himself with Dante, and of Lizzy with Beatrice. *Beata Beatrix* is a portrait of Lizzy as Beatrice, at the moment of her death.[43]

The painting is read in terms of Rossetti's personal feelings, proposed as universal. Another version of this same tale of the reciprocity of art and heterosexual romantic love is to be found in *The Art of D. G. Rossetti* (1978). In a section on 'The drawings of Elizabeth Siddal' it is stated:

> The drawings are difficult to date but the great majority seem to have been made in 1854–5 when Rossetti's feelings towards her were at their most tender. . . . In all the drawings after 1853 there is a sense of ennervation, stillness, and of privacy for they were alone together when the drawings were made.[44]

Dissimilar drawings of women are prefaced with a biography of 'Siddal' and a discussion of the relationship with Rossetti, 'overshadowed by her ill health'. It is asserted that 'these facts are not irrelevant for the study of Rossetti's art which always directly linked with the events of his life'.[45]

Functioning within bourgeois ideologies of heterosexual romantic love, these recent texts are marked by decisive historical shifts in these ideologies. In contrast to the image of the betrothed and married man generated and secured for late-nineteenth-century consumption in the texts of W. M. Rossetti, in the 1880s–1900s, since the 1960s Rossetti has been represented as one of 'the sexually potent artists', as 'commuting between the virginal Elizabeth Siddal and his fat whores',[46] 'a roisterous and uninhibited fornicator'.[47] This representation was produced within the discourses on 'liberated' sexuality which have characterized these decades.[48] Books such as Steven Marcus's *The Other Victorians* (1966) and Ronald Pearsall's *The Worm in the Bud: The World of Victorian Sexuality* (1969) presented the Victorian period, in contrast to the progressive present, as an age of sexual repression, of

public virtue and private vice. *The Worm in the Bud* revealed 'the Victorian buried life' of prostitution, perversion, pornography, sexual deviancy.[49] According to this account Rossetti was among those 'who were not afflicted by the climate of repression'. 'Rossetti' was therefore constituted at the intersection of these historically specific discourses on sexuality with those on artistic creativity in which masculine potency was already a component.[50]

Modern art historical texts on Rossetti have been shaped by these preoccupations – there is much discussion of the artist's 'relaxed' sexual habits and practices. His libertarian sexuality becomes the key to, indeed the explanation for, developments in his art: it is said to motivate changes in direction, to be expressed in paintings through his relations with his female models. These women are presented as objects of his desire, unsatisfied or gratified. 'Woman' thus functions in these texts as a sign of 'liberated' masculine sexuality.[51]

In *Dante Gabriel Rossetti* (1975) a consideration of *Found* (Birmingham City Museum and Art Gallery) is prefaced with speech on Victorian sexuality and Rossetti's own proclivities:

> Even now the world of Victorian sexuality is curiously opaque to us, partly because of our own inhibitions and preconceptions, but even more so because of the extraordinary conventions, beliefs, pressures of the time. To a degree Rossetti shared these inhibitions but the scatalogical sonnets that he wrote in Paris in 1849, the unconventional nature of his relationship with Elizabeth Siddal, his subsequently promiscuous liaisons in the 1860s and the erotic and eccentric tastes which he shared with Swinburne, all indicate a relaxed approach to sexuality and sexual relations.[52]

In this literature Rossetti is positioned in terms of gender difference to 'Siddal' perceived as virginal, beautiful, ill;[53] and 'Siddal' is held in contrast to 'more robust' working-class women such as Fanny Cornforth.

> Like Dante, whose spiritual passion for Beatrice did not preclude him from having a wife and family, Rossetti had a Latin realism in sexual matters. In the late 1850s when Miss Siddal's health was declining and their relationship was under increasing strain, he turned with relief to the opulent blonde beauty and frank vulgarity of Fanny Cornforth, who was to remain his mistress and occasional model until the end of his life; and who, though grasping and illiterate, provided him with something of the uncomplicated affection and domestic warmth that he needed.[54]

According to most accounts of Rossetti the change in his models in the later 1850s brought about a decisive change in his artistic career. With the appearance of Fanny Cornforth in particular a new type of picture

is said to come into being. This point is made in the following extract from the entry on *Bocca baciata*, 1859 (private collection) in the *catalogue raisonné* of Rossetti's works, which also neatly demonstrates the insistent biographic and narrative impulses of this literature:

> This painting (which, according to W. M. Rossetti, is a faithful likeness of Fanny Cornforth, against a background of marigolds) represents a turning-point in the career of the artist. Arthurian and Dantesque subjects had begun to vanish from the easel; with the declining health of Elizabeth Siddal the small angular figures with their medieval accessories familiar from the earlier water-colours gradually disappear, and in her place appears a new type of woman already observed a year earlier in the pencil portrait of Ruth Herbert (No. 325) in which the sweep of the neck, the curved lips, the indolent pose of the head and the emphasis given to the fall of hair foreshadow his prolific output of studies of women (often with similarly fanciful Italianate titles), sensual and voluptuous, mystical and inscrutable but always humourless, gazing into the distance with hair outspread and hands resting on a parapet, often with some heavily scented flower completing the design.[55]

This passage also indicates another of the complex ways in which woman functions as a sign whose signified is masculine creativity: Rossetti's career is organized into distinct periods classified according to the artist's romantic or sexual interests with women. Thus a correspondence established between Rossetti's attachment to the pure, beautiful and ill Elizabeth 'Siddal' and his production of 'Arthurian and Dantesque' water-colours in the 1850s is matched by a correlation secured between the development of new liaisons and the move to oil-paintings of female figures and flowers in the 1860s.[56]

These conflations of art and biography are sustained at another level. In the catalogues and monographs on Rossetti drawings of female faces and figures are ranked in series as portraits.[57] The *catalogue raisonné* collates drawings, paintings, sketches so as to produce an author for them. The artist is the effect of the collection of works which are treated, ideologically, as the trace of a coherent artistic subject, Dante Gabriel Rossetti, who is installed as their cause and the origin of their meaning.[58] In addition the manner in which the works are classified constructs other complementary subjects. Drawings of female faces and figures are organized under name headings of different models. Drawings are catalogued as *by* Rossetti *of* Elizabeth 'Siddal', Annie Miller, Fanny Cornforth, Jane Burden Morris, Emma Hill Brown.

The assembling and common labelling of the drawings labelled 'Siddal' presents a series of faces with divergent features as if they shared

a singular visual appearance of one model which then qualifies them for entry in the catalogue as portraits. These drawings are never, however, literal transcriptions of an appearance. Drawing is a calculated and mediated procedure which employs socially determined materials and media in conventionally sanctioned syntaxes. A selected topic is represented according to historically specific artistic codes by which the work will be recognized and assessed as art and will be legible to its anticipated publics. The effects produced are peculiar to artistic practice at a specific time and place but they interrelate with and take on meaning from other social practices and systems of representation. As a result of this interdependent relation a specific set of marks signifies; their potential meanings are anchored and elaborated by the dispersed signifying systems of the culture in and for which they are produced. Drawing is not an ahistorical, intimate reflection of the artist's character or mood. As an historically and socially formed practice, it is a point for the production of definitions, a site in which meanings are produced and renegotiated.

The Rossetti drawings of female faces are not portraits. Notable inconsistencies can be discerned between the drawings labelled 'Siddal' which disrupt the desire to read off from them a unified physical appearance and from that, a character (see Figures 5.1, 5.3, 5.5, 5.7). While it could be argued that this was the result of mislabelling, it should be pointed out that there is never any attempt in this art historical literature to justify what is included under the title 'Siddal' and there is no verifiable evidence from which to negotiate exclusions. More significantly it is possible to identify similar features and devices in Rossetti drawings of several female models. The facial type and attitude which are treated as the expressed attributes of 'Siddal' – the positioning of the head, the eyes, the disposition of hair, the gestures, body position, even the overall effects of lassitude and reticence – these can be traced in drawings labelled Fanny Cornforth, Jane Burden, Emma Hill Brown.[59] In turn these correspondences of pose are fractured by the variety of techniques used in the various drawings of the same model (Figures 5.1–5.9).[60]

These patterns of intertextual consistency and inconsistency erode the attempts to secure an identity between the drawings labelled 'Siddal' and a person or personality of whom the drawings are claimed as portraits. In fact consistent ideological work has been required to stabilize the 'Siddal' drawings around a unified subject, and to bind the drawings to written representations of Rossetti's model as a frail and languorous invalid of melancholy disposition. It is effected by the constant and unquestioning reiteration of the image of 'Siddal' initially produced in the memoirs from the 1880s to the 1900s supported by the

selective reproduction of drawings showing a woman lounging in a chair, eyes closed or downcast, impassive and inert.[61] A circular relation between visual and written text is created. The written text functions as a frame, positioning the drawings within an authoritative reading of their meanings. In the ceaseless exchange between written and visual texts the fragility, lassitude and sickliness of 'Siddal' are read off from graphic signs denoting lowered head, averted eyes with heavy lids, upturned lips, hair softly framing the face in deep loops or falling freely. But what is denied the drawings in this process is their status as work, as being worked, the products of history and ideology. Instead they are made to proclaim that the masculine artist, in love, reveals the truth of the feminine model. This relationship inscribes a hierarchy of power in which man is the owner of the look. The drawings register his active looking at and possession of the feminine object, the looked-at, the surveyed which is reconstructed in *his* image.

These Rossetti drawings are not about the model. They operate within an emergent regime of representation of woman in the 1850s. They signify in the ideological process of a redefinition of woman *as image*, and as *visibly* different. They appropriate 'woman', as an explicitly visual image – seen to be seen – as a signifier in a displaced and repressed discourse on masculinity.[62] The drawings do not record an individual man's personal fantasies or romantic obsessions. They are rather symptoms of and sites for the renegotiation and redefinition of femininity and sexuality within the complex of social and gender relations of the 1850s.

Historians of sexuality have drawn attention to the construction of 'Woman' both in terms of gender contrast and around the polarity of virgin/whore, Madonna/Magdalen. In the Victorian period the distinction between Madonna and Magdalen which had previously been seen as residing in all women was reworked as a distinction between women. This is not to say that women were simply divided into two separate categories, but that woman was defined across the opposition of the pure, womanly woman and the impure whore. The contrast had important class connotations. The bourgeois 'lady's' (a)sexuality was defined against not only the prostitute but also a sexuality imputed to working-class women in general.[63] Visual representations of woman in this period participated in the processes of definition and regulation of feminine sexuality.[64] In the images of women produced by D. G. Rossetti in the 1850s opposing categories are constructed; the pure, virtuous woman, such as Beatrice or the Virgin, stands against the impure woman, figured in many guises such as the prostitute in *Found* (Wilmington, Wilmington Society of Fine Arts), or the adulterous woman, Guinevere, for instance.

A drawing or a painting representing the figure Beatrice, therefore, signifies complexly within these historically specific discourses on femininity and sexuality, wherein the feminine is positioned as the object of the look, as Beatrice is placed as the love-object of Dante, the artist-lover.[65] Representations of Beatrice drawn or painted by Rossetti cannot be conflated or confused with the historical individual Elizabeth Siddall, any more than representations of adulterous characters can be accounted for by reference to Jane Burden Morris, or the prostitute in *Found* by the fact that Fanny Cornforth was one of the models for the painting. The drawings labelled 'Siddal' and the subject pictures for which it is claimed she was the model functioned within the extensive and dispersed regime of representations of woman which was the product of historically specific social, economic and ideological practices constitutive of the metropolitan bourgeoisie of the 1850s.

The purpose of this study of 'woman as sign' has not been the criticism of corrigible errors or omissions. We have argued that art history is a field invested with power and that the production of knowledge is historically shaped within relations of power. The discourses which produce the gendered definitions of the artist and creativity have ideological effects in reproducing socially determined categories of masculinity and femininity. The dominant tropes of Pre-Raphaelite literature have functioned to secure a regime of sexual difference. Its currency was recently renewed in the large and prestigious exhibition at the Tate Gallery in London, *The Pre-Raphaelites*, 1984. The exhibition and its accompanying literatures were decisively positioned against feminism and the knowledges it has produced. Women's activity was denied (only two works by one woman, Elizabeth Siddall, were exhibited out of a total of 250 items).[66] Creativity was naturalized as masculine through the circulation of woman as the beautiful, mysterious, desired and loved image for the desiring masculine gaze. As these authors stated in a review of the event:

> The failure to confront the historical and social meanings of cultural practices can no longer be politely dismissed as a 'difference' of methodology, approach or paradigm. Women have been and are today subordinated to men across a range of practices and institutions. High Culture plays a specifiable part in the reproduction of women's oppressions in the circulation of relative values for the ideological constructs of masculinity and femininity.[67]

The exhibition, and its permanent representation in the catalogue, not only displays this regime of difference in spectacular form but positions the visitors/viewers and readers to consume that sexual order as the natural condition of art, truth and beauty.

5
A photo-essay:
signs of femininity

Portraits 5.1–5.9 are all by Dante Gabriel Rossetti. The titles are taken from the *catalogue raisonné* edited by Virginia Surtees where each portrait is attributed to a named individual. The names are in quotation marks to emphasize the necessarily tentative nature of such attributions.

5.1 *'Elizabeth Siddal(l)'* (1860)

5.2 *'Fanny Cornforth'* (1862)

5.3 *'Elizabeth Siddal(l)'* (1855)

5.4 *'Emma Brown'* (1860)

5.5 *'Elizabeth Siddal(l)'* (1854)

5.6 *'Jane Morris'* (1857)

5.7 *'Elizabeth Siddal(l)'* (1854)

5.8 *'Jane Morris'* (1860)

5.9 *'Emma Brown'* (1856)

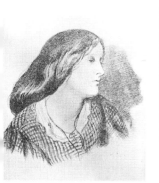

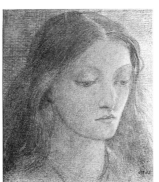

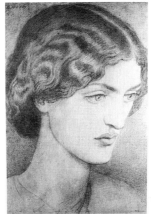

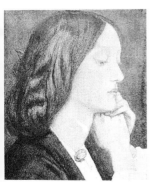

5.10 (a–d) Advertisements for cosmetic products

5.11 The faces of Greta Garbo and Marlene Dietrich

118

(a)

(b)

(c)

(d)

6

Woman as sign: psychoanalytic readings

ARE ROSSETTI'S PAINTINGS MEANINGLESS?

A feminism concerned with the question of looking can therefore turn this theory around, stressing that particular and limiting opposition of male and female which any image seen to be flawless serves to hold in place. More simply, we know that women are meant to *look* perfect, presenting a seamless image to the world so that the man, in that confrontation with difference, can avoid any comprehension of lack. The position of women as fantasy thus depends on a particular economy of vision (the importance of 'images of women' might take on its fullest meaning from this).

(Jacqueline Rose, 1985[1])

These drawings are not about the model. Operating with an emergent regime of representation of Woman in the 1850s, they signify in the historical process of redefinition of woman as *image*, *as visibly different*.

(Deborah Cherry and Griselda Pollock, 1984[2])

There is quite an industry working away on the drawings, paintings and poems of the English nineteenth-century artist Dante Gabriel Rossetti,[3] all seeking a key to explain a body of works which is remarkable for its repetitious preoccupation with woman and desire. Few investigations address the question why woman and desire in those forms and at that date. Instead various 'Rossettis' are constructed from the contemporary and later accounts, memoirs, diaries, letters to secure the necessary and unified image of a creative genius expressively endowing his work with meanings. The fact that the images employed to do this are all of or about woman is too obvious to require explanation. I want to argue

120

precisely the opposite. The fancy dress in which Rossetti dressed up obsessive themes is less important then their central problematics, woman as visibly different, yet woman as fantasy, sign of masculine desire. Furthermore, interrogation of this unremarkable oeuvre labelled 'Rossetti' raises crucial questions for feminist theorization of 'images of women' and the gaze.

I

'Woman' was central to mid-nineteenth-century visual representation in a puzzling and new formation. So powerful has this regime been in its various manifestations (latterly in photographic and cinematic forms) that we no longer recognize it as representation at all. The ideological construction of an absolute category woman has been effaced and this regime of representation has naturalized woman as image, beautiful to look at, defined by her 'looks'. This is best exemplified in those twentieth-century photographic images manufactured to sell the commodities, cosmetics, by which the supposed nature of our sex can be attained by donning the 'mask of beauty' (Figure 5.10 (a–d)).

This latter phrase derives from the title of an essay by Una Stannard published in 1972 which starts:

> Women are the beautiful sex. Who doubts it? . . . Just as all men
> are created equal, all women are created beautiful.[4]

This bit of irony is put into historical context. Not only have the ideals of beauty varied historically, but much, often painful, artifice has been employed to ensure bodily or facial conformity with the ideal. Moreover for many centuries beauty was as avidly pursued by men. Stannard argues that the exclusive identification of women with physical beauty only emerged when men were no longer defined as sex objects. She dates the shift to around 1830.[5] Her point may be arguable but this nexus of changed relationships between the category woman and beauty introduces a significant historical transformation.

In 1979 some students at Leeds University staged a performance dealing with this complex of issues and they used my office as an environment. The walls were papered floor to ceiling with cosmetic advertisements which remained as a ghastly wallpaper for several months. It was only after a long and intimate acquaintance with the serried ranks of female faces that I saw through the powerful illusions the photographic representation sustained. Gradually I perceived the systematic disproportions of the faces, the absence of volume and of the remotest suggestion of three-dimensional bone structure – everything that would be stressed in teaching drawing of faces to art students.

Often there was only a blank, airbrushed expanse of colour in which eyes freely floated above undulations of shocking and moistly shiny red lips. These were not faces, not portraits but fantasy. Figure 5.10(a–e). I recognised a striking parallel with nineteenth-century drawings of female faces by D. G. Rossetti which were also *not* portraits.

The portrait documents an individual's presence and, only in recent times, appearance, inscribing by the same token social status and place. The drawings by Rossetti (Figures 5.1–5.9) offer no location except the blank page. These faces are transplanted to a realm apart, a world of decorative hatching, incised lines, smudged contours or empty expanses of pristine paper. On show is very little of the model, but a great deal of drawing. The myth of woman is that she is simply revealed by the genius of the artist; the heavily laboured surfaces belie that myth with evidence of the work required to manufacture it. The pleasure these images offer, their beauty, is manufactured by the rhetorics and codes of drawing, of painting or photography, yet the drawing, painting or photograph seems merely the medium through which the viewer enjoys specular contemplative access to the natural beauty which is woman. When we look at these images we conflate beauty of the drawing or photograph with woman as beautiful and fail to question what motives this fantasy of visual perfection, why and for whom was it necessary?

The issue of sexual difference is operative in most societies but its forms vary historically and culturally. Putting it at its baldest, one of the key features in mid-nineteenth-century discourses on masculinity and femininity is the absoluteness of gender difference (the two terms gender and sexual difference are not synonymous: sexual difference refers to the socio-psychic construction of sexualities with its attendant positionalities; gender difference as used here refers to the public discourse about what men and women are/ought to be). Take for instance this verse from Tennyson:

Man for the Field and Woman for the Hearth:
Man for the Sword and for the Needle She:
Man with the Head and Woman with the Heart:
Men to command and Woman to obey;
All else confusion.

(*The Princess*), 1847

An unarguable otherness is declaimed in these cryptic, noun-laden verses where man and woman are produced as absolute opposites. Difference is made obvious and self-evident while the anxiety which underpins these 'facts of nature' is hardly kept at bay by the aggressive brevity of the statements. The linguistic form is eloquent testimony to

the contrivance of the poem's claims. In the visual sign, woman, manufactured in a variety of guises in mid-nineteenth-century British culture, this absolute difference is secured by the erasure of indices of real time and actual space, by an abstracted (some would call it idealized) representation of faces as dissociated uninhabited spaces which function as a screen across which masculine fantasies of knowledge, power and possession can be enjoyed in a ceaseless play on the visible obviousness of woman and the puzzling enigmas reassuringly disguised behind that mask of beauty. At the same time, the face and sometimes part of a body are severed from the whole. Fetish-like they signify an underlying degree of anxiety generated by looking at this sign of difference, woman.

In the production of a signified woman as beautiful face, a newly defined order of sexual difference was being inscribed. Neither the masculine positionality of the producer/viewer nor the feminine positionality of the produced/viewed pre-existed the manufacture of the representations as if completely formed elsewhere, merely reflected in art. The specificity of visual performance and address has, moreover, a privileged relation to the issues of sexuality.[6] On the other hand this is not merely a phenomenon of visual representation. The renegotiation of sexual difference within the urban bourgeoisies of the nineteenth century was a complex process operating unevenly and contradictorily across multiple points of discourse and social practice. But nowhere was this *inscription* so compelling as in those sites where it could be consumed as mere *description*.

> The dominant form of signification in bourgeois society is the *realist* mode, which is fixed and curtailed, which is complicit with the dominant sociolects and repeated across the dominant ideological forms. Realism offers a fixity in which the signifier is treated as if it were identical with a pre-existent signified and in which the reader's role is purely that of consumer. . . . In realism, the process of production of a signifier through the action of a signifying chain is not seen. It is the product that is stressed, and production that is repressed.[7]

It may seem odd to introduce realism in this context. In art historical terms Rossetti is privileged over other Victorian artists precisely because he transcended contemporary realism, typified by the works of Hunt, early Millais and so forth, by his interest in colourism, allegory and poetic symbolism.[8] John Tagg's Barthesian notion of realism does not have a great deal to do with definitions of realist art as a matter of socially inflected contemporary subject matter, a preoccupation with the material qualities of painting, or precise naturalistic schemes of

123

representation – truth to nature. Realism as *a mode of signification* (not a matter of style or manner) became increasingly dominant in bourgeois culture – in literature as well, and more so with the establishment of photographic practices. Photographs offer particular pleasures and sustain specific illusions. A sense of actuality – someone like this was here, once – combines with and plays against the freedom of fantasy, for the only actual presence, *now*, is the viewer's. Fantasy can be satisfied by realist means which secure the credibility of the imaginary scene, with details of costume, setting, accessories. The realist mode of signification disguises the fact of production beneath its veneer of appearance. It can work therefore just as powerfully in the satisfaction of fantasy by means of its management of specifically visual pleasures for a viewer who is protectively placed as privileged voyeur.

Works collectively classified by the author name 'Rossetti' have been selected for this study for several reasons. These paintings provide a symptomatic site for the study of a new regime of representation of woman on the axis of bourgeois realism and erotic fantasy. In no sense do I wish to privilege Rossetti as representative artist nor do I intend to interrogate his personal or even social life to explain the paintings.[9] I am concerned here to provide a textual analysis of a series of paintings which are related by the fact of a common producer. But they are in themselves inconsistent in the manner of their handling of an obsessive subject whose insistence is socially determined rather than privately motivated, namely, the negotiation of masculinity as a sexual position.

II

After 1858 Rossetti began to produce a series of oil-paintings, few of which were ever exhibited for they were mostly made to commission or offered to a limited circle of regular buyers, many of whom were industrialists and businessmen. 'Female heads with floral attributes' was William Michael Rossetti's term for this repetitious cycle of half-length paintings of female figures in varying settings (Figure 6.1). Despite their opacity there has been no lack of enterprise in their interpretation. Writing in 1897, F. W. H. Myers offered an extremely pertinent assessment of these paintings. Although he identified them as sacred pictures in a new religion, he also specified precisely the 'oddities' which should detain us:

> The pictures that perplex us with their obvious incompleteness, their new and daunting beauty, are not the mere caprices of a highly dowered but wandering spirit. Rather they may be called . . . the sacred pictures of a new religion: forms and faces which

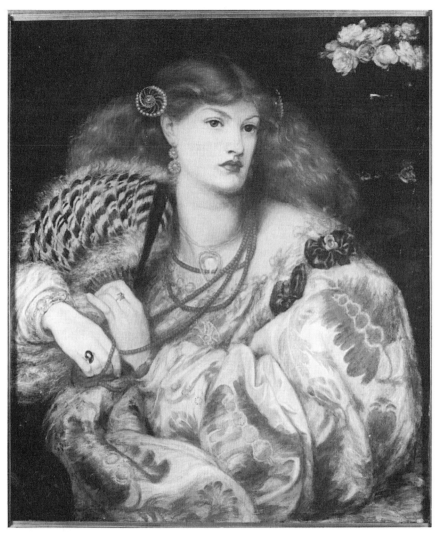

6.1 *Monna Vanna* (1866)

bear the same relation to that mystical worship of beauty on which we have dwelt so long. It is chiefly in a series of women's faces that these ideas seek expression. All these have something in common, some union of strangeness and puissant physical loveliness with depth and remoteness of gaze.[10]

Myers's comments are spot on. This text identifies the salient features of these works. Even if the idea of a new religion of beauty no longer

compels, it invokes the cult, or iconic quality, of many of these images, which resides in that particular combination of *physical* loveliness and a remote *look*.

Twentieth-century art historians do not engage in such comprehensive explanations of the content. As good modernists, they concentrate instead on the sensuous materialism of the facture. In the development of this series of paintings the subject is irrelevant by virtue of its constancy. Stylistic innovation is important and it is explained by the influence of sixteenth-century Venetian painting whose importance was advertised by major writers such as John Ruskin and later Walter Pater.[11] There have been Marxist accounts attributing the production of yards of canvas with decorative females in fancy dress to Rossetti's submission to market forces and the industrialist patrons for whom Rossetti worked.[12] Finally there have been feminist readings. Virginia Allen's study of one of the series, *Lady Lilith* (Figure 6.8), argues that the fearful images of fatal women incorporate a response to contemporary feminism wherein the New Woman was perceived as a modern destroyer of men.[13]

All of these varying explanations, bound as they are within their own historical and ideological frameworks, contribute something of interest and pertinence. But each constructs an intentional author for the works, a Rossetti who then deposits his philosophical interests, painterly concerns or personal quirks and political fears in the pictures. Meaning becomes an extractable facet of the artistic personality who created the paintings. Such approaches do not attend to the work being done in and by the paintings in the process of their production (why and for whom were they made) and in the process of their consumption and use (what pleasures do they produce and what fears do they manage?). I want to ask why those who commissioned and bought them wanted to look at them.[14] Are these sexual images, i.e. erotic as in the manner of Venetian courtesans? In that case how can they be compared with Raphaelesque Madonnas? What role has beauty to play in securing visual pleasure? Is the beauty of the physical object, the painting, a defence against anxieties excited by the represented object, woman? In what system can these contradictory and interrelating pressures be accounted for?

In December 1856 Christina Rossetti wrote a poem, 'In an artist's studio'. It is usually read biographically, as a reference to her brother Dante Rossetti, but it could be any contemporary studio and it is interesting for the way it identifies the obsessive quality of repetitious images of a female face:

Woman as sign: psychoanalytic readings

One face looks out from all his canvases,
One selfsame figure sits or walks or leans:
We found her hidden just behind those screens,
That mirror gave back all her loveliness.
A queen in opal or in ruby dress,
A nameless girl in freshest summer-greens,
A saint, an angel – every canvas means
The same one meaning, neither more or less.
He feeds upon her face by day and night,
And she with true kind eyes looks back on him.
Fair as the moon and joyful as the light:
Not wan with waiting, not with sorrow dim;
Not as she is, but was when hope shone bright;
Not as she is, but as she fills his dream.
 (Christina Rossetti, *Poems*,
 ed. W. M. Rossetti, London, 1895, 114)

'That same one meaning.' 'Not as she is, but as she fills his dream' –
the very terms invite some reference to psychoanalysis which attends
specifically to analysis of the unconscious meanings of the dream and
to those unconscious formations which press upon the conscious by
means of repetition in the form of neuroses.

To invoke psychoanalysis might seem to fall prey to a similar criticism
of overprivileging the individual artist and looking for explanations
within his psyche. Psychoanalysis has, however, been deployed within
feminist theory, film and literary criticism as well as art history in order
to expose structural formations not personal idiosyncrasies. Psycho-
analysis is a tool used to alert us to the historical and social structures
which function at the level of the unconscious. Not only has feminist
political theory stressed the necessity of subjecting the so-called
personal to socio-economic and ideological analysis but developing
theories of ideology within Marxism have involved recognition of the
unconscious level of its operations in producing us as subjects for
specific regimes of meaning. The unconscious is represented not merely
as object of personalized interrogation but as a site of social inscription
of gender/class formations operative through social institutions such as
the family. Instead of seeing Freud as reducing all explanations back to
personal factors, this historicized use of psychoanalysis places the
bourgeois family as both social institution and discursive formation for
the production of masculine and feminine subjects. In its complex
relationships and representations it is the locus of sexualization, and
therefore for the initial installation of sexual difference. To locate this
historically is equally important. The family of psychoanalysis is

historically and culturally specific – the bourgeois family of western Europe. The work collectively labelled 'Rossetti' is an especially significant trace of these psycho-sexual formations. At the manifest level they are specifically about sexuality, attempting to stabilize positions of masculinity and femininity through the language/hierarchies of romantic love. But structurally they can be read as constructions of a visual field, a scene which attempts to organize visual pleasure orchestrated around the troubling act of looking at an image of woman/difference.

III

It is generally agreed that a painting, *Bocca baciata* (Figure 6.2), of 1859 marks a turning-point in the work of Rossetti heralding a shift from medievalizing and narrative water-colours to 'single figure paintings of sensuous women'.[15] These figures are partial, however, trapped in a shallow and enclosed space, which only provides visual access to head, neck, shoulders and hands, usually shown leaning against a parapet which functions as a barrier between viewer and figure and a boundary for the figure's space. Any indication of setting is prevented by filling the background with a decorative trellis, wallpaper or a mass of flowers. *Bocca baciata* exhibits all these features and in addition demonstrates the sensuous application of paint to the flowing hair and velvet robe as well as the jewellery and exposed areas of flesh.

It is important to stress that this is not a female figure, but a fragment, *'corps morcelé'*. The title, translated as 'The mouth that has been kissed', further isolates a body part. It derives from the Italian poet Boccaccio: 'The mouth that has been kissed loses not its freshness; still it renews itself even as does the moon.' The metonymy (i.e. where a part stands for the whole) of a mouth introduces diverse connotations. The mouth as ruby wound can function as a displaced sign of female sexuality, her genitals. But on another track the insistence upon the mouth suggests regression to the oral phase, a pre-Oedipal moment prior to the encounter with sexual difference. The mouth functions as a classic fetish, some sign which both involves and displaces visual knowledge of female genitals but can disavow the threat of that knowledge by harking back to another more comforting visual encounter and sensuous experience – that of looking up to the mother/female caretaker in the course of being suckled.

Yet another connotation is brought into play by what almost all commentators note, the remoteness of the figure's gaze. However desirable, the figure is both lost and an embodiment of melancholy resulting from loss, a kind of mourning.[16] The image is played across by conflicting possibilities of pleasure, fear and loss.

For its immediate viewers in 1860 the painting did function as a sexual

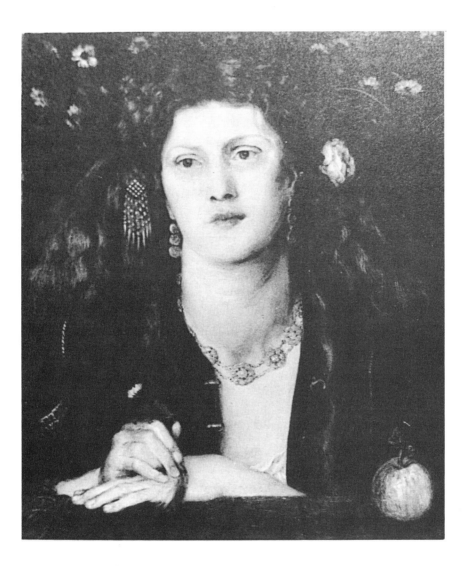

6.2 *Bocca bacciata* (1859)

image, but in significantly varied ways. For instance, the painter Arthur Hughes wrote about the painting to the Irish poet William Allingham in February 1860:

> Rossetti has lately painted a most beautiful head, marigold background, such a superb thing, so awfully lovely. Boyce has bought it and will I expect kiss the dear thing's lips away before you come to see it.[17]

Frank admission of the use of an image to stimulate sexual desire perhaps but what is important is that Hughes assumes an erotic position for its viewer/purchaser. In a letter by William Holman Hunt to the collector Thomas Combe of 12 February 1860 a more critical and symptomatic view of the picture's erotic effects was articulated:

> Rossetti's head I shall be curious to hear your and Mrs. Combe's opinion about. Most people admire it very much and speak to me of it as a triumph of our school. I have strong prejudices and may be influenced by them in this respect. . . . I will not scruple to say that it impresses me as very remarkable in power of execution – but still more remarkable for a gross sensuality of a revolting kind, peculiar to foreign prints, that would scarcely pass our English Custom house from France. . . . I would not speak so unreservedly of it were it not that I see Rossetti is advocating as a principle mere gratification of the eye and if any passion at all – the animal passion to be the aim of art.[18]

For its initial viewers therefore this painting introduced the problematic of the representation of sexuality and focused on the issue of the gaze. In Hunt's letter there is some suggestion that he actually finds the painting pornographic, viz. the reference to foreign prints. However, pornography as such was scarcely defined by that date and we must be wary of anachronistic classifications.[19] None the less the letter is about the limits of acceptable excitation and visual pleasure. This is not a matter of prudery or repression as conventional definitions of Victorian society have misleadingly represented the discursive anxieties about sexuality. Sexuality, masculine of course, could find its pleasures in representation, but according to Hunt not simply through an appeal to the eye. For Hunt, in the public representation of sexual material the gaze must be tempered by a narrative which contextualizes its pleasures within regulated, moral scenarios. It cannot be allowed its solitary freedom to fantasize.

Later in the letter Hunt added: 'I disavow any sympathy with such notions, if Art could not do better service than dressing up the worst vices in the garb only deserved by innocence and virtue.'[20] Love and desire can be evoked but only in the representation of their proper objects. Within the dominant ideology of the evangelical bourgeoisie which has been shown to be the ideological avant-garde of not only that class but the ruling groups and later the respectable labour aristocracy as far as mores were concerned[21] – the proper object is the virtuous lady who is ignorant of sexual knowledge and therefore desire. Her lack of physical desire inspires in the man the necessary self-restraint and spiritual transcendence of his base animal instincts. As Peter Cominos

has demonstrated in his anatomy of what he labels the Respectable Social System, true manliness is accomplished by self-control and continence.[22] The complementary ideals therefore of bourgeois manliness and the bourgeois lady function in implied contrast to the *fallen* woman (who is seduced into knowledge and impurity), and to the contaminating physicality of the prostitute and by extension the working classes in general.

For Hunt therefore high art, which has a public and moral function, should clearly handle the pressing issues of sexuality by demonstrating the ideals of manliness and ladyhood and by contextualizing the morally fallen and the weak. He demands ideological consistency. Considerable and revealing anxiety is betrayed about the pleasures evinced by the viewers of *Bocca baciata* because it trades on relays between sexuality and sight outside of such fixing ideological narratives.

For Hunt, indeed more pleasurably for Hughes, *Bocca baciata* transgressed all these limits. It is hard to perceive the material for such anxiety/excitement when we look at this painting. Certainly it is painted in luscious colours reminiscent as it was intended to be of the Venetian school of colorist painters of the erotic woman.[23] Derealized and confined, the setting suggests the private realm, perhaps a boudoir, perhaps a bower, but there are no details of location as for instance typical in French images such as *Rolla* of contemporary prostitution.[24] Costume is imprecise but certainly not contemporary (no corsets). It is fantasy made compelling by the very sensuous treatment in paint of flesh, velvet, flowers, hair and jewellery; visual realism, is deployed in service of a sexual fantasy – one dependent therefore explicitly on sight. This painting was repeated in various formats, colour schemes, costumes and titles over the next few years, for instance *Fair Rosamund* (V. Surtees 128), *Girl at a lattice* (V.S. 152), *My Lady Greensleeves* (V.S. 161), *The blue bower* (V.S. 178), *Fazio's mistress* (V.S. 164), *Helen of Troy* (V.S. 163), *Monna Rosa* (V.S. 153) and *Regina cordium* (Figure 6.3) (V.S. 120) of 1860.

IV

In 1866 Rossetti reused the title *Regina cordium* which means Queen of Hearts for a painting (Figure 6.4) which marks a subtle shift in the scheme of representation. There is still an enclosed and confined space containing a head and shoulders seen leaning against a parapet. But the facial type has changed. It is usual to explain the differences amongst Rossetti's paintings and phases in terms of the model's looks and relationship to the artist as if they were sufficient causes of a change. The use of a different model (Alexa Wilding) – Rossetti always used and

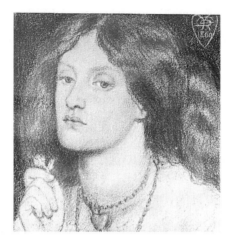

6.3 *Regina cordium* (1860)

claimed to need a model – was rather the result of what was to be
represented. Rossetti's assistant Treffry Dunn commented on this
reversed process: 'When the sketch was to his liking, then came the
question, which model was best fitted for the subject?'[25] All the faces
that appear in works labelled Rossetti are drawn or painted; they are
representations, patterns of lines, colours, shapes, not transcriptions of
a real person's appearance. When the face of 'Alexa Wilding' is
introduced in the oeuvre we must ask what did this schema of a face-
sign signify. The two remarkable features of this facial type are its
extreme symmetry and the absence of a forehead. The eye to chin area
is thus unnaturally enlarged. When children first draw faces they tend
to draw a circle, put the eyes at the top and the mouth at the bottom.
Later we are taught that to make a face look like a human face one must
place the eyes just above the median line allowing for forehead and the
curve of the skull. The 'Wilding face' refuses this convention. There is
no forehead, only curving wings of hair directly above the brows with
a curved parting running up the skull. This makes it difficult to read this
as a forehead and puzzling because to see that much of the skull we
should be above the model looking down. Yet the figure's gaze is level;
because of the parapet setting the viewer is notionally below the painted
figure. This abstracted or schematized quality does not disturb; indeed
it takes some seeing. That it does not seem grossly unnatural is evidence
of the fact that what we are consuming pleasurably is an artistically
imposed order not a depiction of a human one.

What does this face-sign signify? It can be approached by making a
comparison between the two versions of *Regina cordium* (Figures 6.3 and

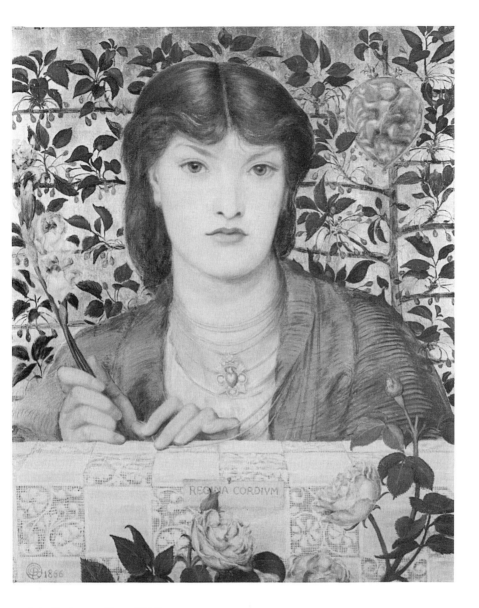

6.4 Regina cordium (1866)

6.4). The 1860 version is a very flat image, tightly pinning the woman's head and shoulders to the surface of a decorative, gridded plane. But her hair is loose, a decent and suggestive sign of allowed disorder, conventionally a sign of woman's sexuality.[26] The face has limited expression but the angle of the head and distanced gaze again functions

as a signifier of melancholy and by displacement of loss. The downcast eyes, however, also serve to offer the face for the viewer's uninterrupted surveillance. The 1866 version is radically different (Figure 6.4). The hair is controlled and symmetrically arranged. The grid-like trellis further underscores nature controlled, ordered, trained, and flatness is intensified by the golden background. The abstracted symmetry and severely restricted potential for reading and expression produces an iconic, hieratic face. But unlike the icons of religious art which are imagined to be empowered to gaze upon the spectator, the look here is almost blank. The importance of this phenomenon cannot be overemphasized. There is a long tradition of eye imagery in love poetry in which the look of the beloved at the male poet/lover is central to the instigation of love. This has been called the aggressive eye topos, for the eye is imagined to send out darts and arrows which pierce and penetrate the lover, with obvious phallic implications. The masculinity of the gaze even of the lady is further explained by the relation between the beloved lady and the gods, or superior powers, a link which exists in the masculine symbolism of the sun. On the other hand there is a tradition in which the eye is the symbol of female genital organs. In all its guises the sexual connotations of the aggressive eye imagery are significant, but it is the gaze of the beloved at the lover which bears these meanings.[27] Conventional feminist theorization has stressed the possessive look of the presumed masculine spectator *at* the objectified female form. Correct though this may be it is only half the story for the pleasure of looking at images involves the imaginary empowering of the 'gaze beyond', not just of the persons in the representation but of the Other which they momentarily stand in for. So I have emphasized the remote gaze as signifier of melancholy and thus generator of a sense of loss in the viewer and later I shall analyse a work in which the figure's dominating gaze becomes a crucial signifier. In the 'Wilding face' there is a highly significant stasis round the gaze – a freezing of the exchange of looks by which desire is pictorially articulated.

The notion of the cult image or icon was correctly raised by Myers' label of sacred pictures of a new religion. This inference is supported in a poem by Rossetti about a painting of a 'beloved lady'. In 'The portrait' we read:

Lo! it is done. Above the long, lithe throat
The mouth's mould testifies of voice and kiss,
The shadowed eyes remember and foresee.
Her face is made her shrine. Let all men note
That in all years (O Love! Thy gift is this)
They that would look on her must come to me.

The poem is apparently about a portrait. It articulates crucial desires for possession of the loved object in the manner of a collector of paintings. The painted image of the loved one is that which can be utterly and timelessly possessed.[28] This introduces a classic form of fetishism. Inanimate symbols are invested with the powers of the meaning, in fact the property of people and their social interactions. This fetishistic quality – in the religious or magical sense – is further heightened by the term shrine; a shrine is used to celebrate some usually saintly person, *after their death*. The word shrine metonymically introduces the trope of death into the field of love, and also of art. Art both kills – stops time – and enshrines. It refuses death, by perpetual representation, once again in the service of psychic need.

To pursue these strands further we must consider an exceptional painting in the collected works 'Rossetti' for it is a partial nude, *Venus verticordia* (Figure 6.5). The painting was commissioned in 1863 or 1864 by J. Mitchell of Bradford. The original model for the body was a cook who worked for a family in Portland Place. (Note the use of a working-class woman for the body and her features originally appeared on the face too.) A red chalk drawing of 1863 from this model places the half-length naked figure in a typical setting against a parapet, with a trellis closing off the background (Figure 6.6). In the top right-hand corner, on a hand-written paper, is a poem by Rossetti. Between 1864 and 1868 an oil-painting was made of this subject. It had undergone remarkable changes. The figure of Venus rises out of a bower of rampant roses and blood-striped honeysuckles all painted with a remarkable insistence on their finger-like tendrils. Floral symbolism was widespread in nineteenth-century art and literature and Rossetti and his circle made much use of the particular meanings associated with specific flowers.[29] But their profusion in this painting exceeds that managed meaning and signifies by virtue of its excess. Flowers have often been used as a metaphor for women's sexuality, or rather their genitals.[30] Here I suggest they function as a metaphor which simultaneously acknowledges and displaces those sexual connotations covering or masking the sexualized parts of the body which are traditionally erased in the representation even of Venus in western European art. But by covering up so excessively, the flowers draw attention both to what is absent and to the anxiety presence/absence generates in a masculine producer/viewer. John Ruskin actually called the picture *Flora* (conflating woman and flower precisely at that sensitive point of sexual specificity). He hated it, *because* of these flowers:

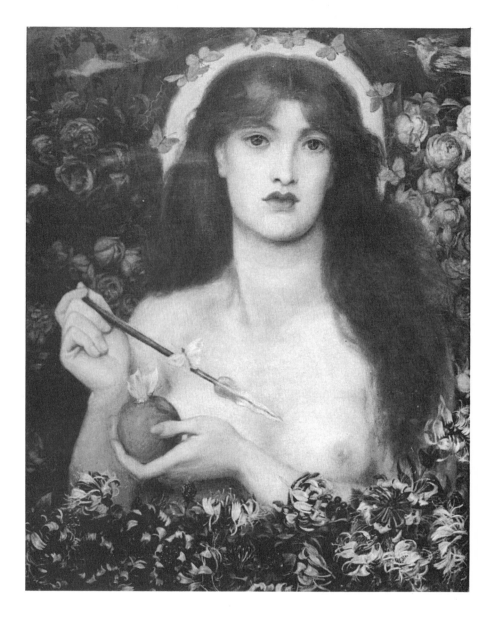

6.5 *Venus verticordia* (1864–8)

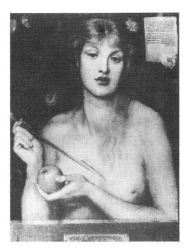

6.6 *Venus verticordia* (1863)

I purposely used the word 'wonderfully' painted about those flowers. They were wonderful to me, in their realism; awful – I can use no other word – in their coarseness: showing enormous power, showing certain conditions of non-sentiment which underlie all you are doing now.[31]

Coarseness and non-sentiment recall the criticism of William Holman Hunt and bespeak a discomfort which cannot be addressed directly. Perhaps part of the problem is the ambiguity resulting from the conjunction of competing iconographical signs. The figure is a Venus, by the title, and the dart – Cupid's, and the golden apple – the goddess's prize in the famous beauty contest adjudged by Paris. But the apple also functions in Christian iconography as the attribute of Eve, the sign of her sin, the discovery of that sexual knowledge which introduced difference and its pains.[32] Finally the figure is provided with a halo, a sign of holiness or saintliness, of a cult figure like the Madonna, the fantasy of the pure non-sexual mother, who can procreate in sexual innocence – like the lady. Does it, can it all add up?

F. G. Stephens, a close collaborator of Rossetti's and a critic whose regular page on the *Atheneum* Rossetti used to publicize his career since he chose not to exhibit, offered an interesting account of the painting in 1865:

She appears to be a Venus after Chaucer's heart, not the grave mother of the grand Greek school, still less the small meretrix-like Venus de Medici. . . . She guards her apple with the threatening dart, while the Psyche all tremulous of wing traverses its surface.

> Winner of hearts, she recks not of the soul; fraught with peril her
> ways are inscrutable; there is no more of evil than of good in her;
> she is victorious and indomitable.[33]

Stephens's indulgence in terror and subordination flirts with the popular fascination with the *femme fatale*. Does the identification as a *femme fatale*, destroyer of men, suggested also in the accompanying poem make sense when we look at the painting? Does it reek of gross sensuality? The painting is, I suggest, scarcely Venusian or voluptuous at all. It lacks the effect its constituent elements might lead the viewer to expect. We confront instead an unstable sign vacillating between what one might call a maternal image and an erotic image of cold ruthless domination.[34]

The meaning signified by this painting is not what is there, but what is not, what cannot be articulated. From all the signs, emblems, clues to ensure this image signifies femaleness and a sexualized and desirable one, the finished work is a kind of stalemate, unerotic, unsentimental, cold. Sexuality is vividly represented but in a displaced and over-anxious profusion of honeysuckles and roses which distract, mask but signal what cannot be shown. The conjunction of Eve, Venus, Madonna constitutes woman as an ambiguous sign, dangerous to man through knowledge, domination or sexuality, dreadfully distant, but anxiously desired, an almost hallucinatory presence.

One way to explore these contradictions is by reference to classic Freudian theories of fetishism. Freudian theory attempts to theorize the manner in which we acquire a gendered sexuality, i.e. the motivations which transform polymorphously perverse and bisexual infants into (more or less fixed) masculine or feminine subjects. Freudian accounts privilege what is alarmingly called the castration complex. (A complex is a group of interconnected conscious and unconscious ideas and feelings which exert a dynamic influence over behaviour.) Castration means more than loss of male sex organs. At the historical point at which this complex takes hold the male child (for that is Freudian theory's main subject) is at the phallic stage, the point at which the body is able to satisfy a need for comfort and provide gratuitous pleasure. Fear of damage (castration) is not localized on loss of a specific organ. Rather it represents a threat to the body's narcissistic possibilities signified by the organ of gratuitous pleasure. The child has an incomplete and unstable sense of what it is – preliminary moves towards the formation of an ego depend upon an image of the body perceived from outside, for instance in a mirror. The image of the body imagined as a complete, coherent, self-sufficient unity is the precondition for the formation of subjectivity. Thus fear of damage to the wholeness of the body signifies

a threat to the still precarious forming sense of self at a critical moment of narcissism. In this complex field of unstable significations, the discovery (for Freud a visual one) of anatomical differences in body types – a difference articulated as presence and absence, is hugely overdetermined in its effects. The revelation of loss signified by the absence of a particular sign/locus of autonomous gratification opens up not only the possibility of damage to one's own body but of damage already done to the maternal body which was until that moment the guarantee against disaster. Generated at this intersection of knowledges and still sliding meaning are twin images of what will later be linguistically fixed as woman (as difference). One is the compensatory fantasy of the pre-Oedipal mother, still all-powerful, phallic; the other is the fantasy of woman not only as damaged, but as damage itself, castrated *and* the symbol of castration.

In those familial structures organized by the sexual division of labour, a female caretaker is usually the primary source of life and love. Over this foundation is laid a split image of that dominating figure, one part powerful but forever threatening, the *femme fatale*; the other powerful but forever lost, the perpetually desired phallic mother of infancy.

In Freudian theory, the discovery of anatomical difference is traumatizing and several defences are established against this terrible knowledge – this expulsion from the Eden-like unity with the mother. The knowledge can be disavowed; we know but pretend not to know and live in constant danger of being confronted with this threatening knowledge. The myth of the Medusa's head is a classic representation of the fantasy.[35] With an overload of compensatory phallic snakes for hair the Medusa's head will turn you to stone if directly gazed upon. It can, however, be safely viewed reflected in a mirror – an image of great significance for the function of visual representation and sexual positioning.

The Medusa's head is also a fetish and fetishism forms another major defence. This involves the displacement of the anxiety created by the sight of the different body on to another object. Freud explains some of the classic fetishes, shoes, legs, fur, velvet, underclothes as items associated with the moments before the alarming discovery. But he also reports a case of a young man whose fetish was a glance at a shiny nose.[36] John Ellis has developed this example further to postulate the woman's ressuring gaze at the child prior/post the discovery as a fetish itself.[37] A final form of fetishism, which also involves not just displace-ment but fetishistic conversion, takes the form of reshaping the whole of the female form into a fetish, a substitute for what appears lacking on the maternal body, the phallus. Laura Mulvey has usefully applied this not only to the bound, high-heeled, whip- and fur-toting figures of

pornography and the Pop art work by Allen Jones[38] but to the phenomenon of the female star in cinema (Figure 5.11).

This second avenue, fetishistic scopophilia, builds up the physical beauty of the object, transforming it into something satisfying in itself. . . . Fetishistic scopophilia can exist outside the linear time as the erotic instinct is focused on the look alone.[39]

The conflation of woman and beauty can thus be explained in terms of fetishism attendant on the psycho-dramas by which we encounter the patriarchal regime of sexual difference. The reduction of narrative and the privilege of the gaze according to whose demands the female figure is styled which characterized Rossetti's work offer a historical location for the formation of what Laura Mulvey perceived in cinematic representation.

It is possible to utilize this reading of fetishism on the problems posed in the *Venus verticordia*. The point is not now to explain its meanings, but to understand its failure to mean – to produce knowledge. The painting juxtaposes signs which could be anticipated to signify erotically, representing the nude female body as a desirable object for a masculine sexuality which it signifies. But the relations between these signs do not ensure a full meaning. Their signification is stalled; the spectator's gaze is fixated upon a fetish, a fragment of a body, a schematized face, a blank look. Therefore in a displaced register, the whole signifies an absence, the phallus, allaying the castration anxieties, which the exposure of woman as non-man, as difference, incites.

The repetitions which modernist art historians have to explain away as creative laziness or servile production for the market can now be accounted for in terms of a psychic knot. Repetition functions as 'insistence, as the constant pressure of something hidden, but not forgotten'.[40] As a series the paintings constitute a visual screen on to which are projected the founding dramas of the formation of bourgeois masculinity. The scenarios have their variations. At times the phallic mother and the erotically dangerous conjoin in a frozen moment of exposure and disavowal, as in *Venus verticordia*; at other times they are elaborated in distinct but interdependent imageries.

V

Between 1866 and 1870 Rossetti produced companion pieces, *Sibylla palmifera*, soul's beauty and *Lady Lilith*, body's beauty (Figure 6.7 and 6.8). The polarity of body and soul functioned centrally in the contradictory construction of Woman in bourgeois ideology. Lucy Bland has argued that

the contradictory representation of woman as on the one hand moral and virtuous, on the other, 'animal', was possible through a splitting of women into three, rather than the usual cartesian duality of mind and body: woman's spirituality (her morality) was pure and ethereal, but continually risked being overpowered by animal instinct of reproduction which ruled her body *and* her mind.[41]

Although this splitting affected images of all women, it also functioned to segregate women on class lines – a phenomenon produced within the social institution of the bourgeois family, where child care was divided between moral instruction from the mother and physical day-to-day labour by servants. The mother/lady was an idealized and remote fixation for the male child. Aided by servants and nannies she remained aloof from all soiling, bodily contact, imagined as a result to be herself almost without a body, and certainly asexual.[42] By complete contrast, the body (of the child and others as physical beings) is palpable amongst the female servants who tend, clean, feed and fondle the small child. In an essay on the 'Universal tendency to debasement in the sphere of love' Freud attempts to explain psychically the effects of this social and sexual division of labour in the bourgeois household which both fosters and proscribes, constructs and channels the infant's sexuality and gendering. The ideal masculine adult coalition of the affectionate and sensual is often impeded, according to Freud's analyses, by a split between an idealized representative of the forbidden mother and a debased sexual object. (Freud of course does not comment on the class implications; the gender and class power accruing to the bourgeois man to avail himself of socially subordinate women who are sexualized, objectified and used.)[43]

For the painting *Lady Lilith*, the figure and features of the model 'Cornforth' were used, a sensualized and sexually used woman. Begun in 1864, in the manner of the *Bocca baciata*, completed in 1868, the painting was reworked in 1872 and the face altered to a 'Wilding' type. A water-colour, dated 1867 (VS 2050), probably a copy by Rossetti's assistant H. T. Dunn, provides some clues to what originally occasioned the following lines by F. G. Stephens.

As Rossetti painted *Lilith* she appears in the ardent langour of triumphant luxury and beauty, seated as if she lived now, and reclining back in a modern robe, if that term be taken rightly; the abundance of pale gold hair falls about her Venus-like throat, bust and shoulders, and with voluptuous self-applause . . . she contemplates her features in the mirror. . . . The haughty luxuriousness of the beautiful modern witch's face, the tale of a

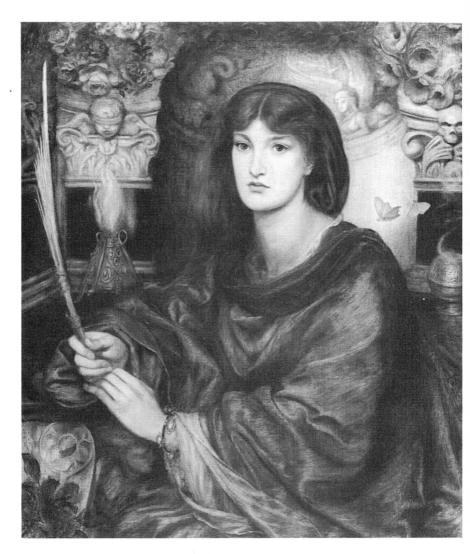

6.7 Sibylla palmifera (1866–70)

cold soul amid all its charms, does not belie . . . the fires of a
voluptuous physique. She has passion without love, and langour
without satiety – energy without heart, and beauty without
tenderness or sympathy for other.[44]

She is body; she is sexuality; she is danger. This text is structured by the
phenomenon of splitting but articulates the anxieties attendant on it.
Passion without love bespeaks an autonomous female sexuality in a

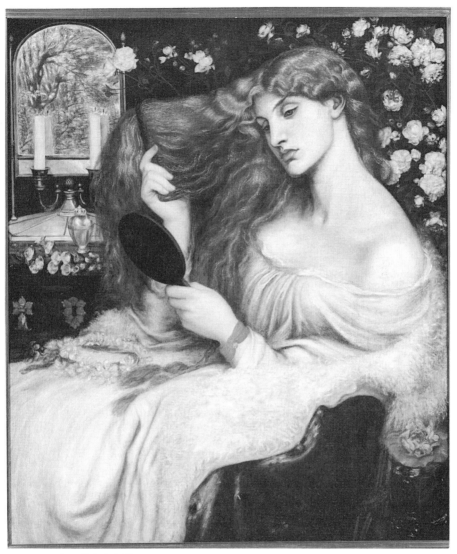

6.8 Lady Lilith (1868)

social system in which love signifies women's submission to legal and
moral control and definition of their sexuality by men. A rapacious
appetite implies that this fantasy female will not confer upon her lover
that gratification of the power of the phallus to fulfil (and again thereby
define) female sexual needs.[45]

It is, however, possible and pleasurable – the prose trembles with
excitement over its evocation of this stultified image – to contemplate

this figure in the safety of the mirror of art. The picture indeed plays with mirrors and gazes. *Lilith* is represented captured by her own image in the mirror which contains a look at the viewer, which could be dangerous for the sexual hierarchy of looking/being looked at would be reversed. An accompanying sonnet, 'Body's beauty', isolates this problematic:

Of Adam's first wife, Lilith, it is told
(The witch he loved before the gift of Eve),
That, ere the snake's, her sweet tongue could deceive,
And her enchanted hair was the first gold.
And still she sits, young while the earth is old,
And, subtly of herself contemplative,
Draws men to watch the bright web she can weave,
Till heart and body and life are in its hold.
The rose and poppy are her flowers; for where
Is he not found, O Lilith, whom shed scent
And soft-shed kisses and soft sleep shall snare?
Lo! as that youth's eyes burned at thine, so went
Thy spell through him, and left his straight neck bent
And round his heart one strangling golden hair.

Named a witch, the term invented for women who contest the patriarchal orders of theological or medical knowledge, Lilith's *spell* works by a penetrating, castrating gaze. The image of a heart strangled by a golden hair can only be described as cutting. Furthermore Lilith defies other regulating orders of nature and time, and thus of woman's bond to the post-Eden body.[46] She is, like Walter Pater's fantasy of the *Mona Lisa* by Leonardo da Vinci, 'young while the earth is old'; the danger of her beauty is eternal[47] and this relates to her evil pre-existing the fall of Eve. Lilith is irredeemable, for she is represented as evil by nature. Indeed in another poem, 'Eden bower', it is Lilith who first seduced the snake. Lilith is primordial in another sense more intimately related to contemporary ideologies. Lilith represents woman saturated by sexuality, never in a state of innocence (recall Hunt's characterization of innocence and virtue). The fantasy realm of mythic *femmes fatales* and goddesses was structured by dominant social relations and discourses on class and gender. Prostitutes for instance were viewed as representatives of a more primitive stage in evolution, a notion supported by anthropologists who viewed contemporary women labelled 'primitive' as virile, highly sexed and promiscuously immoral.[48] Thus dressed up in mythological costume and fine poetry, the Lilith figure of painting and poem stands for the debased but desirably dangerous figure of female sexuality deformed in its representation by the projection of a

144

complex of inconsistent fantasies and fears.

Sibylla palmifera, accompanied by a poem, 'Soul's beauty', is the triumph of the spiritual over the dangerously sexualized mind and body of primitive/working-class women. The class connotations are evoked by the chain of signifiers set in motion by the term 'enthroned' – queens are enthroned, the Queen of Heaven, for instance, the virginal Madonna, the Queen of Hearts, the Queen as the mother-sign in most fairy stories. Yet she is 'enshrined' – dead, but commemorated. This beauty too has a powerful gaze:

Under the arch of Life, where love and death,
Terror and mystery, guard her shrine, I saw
Beauty enthroned; and though her gaze struck awe,
I drew it in as simply as my breath.
Hers are the eyes which, over and beneath,
The sky and sea bend on thee, – which can draw,
By sea or sky or woman, to one law,
The allotted bondman of her palm and wreath.

This is that Lady Beauty, in whose praise
Thy voice and hand shake still, – long known to thee
By flying air and fluttering hem, – the heat
Following her daily of thy heart and feet,
How passionately and irretrievably,
In what fond flight, how many ways and days!

The gaze is petrifying – an image of castration again, but by a curious slippage, this look can be consumed orally, drawn in like breath, the breath of life which can be a metaphor for the milk of life which infants consume in a condition where the pleasures of suckling and being comforted, being satisfied are inextricably bound up with being looked at by the feeding woman. The evocation of the maternal can further be traced in the penultimate line composed only of two powerful adverbs: 'how passionately and irretrievably'. There speaks desire, not sexual lust, but the compulsive pursuit of the forever lost primary object – the pre-Oedipal mother. The reference point here is the work of Jacques Lacan, a French psychoanalyst who challenged the prevailing Freudian interpretations of a linear, developmental schema of infant progress through oral, anal, phallic phases and propounded a theory about the construction and the sexing of speaking human subjects based on orders of meaning. The major orders are the real (on to which the other two are mapped), the imaginary (based on the mirror phase) and the symbolic (the cultural order of language and the psycho-social places assigned to the system's speakers). We are 'accessed' to the symbolic

145

order by the acquisition of language which is predicated on the Oedipal trauma as the latest and most complex moment in a series of splittings and losses to which the child has been subject since being born. The imaginary represents an intermediate phase *between* an infant's state of total dependence, its body an incoherent mass of drives and sensations, without determined boundaries, locations or differentiations from the world and its mother/caretakers *and* its symbolic positioning as speaking subject. In the mirror phase the infant beholds an image – something more complete, perfect, competent, a fantasy and an other from which 'it' must derive its first intimations of a separated, discrete being – an ego. This splitting and imagined separateness we partially overcome by the identifications which define the imaginary order, identification particularly with the mother – as if to say that while separateness looms to threaten the still incompetent infant, a unity can be imagined, the imaginary identification of child as like the mother, thus annulling both separateness and any intimation of difference.

But it must also involve two further points relevant to our discussion. The mother of these identifications also appears in the mirror as image – and the imaginary also depends upon a relay of looks – at the image in the mirror and at an Other who can confirm the meaning of that image. The ego's formation also builds on the second mirror, of the mother's gaze at the child.[49] Although overtaken by the accession to the symbolic order, this imaginary mode is never fully superseded. As Jean Roussel explained in an introduction to Lacan's work in terms which seem especially illuminating about several phenomena in work by Rossetti:

> The imaginary and the symbolic being close correlates, there is always the possibility of regression in man to the imaginary mode, with its hankering after the *super-real, permanent object*. When this happens there is a withdrawal from open exchange of truth in human discourse, and the word becomes a representative of a petrified thing at the service of *the hallucinatory satisfaction of primal desire*. (my italics)[50]

At the beginning of this chapter, I referred to the puzzling conjunction of realism and fantasy. The super-real and hallucination seem highly appropriate to define the way a highly detailed, evocatively coloured, credible but fictional world of representations can satisfy the hankering after the forever lost object. Is this what determines and structures paintings such as *Sibylla Palmifera*, with its static, almost hieratic, presence held at bay by its very monumental stillness and remoteness of gaze (H. Myers)?

146

VI

Lacanian theories of desire and the imaginary introduce a function for the image as a means to regain visual access to the lost object. This is in seeming contrast with the earlier use of psychoanalytic theories of fetishism in images which indicated a need to disavow and keep a distance from a potentially threatening sight and the knowledge of difference that sight precipitates. This conflict is not the only one and some recapitulation may be of use. I began by matching novel pictorial schemes for representation of female heads and mid-Victorian ideological polarization of man and woman as absolute and self-evident opposites. The Rossetti drawings signify woman as visibly different, and the sign woman is equated with a beautiful object to-be-looked-at. At the next level of analysis this phenomenon was examined under the rubric of woman as sign of difference. Beautification functioned as the means to manage the threat and loss upon which sexual difference is constructed. In addition, at this structural, psychic level, the troubled relationship between masculine *sexuality* and sight was proposed. Sexuality, in this theoretical account, is a product of the establishment of sexual difference not an innate capacity or precondition. Sexuality is produced with desire, both predicated upon the patriarchal price of acquiring gender and language – the repression of the mother and the dyadic unity of mother and child. The play of desire within and generated by looking at images is fundamentally contradictory, a) fearful of the knowledge of difference (woman as threat) and b) fantasizing its object (the image of woman as a fantasy of male desire, its sign). The use of psychoanalytic theory not only provides some interpretative tools for understanding the obsessive preoccupation with images of woman and their inconsistent characters, but shifts attention away from iconographic readings to the study of the process of the image, what is being done with it and what it is doing for its users.

In her now rightly famous article referred to earlier in this chapter, Laura Mulvey demonstrated both uses of psychoanalysis. She posed the cinema as an apparatus which managed pleasure for its viewers in accordance with the psychic formations of masculine sexuality within bourgeois patriarchal societies. She argued firstly that the image of woman (note it is a question of an image) 'stands in patriarchal culture as the signifier of the male other, bound by the symbolic in which man can live out his fantasies and obsession through linguistic command by imposing them on the silent image of woman still tied to her place as bearer and not maker of meanings'.[51] But Mulvey also identified the paradoxes of phallocentricism in whose representational systems the pleasures generated by the visual domination and voyeuristic

consumption of images of a female form evoke the anxiety that female form is made to signify within a patriarchal culture. The resulting regime of representation is fetishistic. Fetishism as an avenue of escape and a defence mechanism is imposed upon an earlier pre-Oedipal organization of the drives, the component instincts of sexuality, the prime one of which is scopophilia, love of looking. This love of looking derives, according to Freud, from the pleasure taken by the incompetent and immobile infant in imagining control over another by subjecting them to a controlling gaze. The combination of scopophilia and fetishism, fetishistic scopophilia 'builds up the beauty of the object transforming it into something satisfying in itself.'[52] Mulvey also points out how this process takes place outside of the linear time, suspending the narrative of a film, feasting the eye with a forty-foot close-up of Dietrich's or Garbo's face.[53] Is there not some echo here of Holman Hunt's regret at Rossetti's lack of narrative and his anxieties about gratification of the eye?

The paintings which mark the turning-point from 1858 onwards were increasingly devoid of narrative, relying instead on linguistic messages in the form of titles and poetry inscribed often on the canvas or frame. These word-signs serve as relays not to complete narratives elsewhere but to sonnets, a form which establishes particular positions from which the object in the poem or painting is obliquely viewed, like Medusa's head in a mirror. . . . A position of vision is quite explicit in phrases such as 'lo! there she sits' or 'I saw Beauty enthroned', etc. The positionalities of viewer and viewed enact a specific order of sexual difference and determine whose ordeal is being negotiated. It is not a natural order that men should like to look at lovely women, however much that order has been naturalized. The relations of pleasure in this activity have to be constructed and managed to deal with the attendant dangers when that look is focused on that which signifying differentiation also implicates loss and death.

The peculiarities of anatomical structure only matter within a cultural order which makes variety signify difference, 'a' and 'not a'.[54] The term man is secured as meaningful only in negative relation to another. This occurs in human societies in which the primary bond is between a female caretaker/mother and children of all sexes. Differentiation is dependent upon the introduction into this dyad mother and child of a third term, an Other, a 'father' figure, an authority who can intervene and delimit the mother-child relation. The imaginary phase refers to that moment when the child is forced to intimate its own separateness on two registers – of its mother's body from itself and of itself as a discrete entity perceived firstly as an image in another place, a mirror. The discovery is compensated for by identifying with the mother, imagining

148

oneself to be like her. It is the confrontation with what the culture defines as two different terms, mother and father, which precipitates the crisis Freud called Oedipal. Once difference is introduced to shatter the imaginary unity of mother and child, the child is forced to adopt a position relative to these terms of difference, i.e. to take up a position as masculine or feminine subject, and give up the mother for a substitute object. Within a patriarchal system difference is ordered in the name of the father. The attributes of the father function as props for the signifier of difference, the phallus which as a result signifies both power/presence *and* loss/absence. It is also the signifier of desire, which is produced at this moment of loss of unity with the mother. Sex is therefore acquired at the price of the repression of the mother and submission to the law of the father. Masculinity is shaped by the ordeal and femininity is produced as its sign. This schematic scenario is highly abstract. Indeed as in the case studies undertaken by Freud the hypotheses are construed from life stories which demonstrate the variability of each trajectory through this formation and its instability. Organized negotiation of the pressures and limits of psycho-sexual formation are the substance of the pleasures and purposes of a vast amount of cultural production.

Earlier in this essay I stressed the methodological issue of replacing interpretation of meanings in paintings by examination of the work being done through their production and consumption. It might seem that I have reneged on that commitment by using psychoanalysis to explain the typologies and even the stylistic and material properties of the works in question. Psychoanalysis has not been used here as a key, but rather as a means to identify the process of psychic formation under a specific social and ideological order. The practices of representation are both shaped within such processes and contribute to their ceaseless reproduction. But if they are sites for the production of meanings and their attendant positionalities they can also be sites for their negotiation. Thus when I asked why the bourgeois male buyers of these paintings liked to look at them, I had in mind the possibility that the paintings would both function within prevailing ideological fields (intimated for instance by the Ruskin and Hunt texts quoted above) and also permit some journey across their symbolic boundaries. The Lacanian account of the potential slippage between the two orders of meaning constitutive of our making as subjects enabled me to articulate that process.

VII

To make this point plainer I want to turn to one final painting, *Astarte Syriaca*, 1877, painted from yet another facial type, that associated with Jane Burden Morris, which is characterized by a wealth of dark, crinkly

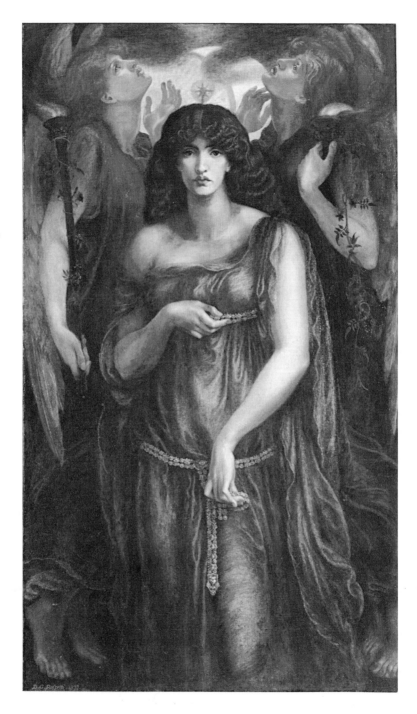

6.9 *Astarte Syriaca* (1877)

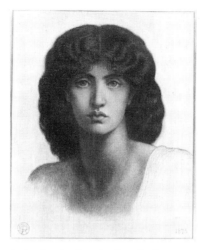

6.10 Study for the head of
Astarte Syriaca (1875)

black hair, large eyes under heavy and continuous brows and a hugely
exaggerated red mouth. The *Astarte Syriaca* (Figure 6.9) is the image of
the Syrian goddess of love which breaks the mould of the Rossetti work
in both the 'Cornforth' and 'Wilding' typologies. The figure is upright,
seen almost full length, as if striding towards the viewer out from her
pictorial space.

The 'Morris' face dominates production by Rossetti in the 1870s. Its
features were subjected to extreme schematization and symmetry. This
is vividly shown in a preparatory pastel drawing dated 1875 of the head
of the Astarte which was made by Rossetti into an independent work
(Figure 6.10). It epitomizes the development of the face-object adum-
brated in the drawings of the 1850s discussed at the beginning of the
chapter. Here a head floats on a field of blank paper, severed from its
body, a flat, perfect object of a face. But the difference between this
format and the effect of the face reunited with its mobile body in the
final painting is striking and revealing. The face of the Astarte figure is
more charged with expression. It appears as if Astarte looks down upon
a spectator/subject/worshipper who is positioned in subordination to
this towering and monumental figure. Here the question of scale is vital
for it dramatically removes the viewer from a voyeur's intimacy with the
private space characteristic of *Bocca baciata* for instance. The relations of
looking are reversed in a manner reminiscent of medieval cult images
where the image as icon was endowed with the power to look upon the
viewer. Some art historians have found *Astarte Syriaca* a cruel and

frightening image of love,[55] obviously reading it as a kind of *femme fatale*. I would like to propose an entirely opposite reading, seeing in its scale, active posture and empowered glance an image which transcends the stalemated, fetishistic quality of so many of the images previously discussed.

In an essay on 'Woman and the literary text' John Goode examined the ways in which literary analysis could be useful to feminist studies. Working against any tendency to reduce a literary text to something outside itself – be it history or intellectual trends (or artistic personalities), he stressed the necessity of analysing the *articulation* of the text – or the manner in which as text it transforms the materials which are its subjects. He furthermore distinguishes between two kinds of coherence which we can perceive in texts – an ideological coherence, where the material/representation remains untransformed, unexposed, familiarized; and a fictional coherence where we become 'conscious of the sense of ideology itself, shaping, motivating the representation'.[56] At that point, as I shall argue in the case of *Astarte Syriaca*, the dominant ideological structures within which the fetishistic regime of representation is founded are exposed and the viewer is positioned against the patriarchy.[57]

In one section of the essay Goode deals with images of dangerous women, discussing George Macdonald's novel *Lilith* (1895) and also H. Rider Haggard's *She* (1887). Goode reads *She* as a novel about the ordeal of masculine sexuality of which Ayesha, She, is the primary cause and also its liberation. The tale is about a desiccated and misogynist academic, Holly, and his young companion Leo Vincey, who set out to avenge the murder of Vincey's forebear Kallicrates by Ayesha.

The narrative soon gives way to metaphors of sexual struggle which make plain the nature of their project as a 'crusade against female power over man'. 'She' rules a matrilinear society where women choose their sexual partners non-monogamously. Like Lilith, working-class prostitutes and 'primitive' peoples, they embody a female sexuality antipathetic to the bourgeois regulations institutionalized as femininity. When Ayesha appears she does not, however, symbolize the anticipated and primordial evil. 'She' embodies an alternative principle of knowledge based on love, through which she aims to revolutionize the world. 'She' dies, however, in the flame through which she hoped to gain eternal life (compare Lilith's dangerous eternity). The ideological necessities of the order within which the novel is produced demand that this transgression of eternal law be punished by death: 'She' cannot be allowed to succeed. But Goode argues that what makes *She* a fine novel is that the fictional characters Holly and Vincey and thus the readers are estranged by the novel from that ideological law:

The journey outward becomes not release from the past (the revenge intention) but a journey back to that past to reveal the puniness of male fear and its comfortable accommodation within eternal law, so that there can be no return journey. . . . *She* is a fine novel because it brings us (the readers) to ask the repressed question of its project: what does the destructive woman destroy, ourselves, or ourselves' subjugation?[58]

The fictitional trope of a return journey serves the fantasy of regression to a moment prior to the fixing of the patriarchal law which demands subjugation to an order that denies the primary object of love on pain of loss of self/death and initiates unfulfillable desire. *She* reveals the price exacted by the patriarchal ordering of sexuality, the incompatibility of love and desire.

I want to suggest that, momentarily, *Astarte Syriaca* also appeals to that realm of fantasy and achieves a similar order of fictional coherence. It raises to a visible level the pressures that motivated and shaped the project of 'Rossetti' – the negotiation of masculine sexuality in an order in which woman is the sign, not of woman, but of that Other in whose mirror masculinity must define itself. That other is not, however, simple, constant or fixed. It oscillates between signification of love/loss, and desire/death. The terrors can be negotiated by the cult of beauty imposed upon the sign of woman and the cult of art as a compensatory, self-sufficient, formalized realm of aesthetic beauty in which the beauty of the woman-object and the beauty of the painting-object become conflated, fetishized. But on occasions some works transcend that repetitious obsessive fetishization and image a figure before which the masculine viewer can comfortably stand subjected. The Syrian Venus, in scale, activity and gaze constructs a fantasy image of the imaginary maternal plenitude and phallic mother. But the majority of female figures in the oeuvre of Rossetti do not function this way. Like the goddesses of the Hollywood screen they take on an iconic fascination of being seen, while *unseeing*. Rossetti's paintings trace a journey where Woman is obsessively pursued but where woman as woman rarely appears. Woman as sign is a function of a struggle to accommodate to the order of sexuality in process of being established, but an order which is constantly threatened by the return of the repressed, by the regression to the imaginary, a regression characterized by the hankering after the super-real permanent object – a desire that was to be better fulfilled in the frozen, unchanging 'here' and 'thenness' of the still photograph, or the cinematic close-up, both of which rapidly superseded the function of the painting in dealing with these areas of representation and sexuality.

The dominant tendency to become obsessed with the fetishized image, the petrified 'face-object', functioned on the axis of social and sexual regulation of the emergent bourgeois order in mid-nineteenth-century Britain. Rossetti and the circle of intellectuals and artists with whom he mixed negotiated on behalf of that order the accommodation of masculine sexuality, effecting an ideological form of representation on behalf of the class they served.[59] The texts they produced inscribe the struggle to adjust to a social order instated at the level of the psychic formation of sexuality – and usually addressed by the management of the gaze and viewing positions. This is therefore a question of sexuality and the mode of representation. Rossetti's works predate Freud and the Hollywood cinema. But out of the same formations and its ordeals came both the analytic theories of Freud and the representational project of classic Hollywood cinema.

7

Screening the seventies: sexuality and representation in feminist practice – a Brechtian perspective

You should have a practice in art that actually looks forward to a moment that will be different. I think that's the point that we haven't actually grasped. Critics look at a work and they say, 'That's only a negative deconstructive understanding of personal experience', without seeing what the work as a whole represents in terms of a positive view of social change and what art could be in the future.

> Mary Kelly interviewed by Monika Gagnon, *C Magazine*,
> 1986 (10), 24

I

In September 1985 an exhibition entitled *Difference On Representation and Sexuality* opened at the Institute of Contemporary Arts in London. It was undoubtedly a major feminist event and the show featured work by women and men: Ray Barrie, Victor Burgin, Hans Haacke, Mary Kelly, Silvia Kolbowski, Barbara Kruger, Sherrie Levine, Yve Lomax, Jeff Wall and Marie Yates.[1] Supported by a film and video programme, this exhibition had first been seen at the New Museum of Contemporary Art in New York in December 1984. Curator Kate Linker opened her foreword to the catalogue with this statement:

Over the past ten years, a significant body of work has explored the complex terrain triangulated by the terms of sexuality, meaning and language. In literature, the visual arts, criticism, and ideological analysis, attention has focused on sexuality as a cultural construction, opposing a perspective based on a natural or

'biological' truth. This exhibition charts this territory in the visual arts. It presents work by its main participants. And it explores the radical implications of this approach. Its thesis – the continuous production of sexual difference – offers possibilities for change, for it suggests that this need not entail reproduction, but rather a revision of our conventional categories of opposition.[2]

The *Difference* exhibition sustained a critical concept of artistic practice and cultural politics generated during the 1970s in contest with the crumbling hegemony of American modernism and the New York galleries and institutions at the centre of the capitalist west's art industry. In the current climate of what has been termed the 'post-modernism of reaction' these practices have been marginalized. The show itself was a statement of refusal to permit such obliteration of the critical project of the 1970s in the present financial and curatorial celebrations of born again painting and expressionism.[3] For not only does the new expressionism reintroduce the unquestioning sense of the Grand Tradition, it significantly defines art and its creative processes and materials as exclusively masculine. Witness the total exclusion of women from the celebratory event housed in London at the Royal Academy in 1981, *The New Spirit in Painting*.[4]

Although the work presented in the *Difference* exhibition could only be read as in conflict with such traditionalist revivals of painting and its expressive ethos, there are some radical critics who have expressed reservations about the theoretical resources and strategies of representation employed by artists such as Burgin, Kelly, Barrie, Lomax and Yates. It is precisely the triangulation of sexuality, language and meaning through the use of Lacanian psychoanalysis which has become contentious.[5] For instance in the introduction to a series of his essays on contemporary art and culture Hal Foster worries that 'due to its adversarial stress on the Lacanian definition of the Oedipus complex in terms of the Name-of-the father, the specificity of patriarchy as a social formation and as an everyday practice is sometimes lost'.[6] This then leads to a potential contradiction between 'its political desire to transform social institutions and its historical pessimism regarding patriarchy. . . . This art does indeed demonstrate that the subject is produced socially, but it is not enough to say that its patriarchal structures are thus "subject to change" when no strategies for change are offered and when these structures are presented as all but trans-historical and urpsychological.'[7] Admitting none the less the importance of this area of work Foster adds one final caveat. He is worried about the 'fascination with the representations it impugns' and further that feminist insistence on the social construction of sexual difference

and the role of 'woman as sign' has been overargued.

There clearly is a political worry about the use of psychoanalysis, the deconstructive work on representations and feminist cultural politics involved. But what is missing from the way in which these issues are being discussed in the 1980s is a historical understanding the political motivation for these strategies grounded in specific developments in the 1970s. One major omission from the current terms of analysis of these British practices is the recirculation in the early 1970s of the theories and practices of the German dramatist, film-maker and cultural theorist Bertolt Brecht through the pages of the British film magazine *Screen*.

II SCREENING THE SEVENTIES

I want to start with boys.[*] In 1980 *Screen* magazine made a foray into art history, inviting T. J. Clark to publish one of the versions of his study of the painting *Olympia* (1863) by Edouard Manet. The polemical orientation of his arguments about the founding practices of modernism were made explicit in the final sections. He projected from what he took to be Manet's failure to sustain a radical critique of bourgeois ideologies what would be necessary for a painting to accomplish such a position.[8] In the following issue the film-maker and theorist Peter Wollen published a reply to the Clark essay in terms which openly suggested a rematch of the famous debate between Bertolt Brecht and George Lukacs in the 1930s on the political merits of realism versus modernism.[9] Wollen accused Clark of negating the modernist project in all its guises by seemingly calling for a return to realism. (Clark later refuted this.) None the less the misunderstanding occasioned from Wollen a defence of contemporary artists working within a radical or political modernism, taking its cues from the theories of Bertolt Brecht. Wollen attacked Clark's argument as 'an attempt to undermine the whole paradigm of modernism and, specifically the aesthetics of its radical avant-garde sector. This surely is to turn one's back on the whole history of political art this century.'[10]

Wollen also took Clark to task for ignoring feminist theorizations of sexual difference and their use of psychoanalytical analysis of the look and subject positions which were being so productive in British critical

[*] It is no coincidence that my point of entry for this debate should involve writers, texts and issues which have figured earlier in the book. Their conjunction in the pages of *Screen* in which Clark's essay appeared was undoubtedly a boys' issue, with papers by Clark, John Ellis and Victor Burgin all addressing issues put on the agenda by feminism, but taking control of the debate. The girls' issue followed up but it was also dominated by the boys – Willemen's reply to John Ellis, 'Dear John', and Wollen's to Clark.

culture at that date. In a significant passage Wollen makes indirect reference to two of the major projects of this cultural fraction, *Riddles of the Sphinx*, 1977, a film by Laura Mulvey and Peter Wollen, and *The Post Partum Document*, 1973–9, by Mary Kelly.

> There is a passage in Timothy Clark's essay where he imagines a picture in which 'the production of a sexual subject' would be depicted in a 'particular class formation'. This is indeed *the* picture (if it is a picture rather than some more complex form of art) which it is important to think about. Within my terms this is a picture about, not Woman, but the production of woman as a fetish in a particular conjunction of capitalism and patriarchy. . . . Such a picture would not identify 'Woman' or any particular woman but would confront the underlying mechanisms which produce the sexual discourse within which women are placed. Consequently when Timothy Clark asks 'Do dis-identificatory practices matter?' the answer must be 'yes'.[11]

Dis-identificatory practices refer to the strategies for displacing the spectator from identifying with the illusory fictional worlds offered in art, literature and film disrupting the 'dance of ideology' which engages us on behalf of oppressive regimes of class, sexist, heterosexist and racist classifications and placements. Although such strategies were associated with *Screen* theories deriving from semiotics and psychoanalysis Wollen clearly made the link with Brecht and he saw Clark invoking realism as the opposition to the modernism associated exclusively with American and Greenbergian definitions rather than looking to the political deployment of another modernism associated with Brecht.

This little exchange may seem somewhat dated when the postmodern is so much to the forefront of our critical debates and a defence of modernism, Brechtian or otherwise, may seem, if not quaint, positively reactionary. However much we may concede that the postmodern condition is now our inescapable horizon, the issues raised by our recent history in the 1970s are not thus superseded. Indeed specific historical knowledge is a vital defence against postmodernist suspension of history. Even in radical critical circles this takes the form of an over-emphasis for instance on the psychoanalytic theory used by certain artists at the expense of an understanding of the political reasons for its strategic use in the struggle against sexual oppression.

But what has this debate to do with feminism?

The site of the debate was the representation of the body of woman. Clark addressed, as a canonical modernist painting, *Olympia*, without a serious pause to question why modernism is installed upon the territory

of a commodified female body let alone consider the sexual politics of his position as a writer.[12] Wollen was easily able to dismiss Clark's obstinate puzzlement about the inconsistencies of the painting's signifying systems in relation to the signification of sexuality, but he was able to do so by referring to feminist work on psychoanalysis, to feminist theses about the representation of woman, fetishism and the gaze. (It is important to note that neither deal with the dimension of race, so central to the sexual representation and meanings within *Olympia*.) The central text articulating this problematic is of course by Laura Mulvey, *Visual Pleasure and the Narrative Cinema*,[13] which identifies as a major trope of the cinematic apparatus an active mastering gaze subjecting the passive image of woman, fragmented, or dismembered, fetishized and above all silenced. Although widely used Mulvey's argument has never been fully developed in relation to modernist representation in the visual arts. Why do the canonical works articulate precisely these power relations, a monological masculine discourse conjuring up the fetish of a female bodily presence and vocal absence? Think not only of *Olympia* but *The Demoiselles D'Avignon* (Picasso) and de Kooning's series *Woman*. In Carol Duncan's and Alan Wallach's substantial essay on the itinerary to which the visitor to the Museum of Modern Art (MOMA), New York, was subjected by the lay-out of the galleries exhibiting the permanent collection of modern art, they suggested it functioned as a ritual and an ordeal based upon an encounter with the great goddess or Mother Earth repeatedly conjured up by the grand works of the modern tradition.[14] Their insight needs to be reformulated to recognize modernist painting not exclusively as the heroic struggle for individual expression or the equally painful discipline of purification and stylistic innovation but as a more fundamental discourse around the paradoxes and anxieties of masculinity which hysterically and obsessionally figures, debases and dismembers the body of woman. As Angela Carter said, 'Picasso liked cutting up women'.

Modernism is to art history and practice what the classic realism of Hollywood cinema is to film theory. We need a similarly comprehensive theorization of the sexual politics which it inscribes. To produce this we need to engage with theories whose primary object is the manufacture of sexual difference. Going beyond offering feminist readings of individual modernist paintings or oeuvres we need to analyse the systems which generated them. Modernism is structured around sexual politics but these are displaced by the manifest content of modernist discourse, the celebration of creative masculine individualism. The figure of the artist always assumed to be masculine in critical and economic practices around art is matched by the sign woman which is its signifier within representational systems. This is as pertinent in

figurative art as in those works that claim to investigate nature or the cosmic void – the polarities are always gendered and hierarchical.

What I have been suggesting might well imply that feminism must automatically be anti-modernist. There have been feminist critics who argue just this. For instance writing in the *Art Journal* in 1980 the leading American feminist critic Lucy Lippard claimed that feminism's greatest contribution to the future vitality of art precisely lay in its lack of contribution to modernism and she claimed, that

> Feminist method and theories have instead offered a socially concerned alternative to the increasingly mechanised evolution of art about art. The 1970s might not have been pluralist at all if women had not emerged during the decade to introduce the multi-colored threads of female experience into the male fabric of modern art.[15]

At the conference held in Vancouver in 1982 Nicole Dubreuil Blondin addressed the antipathy between modernism and feminism by analys-ing Lucy Lippard's trajectory as a critic. She concluded that while feminism was anti-modernist it provided in some senses the paradigm for postmodern art. She suggested that the woman paradigm in art could be seen as the model of rupture, the total other that would finally reconcile aesthetics and politics. Yet there was a common link between feminism and other practices: 'Is not the avant-garde undergoing profound changes in its postmodernist phase, its new configurations corresponding exactly to the problematic of women's art?'[16]

Cutting right across the modernist/anti-modernist and the modernist/postmodernist axes was an article published in *Screen* in 1981. Mary Kelly offered a complex analysis of several major aspects of modernist criticism and practice but crucially positioned feminist practices as a dialectical force breaking through the paradoxes of the late modernist field of which they were in part an effect. Kelly identified three critical areas which had become characteristic of later modernist discourses and were the territory for a feminist intervention across that terrain: materiality, sociality and sexuality.

Materiality: a doctrine of 'truth to materials', or the Greenbergian claims that the character of painting for instance should be determined by the nature of its material medium, represent a modernist stress on materiality. Analysing art from a *historical* materialist position involves admission of the social character of artistic activity taking place within specifiable conditions of production and consumption. Meanings are furthermore considered as being generated through social and historically variable signifying systems. In place of the utopian claims for personal expression and universal understanding by means of the

power of the material or medium of artforms typical of modernist theory, feminist materialism recognizes a textual politics – an interrogation of representation as a social site of ideological activity.

Sociality: indicates an emphasis on the contexts of artistic production. During the 1970s there were various attempts to explore the limits of art institutions, such as galleries which defined what is and what is not art. While attempting to defy the consumption of art as commodities in the art market, new forms of art such as performance, land art, conceptual art, body art and so forth were of limited effectivity. They lacked analysis of art as an institutional practice. While museums, owners' homes, forecourts of banks and big corporations are merely seen as contexts of use which come after the discrete moment of private creation in the studio, artists continue to dream of some means of protecting their art from these 'abuses'.[17] But the studio and the gallery are not separate. They form interdependent moments in the circuits of production and consumption of culture under capitalism. Therefore Mary Kelly argues that the sociality of art is 'a question of institutions which determine the reading of artistic texts and the strategies which would be appropriate for interventions'.[18] Feminist interventions are moreover empowered because they will place art and its institutions on a continuum with other economic, social and ideological practices. Founded in the political struggle of the women's movement with its comprehensive social critique, feminist cultural practices index artistic activity to the social world in which culture is becoming an increasingly significant level of social regulation and ideological consumption.

Sexuality: this item is paramount within feminist theory but there are distinctions to be made between different uses of the term. Since the 1960s sexuality has been a privileged issue in libertarian politics. This legacy informs one thread of feminist culture in which women's claims for an autonomous and self-defined sexuality have almost become a metaphor for our total struggle for personal liberation. In the works of Judy Chicago, for instance, the woman's sexualized body functions as the sign of the reclaiming of women's essential identity and integrity. Sexuality is understood within this tradition as a quality or attribute, innate, essential and liberating; in Foucault's phase, 'the truth of our being'.

Countering this discourse is a notion of sexuality compositely fashioned from the Lacanian rereadings of Freud by Lacan and the historical project of Michel Foucault in which the potentially oppressive socio-psychic production of sexuality is stressed. Sexuality is perceived as an effect of social discourses and institutions (Foucault).[19] Artistic practices have also been implicated in the manufacture and repetition of sexual positions in the way that they manage desire and pleasure, fuel

fantasies and situate the viewer. Feminist practices have insisted upon the recognition of gender specificity in art as elsewhere but selected practices have addressed precisely the way in which the sexing of subjects and the production of sexual difference are effected and renegotiated in the ceaseless circulation of visual and other representations.

Thus we are back with psychoanalysis, language and meaning and Hal Foster's criticism. But the interrelations of the three levels Kelly identifies indicates an artistic practice of some complexity. At once the social is redefined in terms of textual practices through which both meanings and the positions from we find those meanings normal are manufactured. Yet the textual is also discovered as material, existing not as a discrete, spiritual phenomenon (e.g. the embodiment of creativity or the human spirit as in many conventional art theories) but functioning within economic and social institutions productive of both commodities and ideologies. Within and across both these axes the question of the production of sexual difference insists, demanding varied forms of analysis which seemingly direct us away from the concrete social into the realms of theory and psychoanalysis. But the political purpose is paramount with the intention to expose critical areas wherein we are being produced according to the sexual hierarchies and social divisions constitutive of patriarchal and capitalist social relations.

Screen magazine was a major resource for critical cultural practices in Britain in the 1970s far beyond the confines of film-making and film studies. Indeed the appearance of Clark's article on its pages signalled a momentary alliance with radical sectors of art history and the visual arts. Mary Kelly was put on to the editorial board in 1979 and Griselda Pollock in 1980. The magazine is typically associated with the dissemination of European developments in the theory of semiotics (Saussure), of ideology (Althusser) and of the subject (Lacan).[20] The strong interest in Brecht is often overlooked. Through the example of Brecht many political artists found an archimedian point outside proliferating postmodernist pilferings of other moments of art's history by providing access to a modernism erased from history by the selective tradition peddled by the Museum of Modern Art, New York, and modernist art history. The legacy of Brecht moreover qualified the uses of post-structuralism, psychoanalysis and semiotics by providing a bridge between political engagement and a commitment to develop artistic strategies which could have a political effectivity within the sphere of culture. As a result of Marxist and post-structuralist arguments the cultural level broadly defined was being recognized as strategically significant in the late capitalist world.

At the same time there can be no doubt that Brecht was being re-read in terms of the contemporary theorizations of ideology, language and

subjectivity. Yet Brechtian theory and practice insisted upon a political baseline to debates. This explains why politicized artists in this period could negotiate the play between materiality, sociality and sexuality.

The interest in Brecht was fuelled by translations into English of a number of key texts which had only recently come to light, such as the essay 'Against George Lukacs' which first appeared in English in *New Left Review* in 1974. *Screen* devoted two issues to Brecht and Cinema.[21] In his paper to the Brecht event in Edinburgh in 1975 Stephen Heath stated:

> The problem, the political problem, for artistic practice in its ideological intervention, could be precisely the transformation of relations of subjectivity in ideology.[22]

How does one get from Brecht to that formulation?

Perhaps one of the most well-known of Brecht's strategies is that of 'distanciation' or 'defamiliarization', one of the foundations of 'dis-identificatory practices'. The point was to liberate the viewer from the state of being captured by illusions of art which encourages passive identification with fictional worlds. For Brecht the viewer was to become an active participant in the production of meanings across an event which was recognized as representation but also as referring to and shaping understanding of contemporary social reality. Distanciation is not a style or aesthetic gambit but an erosion of the dominant structures of cultural consumption which as Heath ingeniously pointed out in another article in *Screen* are classically fetishistic.

> Fetishism describes as we have seen, a structure of representation and exchange and the ceaseless confirmation of the subject in that perspective . . . which is that of the spectator in a theatre – or a movie-theatre – in an art of representation. It is this fixed position of separation-representation-speculation (the specularity of reflec-tion and its system of exchange) that Brecht's distanciation seeks to undermine. . . . In Brecht's own words, it is a question of 'creating new contact between stage and the auditorium and thus giving a new basis to artistic pleasure'.[23]

In the fetishistic regime the viewer is at once separated from what he/she is seeing but enthralled into identification with an imaginary world in which threatening knowledge is allayed by beautiful images.[24] Brechtian distanciation aims to make the spectator an agent in cultural production and activate him or her as an agent in the world. The double edge of distanciation theory feeds at once into structuralist insistence on the active role of the spectator-viewer[25] and into post-structuralist

semiotics which stresses that meanings are produced for and secure subject positions.[26] The formalist issues may seem far from Brecht's project of political mobilization. The bridge was built out of the theory of ideology advanced by Althusser.[27]

According to his formulation our sense of who and what we are – i.e. as subjects in the philosophical sense – is not innate and does not precede our access to language and thus society. Subjectivity is constructed through representations circulated by society's major institutions of social reproduction, the family, the school, the church, advertising, culture, i.e. the ideological state apparatuses. These are systematically but independently organized to hail us as their subjects. The word subject has a double meaning. We are subjects in the grammatical sense of being an agent, but we are also subjects in the legal sense, for example subjects of the Queen, i.e. subjected to an authority or system of meanings. Thus political struggle must engage both these social practices which constitute us as social individuals, subject of and for a social system.[28] The relations of subjectivity in ideology have to be transformed at the points of their production. Cultural representations are a significant site.

> We come back here to our discussion of ideology; ideology is not to be replaced by some area of pure knowledge; rather, from within ideology, art, as realism in Brecht's sense, attempts to displace those formations of ideology by posing the specific relations of those formations in the mode of production.[29]

In addition to distanciation Brecht signifies a critique of realism. As Marxists both Brecht and Lukacs were committed to epistemological realism, the premiss that social being determines social consciousness.[30] But they diverged radically over tactics for a mode of representation adequate to provide politically effective knowledge of that social reality. Lukacs privileged forms of literary realism associated with the realist tradition of Balzac and Tolstoy, specifying what Brecht saw as an anachronistic formula. For Brecht each historical movement and social group had to discover its own appropriate strategies and these must be of a complexity adequate to their critical and instructional project.

> Thus Brecht stands against the Lukacsian vision of modernism as *decadence* – the breaking up of traditional forms as barbarism – in the interests of an avant-garde activity of the exploration of reality in the production of new forms of its definition.[31]

Against literary realism, Brecht turned to modernist defiance of the traditional forms and encouraged the use of montage, disruption of

narrative, refusal of identifications with heroes and heroines, the inter-mingling of modes from high and popular culture, the use of different registers such as the comic, tragic as well as a confection of songs, images, sounds, film and so forth. Complex seeing and complex multilayered texts were the project. Distanciation is therefore the theoretical and practical result of this critique of realist representation and a device for achieving a different form of realist knowledge actively involving the spectator in its production and its translation into action.

III

What is feminism's relation to this debate? Necessarily alienated from MOMA's modernism, but also challenging dominant modes of realist representation which naturalize bourgeois hierarchies and service masculine fantasy, feminism is none the less committed, epistemologic-ally, to realism. Political change must come through concrete social struggle in the real world. Much feminist cultural activity was, however, initially realist in an uncritical way. The concern to speak about, docu-ment and investigate women's lives, experience and perspectives found immediate expression in documentary films and photography projects, as well as in figurative imagery in the visual arts.[32] There is no doubt a tactical importance in the construction of women's lives and histories with which the alienated woman spectator can enthusiastically identify as part of a political process known as consciousness-raising. But as feminists soon discovered the desire to make visible could not of itself produce knowledge. Vision may only confirm ideologically sanctioned perceptions of the world or at best simply invert them; as Heath says: 'Reality is to be grasped not in the mirror of vision but in the distance of analysis, the displacement of the ideology that vision reflects and confirms.'[33]

Thus feminist artists concerned to explicate the character of women's oppression within classed and racially divided patriarchal societies cannot be content to describe its appearances and symptoms. Structural determinations need to be excavated and tracked through their articula-tion in representation. Brechtian notions of radical art as non-unity, as a many-faceted collage/montage which is open to the play of contradic-tions inspired new ways of making art works, in performance and time-based works, installations, videos, scripto-visual multiple projects.

> Hence art – art as specific intervention – is not unity but contradic-tion, not reflection but construction, not meaning but interroga-tion, is lesson and action . . . in short must pose questions which render action possible.[34]

7.1 Women and work: a document on the division of labour in industry
(1975) Margaret Harrison, Kay Hunt, Mary Kelly
(a) Installation

(b) Hourly-paid women employees

One of the most telling feminist products of that theoretical and political conjucture was the *Post Partum Document* by Mary Kelly made over the period 1973–9 and comprising six parts and 135 units. Currently this work is almost exclusively positioned in relation to feminist interest in psychoanalytic theory. Although this was a major resource and, it must be stressed, point of critique in the work, the conditions of its production and the nature of its intervention will be seriously misunderstood without reference to the historical conjuction out of which the project came.

7.1 *Women and work: a document on the division of labour in industry*
(1975) Margaret Harrison, Kay Hunt, Mary Kelly
(c) Detail of the work processes of women

```
                               7:00 AM: GET UP, GET FAMILY
 6:00 AM: GET UP, MAKE                  READY FOR SCHOOL & WORK
          BREAKFAST            9:00 AM: WASHING, CLEANING
 6:45 AM: LEAVE HOME          10.30 AM: GO SHOPPING
 7:30 AM: START WORK, GET     11:45 AM: PREPARE MEAL
          LINES READY         12:30 PM: SERVE MEAL
 8:00 AM: MACHINES START,      2:00 PM: CLEAN WINDOWS
          KEEP MACHINES RUNNING 4:00 PM: PREPARE MEAL FOR EVENING
12:30 PM: LUNCH, RING WIFE     4:30 PM: MAKE TEA FOR SON
 1:30 PM: START, INSPECTION,   4:45 PM: LEAVE FOR WORK
          GENERAL SUPERVISING, 5:30 PM: START WORK
          LABOUR, PRODUCTION   9:30 PM: FINISH WORK
 9:30 PM: FINISH WORK          9:45 PM: GET HOME, WASH UP
10:00 PM: GET HOME, LIGHT MEAL          HAVE TEA
          CHAT WITH WIFE      10:45 PM: GO TO BED
12:00 PM: GO TO BED

                              EILEEN SZMIDT, AGE 46
CLIFTON McKINSON, AGE 32      4 SONS   1 DAUGHTER
1 SON AGE 10   4 DAUGHTERS    AGES 25, 24, 21, 19, 14
AGES 7, 6, 4, 2
                              DOUBLE SEAM OPERATOR
SECTION FOREMAN               PART TIME   5:30 PM - 9:30 PM
```

(d) Work diaries

It needs, therefore, to be placed within its own history. In the period 1970–2 Mary Kelly took part in the making of *The Nightcleaners*, a Brechtian film partly made in support of the unionizing of low-paid women workers in contract office cleaning and partly made as a critique of the campaign and of documentary.[35] Interest in unionization led to involvement with the newly founded Artists' Union. In May 1972 Mary Kelly was elected its first chairperson. Women in the Union established an active Women's Workshop out of which a major project emerged. *Women and Work*, 1975, was a collaboration between Margaret Harrison, Kay Hunt and Mary Kelly to investigate the impact of the Equal Pay Act of 1970 on the workers in a Metal Box factory in Southwark, London. This Act, which had taken over one hundred years of campaigning to get on the statute books, had specified a five-year period for its implementation. The project was to investigate the real effects of the legislation for working women.

The exhibition defied the conventions for both documentary representation and art exhibitions. It was an installation composed of photographic panels, statistical tables, split screen films, talking phones, copies of recent legislation and official reports and so forth (Figure 7.1). This graphically revealed not a steady progress towards equality, but a calculated restructuring of the workforce and redefinition of skills whose effect was to segregate women more rigidly into low-paid, low-skill categories. Still and moving photography were skillfully juxtaposed to make visible these structural differences. Women's jobs could be adequately represented statically by showing nothing more than hands at work at a machine while men's jobs typically involved movement within a complex and changing spatial environment (Figure 7.1(c)).

In one section men and women had been asked to provide accounts of a typical working day. The results were juxtaposed on a large panel (Figure 7.1(d)). For women, work was what happened around the dead time of paid employment; it had no limits and there was no real division between labour and leisure. But this time and work clearly mattered. The revelation of a sexual division of labour as something happening in the home as well as the factory was nothing new for feminist analysis. But the emotional investment of women in the areas of work associated with child care had not been acknowledged or analysed. Indeed it tended to be dismissed as the major source of women's oppression. The *Post Partum Document* (hereafter *PPD*) was generated as an investigation of that interface between what is conventionally accepted as the social and the hitherto unexplored psychic realities structured through the social division of labour in the so called private spaces.

In 1974 *Psychoanalysis and Feminism* by Juliet Mitchell introduced into

168

anglophone communities an interest in psychoanalysis typical of French feminist groups. The book was both a symptom of and a major force behind the revision of the feminist slogan, 'the personal is political'. From the initial affirmation of subjective experience reported in consciousness-raising groups, feminist theorization of the personal elaborated an analysis of the formation of the subject through social institutions, the family for instance, mediated by the most pervasive of all social institutions, language. Sexual positionality was therefore posed as a simultaneous effect of social and psychic induction in the order of culture, enshrined in language.

The question raised therefore was not only how are human infants made subjects of and to their culture but what is happening to women in their overdetermined relation to the privileged site of that process – child care. While the major but not exclusive theoretical framework of the *PPD* was a revision of the psychoanalytic schemata of Lacan, the representational strategies were informed by the Brechtian uses of montage, text, objects in a sequence of sections which actively invent the spectator as someone who will engage, remember, reflect and reconstitute the traces of the relationship between mother and child which is the document's material. The end product is a new understanding of the passage of the mother and the child through the reciprocal process of socialization as feminine and, in this case, masculine subjects.

The mother and child relation in its social and psychic interplay cannot be pictured for it is a process, like the dream or a fantasy of which we can have knowledge only through its traces, its coded signs. Thus present in the document are objects such as nappy liners, comforters, casts of tiny hands, gifts, words. Like fetishes these are the inanimate signs of the social relation which produced them and for which they bear symbolic meaning. They become therefore clues to that unspoken and hitherto unrepresented realm of meaning and fantasy of the feminine. The physical presence of woman fetishized in modern western art is thereby replaced by another order of presences accompanied by the discourse of and from the place of the traditionally silenced feminine. In place of the exclusively masculine theorization of fetishism, Kelly explored aspects of feminine fetishization of the child and its substitutes.

Secondary discourses are necessary to relocate the meaning of these signs in the production of the mother, the making of the maternal feminine which is the piece's major revelation. Therefore the spectator confronts the materiality of the mother's discourse (often inscribed in handwriting), in transcribed conversations, diaries and commentaries. These texts are not a unifying narrative. There is no one authorial voice

169

but interventions and reworkings, even parodies of several modes of discourse. These are fissured and traversed by desire, anxiety, fear of loss, disavowal and fetishization.

Far from being a piece of conceptual art which refuses the figurative in favour of text as substitute, the document images discourse, not words but speech and statements, as the site of subjective and ideological activity. This necessarily reverses the bodily presence and vocal absence which typifies the representation of woman as sign in masculine representation. It produces a voice from the position of the feminine and makes the spectator study the initiation of the child into a language which is the symbolic system of a patriarchal order. The dialogues between mother and child are circumscribed by the meanings structured in a patriarchal system which is exposed precisely at the points when discourse fails and the mother has no words for the feminine placed outside representation, positioned as the pathological or procreative body. Finally writing is presented as inscription and a site which we must analyse symptomatically, not so much for what is literally spoken or written but for what those markings figure at other registers, such as fantasy, where the meanings are not totally defined by the dominant culture but slide and shift revealing what the symbolic order represses. Writing is a scene for the mother in which the child is retraced, a potential moment of feminine fetishism. Equally, as the final section 'On the insistence of t' letter' suggests, 'the child's alphabet is an anagram of the maternal body'.[36]

Although the *PPD* was produced within the spaces and discourses of the visual arts, its procedures echo Brecht's almost cinematic conception of the interplay of text, image, object, as well as his encouragement to use several registers of representation such as, in this case, the scientific, medical, autobiographical, educational, theoretical and so forth. The *PPD* fulfils Wollen's projection of a complex work of art confronting not Woman or women but the underlying mechanisms which produce the sexual discourses within which women are positioned in contemporary western patriarchal societies. Distanciated from passive consumption of the ideological category of the natural mother or the voyeuristic exploitation of an autobiographical account of one woman's experience as a mother, the spectator is offered a quite new understanding of the intersection between the social organization of domestic labour on the one hand, and on the other, the consolidation of femininity as prescribed within a patriarchal system.

The *PPD* is to be understood as a text, working its materials to produce meanings, not merely to picture already formed meanings. Thus as Stephen Heath stated, art as realism in Brecht's sense, attempts to displace the formation of ideology by making strange, by defamiliarizing,

the relations of subjectivity in ideology – i.e. the making of the feminine and its socio-economic and psychic positions. In addition the Brechtian model proposes a strategic artistic practice which does not operate from some imagined point outside the dominant culture. As practice it seeks to contest the hegemony of the dominant culture(s) by intervening in the relevant territories of production and consumption.

> From then on, the struggle is, as it were, on the very ground of representation – on the very ground of the interpellations of the subject in reality by ideology; art as *displacement* in so far as it holds representation at a distance – the distance, precisely, of politics.[37]

IV

A secondary result of the Brechtian critique of bourgeois realism in the pursuit of a critical realism is the insistence upon the ideological character of the terms of representation. Realist modes of representation present the world as if total knowledge is possible through empirical observation. Readers and viewers are posed as mere witnesses or observers. Yet it can be shown that specific devices are deployed which sustain this effect, positioning the viewer/reader in a specular relation, as if in a mirror, to what is seemingly revealed by its transparent textual devices. Denying the fact of being a construction, being produced, the realist text offers itself as merely a picture of the world which does not depend for its sense on any other texts, references or information.[38]

Critical practices, strategies of subversion, must inevitably involve a critique of dominant realist modes which 'naturalize' bourgeois and masculinist ideologies as fact or common sense. Stephen Heath called this decolonization of the ideologically loaded languages and modes of representation *'depropriation'*.[39] The term was taken up by Mary Kelly in her essay introducing the exhibition she curated at the Riverside Studios in London, *Beyond the Purloined Image*, August 1983. The works on show were made by Mitra Tabrizian, Ray Barrie, Karen Knorr, Olivier Richon, Marie Yates, Yve Lomax, Susan Trangmar and Judith Krowle. This diverse body of work was produced within what could be called a politics of representation and they addressed the codes and conventions of much media imagery, specifically those which perpetuate sexual (and in some cases racial) positionalities within the present regime of sexual (and racial) difference.

The enterprise could be compared to a more widespread phenomenon associated with 'appropriation' and media critique which formed the basis of American exhibitions such as *Image Scavengers* (1982) and *The Stolen Image and its Uses* (1983).[40] Kelly intended however to distinguish the British artists from their American counterparts who take their

the man with the proper imagination
is able to conceive of any commodity
in such a way
that it becomes an object of emotion to him
and to those to whom he imparts his picture,
and hence creates desire
rather than a mere feeling of ought.

psychologist

7.2 Mitra Tabrizian *On governmentality* (1983)

the psyche of the masses
is not receptive to anything that is weak.
it is like a woman
whose psychic state is determined
less by abstract reason
than by emotional longing for a strong force
which will complement her nature.

photographer

images from the fine arts of media and re-present them in visual quotation marks, and who are perhaps more influenced by the situationists and the writings of Jean Baudrillard.[41] The strategy of depropriation takes its cues from Brecht and Godard while utilizing more recent theorizations of representation and subjectivity.

In the Riverside exhibition Mitra Tabrizian showed *On Governmentality* which analysed the institution of advertising (Figure 7.2).[42]

> The work presented here is a fiction placed within a documentary frame, it is at the intersection of two discursive practices: that of documentary photography and that of the discourse of advertising from which representative textual fragments are taken.[43]

Each of the seventeen panels offers us a posed and constructed photograph of an employee within the industry, a caption designating types of professional employed but not necessarily describing the pictured employee, and a quotation from pages of the *Journal of Advertising*. The conventional overlaying and reinforcing characteristic of realist modes of representation are unsettled by the disparities between image, caption and text. They do not add up to provide that appearance of truth revealed. Instead the mechanics of that kind of suturing process are simply broken down. None the less, each element acquires a new signifying capacity. The photographs unsettle a viewer expecting the normal position of dominance and socially sanctioned voyeurism associated with documentary photography. The subjects are seated at a table, screened off or otherwise barricaded against the viewer. They are so obviously posed, so 'frozen', that the usual staying of time by which the photograph 'captures life' is unpleasurably exceeded. Finally the subjects stare back at the viewer defying the usual hierarchy of looking and being looked at. The terms extracted from their point of production and consumption are to be read symptomatically so that we recognize the discourse of advertising, which constructs the consuming subject, possessive, desiring, competitive. In an accompanying introduction to the piece, Mitra Tabrizian gives a Brechtian gloss:

> We should therefore not ask whether advertising informs or represents or misrepresents existing values but should rather open up the question of its effects. Definitions of reality are created within different discursive practices (e.g. advertising) at a particular time in a society. Struggles within ideology are struggles to change these definitions which have to be shifted if we are to create other 'forms of subjectivity'.[44]

Yve Lomax exhibited sections of a continuing project titled *Open rings and partial lines* which is composed of a series of large triptych photographic

panels. Two images confront each other across a third, a divider which does not provide the link or middle term to resolve the relation between or meanings of the flanking pair. The format itself is a protest against the binary oppositions which underpin the heterosexist regime of sexual difference. Montage is used here to refuse wholeness either of woman or in a binary pairing of man/woman.[45]

> What more difference is there than between boys and girls. The difference, obviously. And what could be less than this difference. And being less, how could it ever be more. What more difference is there than between boys and girls – a difference, obviously between more than two. More and no more. . . .
>
> The difference between two reduces everything to the same. No more and yet always more. And even though I may say with much resonance that *I am a woman*, even though I may resonantly speak of *we* don't expect me to remain the same; don't expect that we are all *The Same*, many of the same, a plurality reducible to one.[46]

The tripartite panels jarringly expose diverse images of women which relay us off to major sites for the production and circulation of 'truths' about 'woman' – advertising, film noir, melodrama, fashion photography, television and so forth. Extracting the codes and rhetorics of these modes of representation reveals their unexpected menace. Those images which we recognize as not being quotes or parodies figure woman against the grain of dominant representations. They manage to suggest that their women subjects are not available to the viewer's controlling, possessing or fantasizing gaze. This process negotiates a thin line between presenting woman as mysterious enigma, fascinatingly other and creating a quality of reserve, a state of sufficiency, 'otherwise engaged', articulating a subjectivity and a non fetishized sexuality of and for women.

Since 1978 when she exhibited at the *Three Perspectives of Photography* (Arts Council, London, Hayward Gallery,) Yve Lomax has been investigating the relation between the (so-called) enigma of femininity and truth in the territory of photographic representation. Photography promises power by offering to make truth visible – all is knowable in its gaze. It unites the visible and the invisible, a presence and an absence. Woman is obsessively caught not only as the silenced object of that possessing and empowering gaze, but as its very sign. So how can we represent women unless we work against the contradiction of woman as enigma functioning as sign of truth for man?[47]

Lomax's quotations and reconstructions do not correspond, for instance, with early work by Cindy Sherman in which she reconstructs the codes of the representation of femininity in cinema.[48] Much more

7.3 Yve Lomax *Open rings and partial lines* (1983–4)

than an exposé of the feminine as masquerade, Lomax's work explodes the binary oppositions in which the feminine is trapped as Other, as difference, as much in evidence in feminist as in patriarchal ideologies. For Lomax the point is not to seek another site of feminine truth, some essence or wholeness. In the fragments which refuse to be reunited or even imagined as parts of an original whole, difference and hetero-geneity are postulated in more radical terms. In 1982 she wrote:

> Will we search for that which makes the whole? Searching, search-ing, searching – what a sad search! Will the desire to seek the whole work against women's multiplicity and become a reductionist exercise, building up to a neat, well secured whole, all the diverse and particular parts which women are and make?[49]

In the case of Yve Lomax depropriation goes beyond critique. It involves a double process – a refusal of the dominant hierarchy of sexualized binary oppositions and a preliminary articulation of meanings and desire for female subjects. Thus in the musings which accompany the visual texts Lomax voices irreverent feminist questions about theorizations of representation and the sexual order it underpins. Parodying the psychoanalytical theories of sexual difference Lomax uses irony to expose its phallocentricity.

Lack's last laugh

> Fearing the lack of the whole we journey to seek its presence.
> Between two elements we search for a link – surely this will allow us to arrive at the whole.
> What is it we fear we lack and how shall we exactly know when we arrived, wholly satisfied?
> Around and around we go.
> Desire only comes when Something goes. Yes but also no.
> The whole withdraws itself, it goes into hiding and creates a telling lack. By way of all absence all is set in motion for the whole to be brought back. In the name of absence the whole totalises the parts. It forms a constellation of which it is a non-part. Representation hinges upon lack and this makes all the difference.
> If we no longer play that game of hide and seek.
> Laughter with a thousand edges.
> No part can ever stand alone; it takes many lines to make a specific part.
> The title, the head – that too is an open part. A part which constantly rings with other parts.
> There is no sovereign or whole meaning; no one message going down the line.[50]

Feminist art and argument often oppose dominant representations as stereotypical, false, inadequate, and offer instead a positive, alternative imagery valorizing what 'real' women are 'really like'. This can, however, merely replace one myth of woman with another, presupposing some essence or common identity in place of a radical recognition of multiple differences, class, race, sexuality, culture, religion, age and so forth. Lomax's work recalls a telling refusal of oversimplification by Italian writer Anne Marie Sauzeau Boetti, writing in 1976 of feminist strategies:

> This kind of project offers the only means of objectivising feminine existence: not a positive avant-garde subversion but a process of differentiation. Not the project of fixing meanings, but of breaking them up and multiplying them.[51]

We are not seeking a new meaning for Woman but rather a total dissolution of the system by which sex/gender is organized to function as the criterion upon which differential and degrading treatment is assigned and naturalized.

The importance of this position hardly needs to be stressed in the present context when so many different groups across the world are revolting against their enforced submission to imperializing classifications and claiming recognition of their specificity and diversity.

V

The Lomax text I just quoted in fact accompanied the exhibition of *Open rings and partial lines* at the *Difference* exhibition, the event at which this essay opened. Much of the British work exhibited in the show belongs to a specific cultural fraction with its roots in the debates accessible to us through the pages of *Screen*.[52] It has to be seen within a history but equally it is necessary to see that the artists are constantly adjusting their strategies to the conjunctures within which they intervene. The economic and political, let alone cultural, climate of the mid-1980s is clearly dramatically changed. Equally the process of working through the issues around representation leads to developments and alterations of strategy. The Brechtian lesson remains paramount, if only in this sense of timeliness and refusal of fixed and preferred formulae.[53]

Writing in *Screen*, in an article entitled 'Whose Brecht? Memories for the eighties' in 1982, Sylvia Harvey recapitulated the use made of Brecht in British independent culture and assessed the advances and problems of Brechtian-inspired 'political modernism' of the 1970s.[54] Her

reference was mostly to cinema but the criticism pertains to visual arts.

The Brecht she encourages practitioners to emulate now is the Brecht who insisted upon the audience's pleasure. Brecht's definition of pleasure involved both entertainment and the pleasure of making new sense of the world. For Brecht the audience was always imagined as socially specific, a concrete social group in relation to whose position and needs pleasure and instruction would have to be calculated. How does this inflect feminist practices, utilizing theories about spectatorship while attempting to produce work addressed to, but transforming, its anticipated audience of socially, sexually, culturally differentiated women?

For feminists pleasure has been a problematic concept. Indeed feminists have been occupied in deconstructing the pleasures offered in dominant art forms because they entail the subjection of woman to the fantasy of man. In 1975 Laura Mulvey stated categorically:

> This article will discuss the interweaving of that erotic pleasure in film, its meaning, and in particular the central place of the image of woman. It is said that analysing pleasure destroys it. That is the intention of this article. . . . The alternative is the thrill that comes from leaving the past behind without rejecting it, transcending out-worn or oppressive forms, or daring to break with normal pleasur-able expectations in order to conceive a new language of desire.[55]

But artists have also been aware of the necessity of pleasurable address, an invitation to the spectator. For instance Mary Kelly commented on the PPD:

> But I'm also aware of another implication: what is evacuated at the level of the look (or the representational image) has returned in the form of my diary narrative. This acts as a kind of 'capture' of the viewer which precedes recognition of the analytical texts. For me it's absolutely crucial that this kind of pleasure in the texts, in the objects, should engage the viewer, because there is no point at which it can become a deconstructed critical engagement if the viewer is not first – immediately and affectively – drawn into the work.[56]

The pleasures of which feminists have of necessity been sceptical are those involved in the hypostasized image and those involved in narrative itself. The one promises fullness and wholeness, the palpable simplicity of visible truth – which Yve Lomax works against – the other secures the viewer/reader within a singular flow of interrelating and mutually rein-forcing meanings and positions. These have been eschewed in critical work but there must be pleasure to invite the viewer in. In several examples exhibited at the *Difference* show new directions were evident in the relations between these Brechtian objectives. These begin to answer

the worries of Hal Foster aired at the beginning. What he presumed to be a fetishized fascination with images functions quite differently when considered in relation to the Brechtian dialectics of defamiliarization of both meanings and forms and the management of the spectator's desire to position women as the subject of their own discourse and as desiring subjects.[57]

If the dominant pacification of populations takes place through passive consumption of meanings naturalized through realist modes of representation, feminist critical practice must resist such specularity especially when the visible object *par excellence* is the image of woman. It has to create an entirely new kind of spectator as part and parcel of its representational strategies. But it has on the other hand to engage the social viewer to take up that position as the text's imagined partner.[58]

Two works in this exhibition indicated new directions through which this problem is being pursued by feminists.

For the London exhibition Marie Yates produced a new work called *The only woman* (1985) (Figure 7.4 (a–c)). It was an extension of concerns which structured her previous projects, *Image-woman-text* of 1980 and a long-term project *The missing woman* 1982–4, part of which was exhibited at the New Museum of Contemporary Art in 1984. Marie Yates has produced works which force the viewer to confront whose desire it is to find the woman in the image, who longs for the complete story, to find a truth and make it all cohere around what is in fact a missing woman (never present in the photograph or text). Her work is positioned to contest the narrative and realist forms which secure misrecognition of the ideologically shaped impulse locating it as the natural property of the image and behind it of Woman. On the other hand, *The only woman* represents a new daring, to re-engage with figuring woman, with narrative and heavily invested and emotive materials. The piece balances the continuing necessity to problematize forms of viewing and structures of desire with a more obvious invitation to the social viewer.

The work handles the process of a daughter mourning a mother. It is in many respects both a continuation and the other side of the *Post Partum Document* negotiating the interface between the social mother – the woman who bore and tended her daughter – and the psychic mother, the internalized presence, in the shadow of whose psychic life the child is moulded. Dealing with the process of desire and of separation, it approaches similar themes to those of the *PPD* but from the point of the mother's death. Here, however, the daughter is posed as an instance of the feminine.

The work is structured around the repetition of a limited number of photographic images selected from the family album.[59] These photographs are emblematic for the particular daughter who is the producer

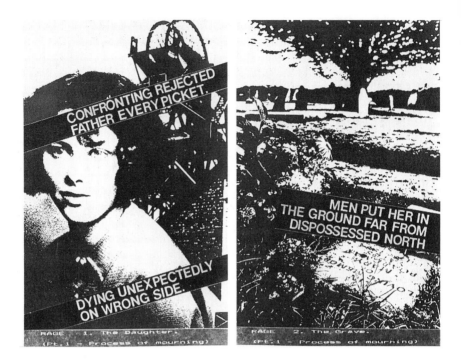

7.4 Marie Yates *The only woman* (1985) (a) *Rage* (four panels)

but they function iconically in the public domain. They articulate common fantasies which not only refer to shared psychic processes of the family and sexual and social positioning but witness to the way our private pictures in the family album conform to and register the larger social patterns which act upon individual families. Marie Yates has referred in an interview to Freud's description of the space of fantasy in creative writing. Creative writing produces in public form the author's own fantasies, but this does not lead us back to the author as exclusive origin of the fantasy. Rather the contingency of personal material maps on to psychic structures and scenarios through which we all are formed as sexed subjects. Thus the viewer draws on her own materials to remake the proffered fiction/history meaningful for her.

One of the effects is to reposition the author and the reader, the artist and the viewer. Whilst disavowing the myth of creative individualism and expressive theories of art, and engaging with post-structuralist theories in which the reader actively produces the meaning, feminist practices none the less acknowledge a social producer. The producer is formed by the social, economic and ideological conditions of her life; she belongs to certain communities, has particular interests and competences,

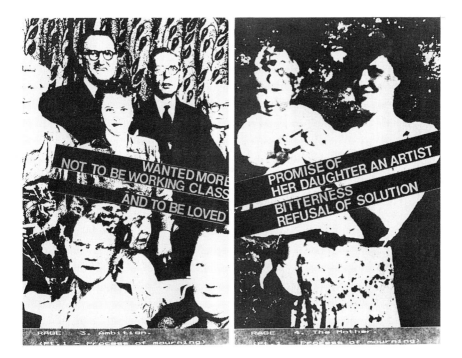

speaks to and with specifiable groups within larger groupings. The work is in part determined by that social locus of production which is quite different from conventional fantasies about the universal voice and visionary powers of genius to transcend the concrete differences in social life. Equally the work addresses not abstract categories – women, the people, the élite or whatever – but a socially produced and placed viewer who must mobilize her own social knowledges and competences or recognize where they do not match with those anticipated by the producer. Instead of confronting a work with the question 'What does it mean?' and, if that cannot be answered, 'Why am I lacking?', we might be forced to ask 'What knowledges do I need to have in order to share in the productivity of this work?' This becomes crucial for feminist interventions because their difference lies precisely in negating the knowledges and ideologies which are dominant and have become normalized as the common senses about art and artists, about women and societies.

That difference is easily dismissed as obscurantism when understanding requires no more knowledge than the consumption of dominant modernist or postmodernist practices. But the hegemony of dominant discourses of art which enthrall many women within the women's movement works always to marginalize and discredit the voices of the dominated by defining them as aberrant.

7.4 Marie Yates *The Only Woman* (1985) (b) *Pain*, details

7.4 Marie Yates *The Only Woman* (1985) (c) *Gaze* (six panels)

The only woman is composed of three sections following the pattern of grieving traced by Freud in 'Mourning and melancholia' (1917). We begin with 'Rage'. Four photographs which recur throughout the text (signifying the insistence of unconscious material through repetition and its revision as part of the process of coming to terms with death) are blown up to poster size and emblazoned with banner headlines. Cryptic phrases hitting the fascinating images designate a trajectory of a woman's life from the coal pits of the north (The Daughter) to a grave in the south (The Grave) through ambition and motherhood (The Mother) with dreams of her artist daughter's future. These images provide an iconography for the daughter's emotional response to grief yet their historical and social markers – the miners' strikes, North/South, art/class – allay any sentimental reading. The second section, 'Pain', requires a more intimate stance. It is composed of ten small panels, one group of which is mounted on an artist's drawing-board, signifying the look of the artist/daughter, while the second group is framed by the mother's reading-glasses, her look across the life charted in a selection of family snaps. The manner of representation signals the stage of mourning when the bereaved clings to the lost object. Separation is refused. But the images themselves begin on repeated examination to tell a story of other separations refused in the criss-crossing of mother/daughter relationships. The final section, 'Gaze', initiates the overcoming of loss and the distanciation from the obsessively possessed object. Fragmentary references to the preceding images are intersected with short texts:

The Daughter

During the Strike. Travelling back North, she must have confronted her rejected father, long since dead, in every picket on the road. She returned South to die the next day, unexpectedly on the wrong side, a miner's daughter.

The Mother

She saw in her daughter as artist the solution for both of them to the problem of class and position and also perhaps, mortality, and she bitterly regretted what she saw as a refusal of it. She felt cheated as though part of herself was offending her.

Who is speaking and from where? Marie Yates writes: 'The spectator may construct the image of a whole character from the fragmentary

indications offered by the work, but the narrator of the non-story is a character amongst all the others as is the spectator'.[60] There is no over-arching discourse in which all this is explained. There are instead suggestions of positions, the mother's place, the daughter's, the intersection of their desires and frustrations which at this moment of forced resolution through mourning finally become plain. The occasion of mourning becomes a space through which the relations within which we are captured and formed become speakable – a story with their leading characters and important events, turning points. Narrative is here not a means to resolve problems into a seamless whole but a means to create a montage of these contradictions which we can recognize even if these particular forms are not our own. The character of the narrator, the daughter and the artist figure too have a history, not actually represented, which has to be imagined by the spectator in order to make sense of the position from which the work is made. The mother is a miner's daughter, witness to the great strike in the 1920s. The daughter is making this piece during the miners' strike of the 1980s.

The final panel is a photograph of the first four images hanging on the gallery wall. 'Here we are distanced from rage and pain. This is the very point of being seen, and one recognizes that the artist has been an actor in that place too'.[61] This suggests a new relation between viewer and producer by means of the mirror phase which is invoked here. We look into a mirror and find intimations of ourselves in an image which comes to us from the field of the other (not only the mirror but the field seem-ingly possessed by that other who appears in the mirror holding the infant). The infant also looks back to the Other who holds him/her or shows the mirror for confirmation of the meaning of what has been seen. Instead of the mythic artist set up as the Other who knows and therefore put the meanings into the image, Marie Yates is inviting us to see the process of making a work as comparable with the mirror phase – art practice reveals something to the artist herself, i.e. knowledge about who and where she is. The spectator does not find in the art work a finished, sealed, completed set of meanings to be consumed, but engages in the making of meanings which while shadowing those the artist producer has been generating out of her own necessity are not thus prescribed.

> The theory, or rather, in the beginning, the theories are not extracted from 'finished' works; they are developed at the points where works bring together cinema and life, taking life in its economico-sociological sense of the term. Such criticism transforms finished works into unfinished works, it proceeds analytically.[62]

The other new project seen in *Difference* was the first part Mary

Kelly's *Interim*. Like the *PPD* this project focuses on instances of the making and living of the feminine under patriarchy. But it is more precise in interrogating the relations between femininity and representation by addressing the moments when the two are thrown into crisis – women ageing. As Kelly herself remarked, within dominant representation

> *'Being a woman is but a brief moment in one's life!'* Definitions of women's femininity are constructed primarily on the body: in its procreative capacity and as fetishized object – 'to be looked at'. *Interim* explores the possibilities for representing middle-aged woman in order to reinstate her as a desiring subject in representation, a position from which she is dominantly excluded.[63]

If woman is fashioned to be the sign and object of man's desire in patriarchal discourse, what happens to women in the transition between femininity as it is represented to us and its negation, the older woman. (I stress that this is within patriarchal discourse.)

> If the mother who knows sexual pleasure, the subject of Mary Kelly's *PPD* is the most severely repressed 'feminine' figure in Western culture, then the middle-aged woman runs a close second. For Lacan, the assumption of an image occasions desire, the middle age marks the occasion of the loss of that assumed image, of not being the object of man's desire, of being out of sync with how you look, of alienation from your image.[64]

The raw material is drawn from many hours of conversation with women of a specific generation and political experience in the women's movement over the last two decades. Mary Kelly discovered four recurring themes, centring on the status of the Body, access to Money and Power, and the sense and significance of the history of the women's movement over the last two decades – History. The Body, *'Corpus'* (Mary Kelly uses Latin titles to remind us that language is a system of naming), is now complete and was first exhibited in 1985 at the Fruitmarket Gallery, Edinburgh and then in 1986 at the Riverside Studios, London. There are five sections each composed of three pairs of image and text. The work is made of large sheets of perspex on to which images and handwritten texts are photographically mounted or silkscreened. These perspex plates are very large (48" x 36"), about the size of advertisement posters encountered at British bus-stops, and they are transparent. Not only do the images and texts cast their own shadows creating a doubling of the image, a depth which animates and refuses the flat stillness of the photographic image, but they capture the spectator who finds herself reflected/incorporated in the mirror-like surfaces. Indeed in one of the stories, reference is made to our tendency

*M*ENACÉ

7.5　Mary Kelly *Interim* (1984–) *Part I: Corpus*
　　(a) *Menacé* and supplementary material from the artist's archive

to seek reassurance by catching a glimpse of ourselves in shop windows, mirrors. Thus the only women 'pictured' are those actually present at the time of viewing – the spectators.

The image in each triptych is a central, unframed photograph of an article of female clothing in one of three poses tracing a development from order and acceptability through exposed anxiety to disarray and confusion (Figures 7.5 (a–d)). These are complemented by panels with a handwritten text tracing through echoes of children's stories women's complex relation to the body, desire and representation. Black leather jacket, handbag, boots, black negligée, white dress are named according to the five passionate attitudes of the stages of hysteria photographically constructed and described by J.M. Charcot in *Iconographie de la Salpetrière* (Paris, 1877–80): *Menacé, Appel, Supplication, Erotisme, Extase* (Threat, Appeal, Supplication, Eroticism, Ecstasy).

Charcot was the leading French doctor with whom Freud studied in Paris and against whose theories of hysteria psychoanalysis was developed. There is a special significance in the moment represented by Charcot when the hysterized body of woman – woman as hysterical body, dominated by reproduction (hysteria derives from the Greek word for womb) – was made the object of pathological scrutiny and deciphered in terms of masculine gaze and speech. (It is relevant to note

189

Fig. 2

MENACÉ

`7.5 Mary Kelly *Interim* (1984–) *Part I: Corpus*
(a) *Menacé* and supplementary material from the artist's archive

the historical conjunction of this practice with the emergence of the regime of representation analysed elsewhere in this book.) Photographic representation couched in an realist ideology functioned to confirm the premiss of a simply *observed* truth. Psychoanalysis dramatically challenged this regime by insisting upon a structural meaning, invisible, to be tracked only through its traces and signs, and treated by *the speaking cure*. In psychoanalysis the patient is not observed while dumb, but listened to. The body's symptoms are also deciphered as speech from the unconscious. Kelly's work juxtaposes these two historic orders in which femininity has been defined and traverses them with feminist appropriations of psychoanalysis as a means of distanciating femininity. Inscribing on the one hand a discourse of and from the place of the feminine, silenced by Charcot and photography, the images displace women's dumb body as spectacle by the expressive presences of the posed objects which stand in for the absented woman and 'speak'. They become emblematic of the conditions of femininity which we live as a confection of images, and discourses through which what woman is, is represented to us. Fashion plates, anatomy and popular medical discourse, romantic fiction are selected and reworked in each of the three pairings.

Expressive images of clothing are juxtaposed with graphic images of

190

Menacé

writing. Handmade marks traverse the surface of a transparent screen. The use of language makes possible the use of and shifting within positionalities – implicitly insisting that that is what language involves – borrowed placements. The registers of the prose parade the codes of fashion writing, medical discourse and romantic fiction invoking other cultural fantasies such as fairy tales (Cinderella, Snow White, the Frog Prince). These are worked into episodic stories. The double images picture for us different and interrelating orders of representation – making visible their interdependence and mutual reinforcement. The different sign systems in play invoke the realm of social signs by which we are made. By juxtaposing visual and graphic signs Mary Kelly refutes the modernist ideology of the priority and sufficiency of the visual sign, and insists too upon the traffic between word and image. Finally she puts into play different registers of drives associated with speech and vision.

Overleaf: pp. 192–7
7.5 Mary Kelly *Interim* (1984–) *Part I: Corpus*, details of (i) Supplication (pp. 192–3); (ii) Appel (pp. 194–5); (iii) Extase (pp. 196–7)

SUPPLICATION

Phone rings. gós on her way. Glad she's coming, though I met her only once before at the museum. Winter, ground covered in ice, everything about to crack, fragile, intense — her performance, my ordeal with the director, our conversation over breakfast. Wonder if she still remembers, if she's changed. Lovely, dancer's body in baggy pants, huge leather jacket, lace-up boots, all carefully battered like her face, small features more defined with some success, emblazoned: live alone, a loft downtown of course, no nonsense baby, if you want to be an artist you must pay. I am in debt, no doubt about it, overdressed and uncommitted, wishing I could seek asylum in her duffle bag. Stunned by the rightness of that image first, then intrigued by every detail, but especially by the boots. They had a presence much like hers, older but not dated and attractive without trying too hard. They haunted me. I had to have them, kept on looking for months after, finally found some that were similar, not soulfully worn out but stylishly distressed at least. In these I could do anything, wore them all the time, have them on now in fact. Will she be wearing hers? The door. I let her in, look down — the boots are different, lighter, higher heels and polished. Then look up — astonishing, a dress, small flowers, forties, second-hand, cut on the bias, screaming: what the hell, feels good to be a woman sometimes, give me credit I'll pay later. And the jacket, padded shoulders, Persian lamb, not black but very much like mine, the one that I was wearing when we met. She senses this and says that's why she bought it, tried to look smart, stylish even, just to please me. Can't help smiling, "See these boots," I ask, "have I succeeded?" "Well, almost," she laughs.

Fig. 2

APPEL

It's late and I'm looking up an emergency treatment for cystitis in a self-help manual called "Woman's Body". The index directs me to L 23. En route I catch a glimpse of a hideous diagram, keep going, then turn back, M 4: The Process of Aging. What do I find so compelling about this graphic destruction of the female figure from age 0 to 80. I resist. She looks much too old for 50, obviously based on the down-to-earth-had-a-hard-life-and-glad-it's-over type. I will never look like that, or will I? Brutal, statistical fact, there it is. I am reducible to example d) middle age: muscle strength and mental capabilities past their prime. So my son had a point asking me if I would still be able to play with him when I was 40. Though it could be worse, e) fertility ceases, and then f) old age: spine drops, hearing impaired, character changes and brain disorders possible. God, why go on. It's already started. Is it irreversible? Anne told me she could remember the exact day, hour even, when she became an older woman. One morning she woke up, looked down at her breasts and realized they had lost their independence. She was laying on her side, she emphasized the importance of her vantage point since it was in that very position she had previously observed two perfectly autonomous hemispheres defying the laws of gravity. That day, they sloped, no, she said slithered to the right as they surrendered to some imperious genetic signal saying "take a break". I asked how old she was and had to laugh when she said 25. But now, reading in reverse I notice c) continuous loss of nerve cells from the age of 25, then b) peak of physical energy over at 12. Finally their optimistic introduction, "The aging process begins suprisingly early and efforts to slow it down are simply guesswork." Organic, inevitable, yet we are obsessed with avoiding it. Anne is right, women are not at one with nature, they are at war with it. The victor becomes a legend like so many aging film stars, forever "Fabulous and Forty-two", meanwhile, the vanquished who refuse to dye their hair or just don't give a damn become old bags, or possibly old ladies if they smile.

Extase

The white dress is part of a plot to escape. From what, I'm not quite sure, but all through the cold, dark and indifferent winter I have been planning it. Learned academic by day, and by night, secret reader of holiday brochures and eater of maple sugar candy, planning how the three of us would meet in Miami, happy family reunited — father, mother, child, against a backdrop of blue sky and pounding surf of course. I have told no one. Finally, the day arrives. I pack the suitcase with devotion, the way a bride would do her trousseau: no jeans, no boots, no leather jacket or coat of any kind and nothing black, only brightly colored blouses, loosely fitting trousers, shorts, halters, high-heeled shoes and all the jewelry I ever wanted to wear and didn't have a chance to. And the dress. I refuse to wear a coat even to the airport in anticipation of the happy metamorphosis that will inevitably take place when I emerge eight hours later. And it does. The air is hot and thick. I feel it soldering the bits and pieces of my body into something tangible, entire. I can be seen, imagine men are looking at me, even look at them sometimes. Soon, they arrive, seem much shorter, fatter, whiter than I had remembered, but it doesn't matter, we are together, I am glad. What's more, today is my birthday. Naturally, I'm wearing the white dress — simple, silk, embroidered bodice, gathered at the waist, full skirt falling just below my knee, and thinking, thank god no one will see me (I mean everyone is in New York), and wondering who am I wearing this for anyway. Not him, he doesn't notice and the prospect of negotiating Disneyland has already given him a headache. Then my angelic son tells everyone, "look at my Mommy." The riddle solved. I am transported in a halo of fluorescent light to the land of "good-enough mothers." The motel manager waves his magic wand and says, "Please come with me into the dining room where you will feast on champagne, strawberries and cream, the Seven Dwarfs will play the Brandenburg Concertos and I'm quite sure you will live happily ever after." And we do.

The implications of the strategies employed by Mary Kelly in *Interim* are explored in an article in *Wedge*:

> What does it mean that feminists have refused the 'image' of the woman? First this implies a refusal to reduce the concept of the image to one of resemblance, to figuration, or even to the general category of the iconic sign. It suggests that the image, as it is organized in that space called the picture can offer a heterogeneous system of signs, indexical, symbolic, iconic. And thus, that it is possible to invoke the non-specular, the sensory, the somatic, in the visual field; to invoke, especially the register of the invocatory drives (which according to Lacan, are on the same level as the scopic drives, but closer to the experience of the unconscious), through 'writing'. Secondly it should be said that this is not a hybrid version of the 'hieroglyph' masquerading as an 'heterogeneity of signs'. The object is not to return to 'the feminine', to a domain of the pre-linguistic utterance, but rather, to mobilise a system of *imaged discourse* capable of refuting a certain form of culturally overdetermined scopophilia.[65]

Interim marks both a continuation of Mary Kelly's project from the 1970s and a departure. It implies an advance upon the disciplines and deconstructions of the 1970s which Laura Mulvey has labelled 'negative aesthetics', remodelled to deal with new materials at a new moment. Visually cued humour and wit acknowledge but interrupt the evident pleasure which feminists now recognize as securing complicity with the images of femininity. In place of the abstract spectator of earlier theorizations, the work addresses a social spectator, a woman, a feminist, a forty-five-year-old . . ., who is invited to share a learning process which moves across the images and tropes of the dominant culture in ways which would not have been possible in the 1970s when the job in hand was to define what they were by a process of negation and deconstruction.

This touches finally on the problematic for feminist artistic practice. Made for and addressed primarily to women, feminist art cannot speak to women in easily consumed terms. For feminist analysis of this level of the social formation has made abundantly clear that the very structures of viewing and taking pleasure in looking at images are implicated in oppressive regimes.

There have been criticisms of 'political modernism' from within the women's community by those who justifiably want a feminist culture that is inclusive, embracing women as broadly as possible in the joy of positive identification with being a woman.[66] But in the light of what feminist art history and feminist studies have revealed about the

mechanisms of the culture apparatus this is double-edged. One of the major problematics for feminist artistic practice must be working over the mechanisms which produce and sustain a patriarchal regime of sexual difference at the level of representation and its institutionalized conditions of viewing/consumption.[67]

A critical resource for this enterprise will be psychoanalytic theories as they are re-read by feminists.[68] But in terms of artistic practice the questions of subjectivity and sexual difference need to be developed in relation to Brechtian strategies and their *political* priorities. This is as it were to reverse the terms of the 1970s when, as Sylvia Harvey points out, the recovery of Brecht was 'effected from within the parameters of an interest in audience subjectivity largely specified in psychoanalytical terms'.[69]

At issue is the balance, crudely put, between the social and the psychic levels of socially constructed subjects. Psychoanalytic theory is no longer of marginal interest; it has been adopted into academe, art criticism and the market; even *Art in America* espouses it. Post-structuralist theories of representation and signification, Baudrillard's theses on the sign and simulacra are part of the normalized language of at least a major fraction of postmodernist critical baggage in art school, art magazine, exhibition catalogue. What may seem therefore a dissemination from a local and specialist interest to a dominant discourse may have its problematic aspects. For that section of British feminist art practices, which I have discussed, a Brechtian input has proved vital and productive. But in the present climate of cultural reaction and widespread appropriation of those tools utilized to such effect in the 1970s, Sylvia Harvey's restatement of a 'Brecht for the eighties' may be timely.

Postmodernism, post-feminism, all, we are told, is retro, passé, no longer relevant. But the changes for which the women's movement struggles have not come about. There remains violence against women, exploitation, increasing poverty and worldwide inequality. There is power, but there is resistance. These facts of social reality must not be swept away in the gloss and glitter of the spectacle – 'fascination with the images we impugn' in Foster's phrase (the replacement of art about art with representation about representation). While the Brechtian modernism of the 1970s is being transformed tactically as it must by the conditions and debates of the 1980s, its theoretical and practical contributions for a political art practice remain a valid and necessary component of the contemporary women's art movement.

NOTES

1 FEMINIST INTERVENTIONS IN THE HISTORIES OF ART: AN INTRODUCTION

1. Freely paraphrased from Elizabeth Fox-Genovese, 'Placing women's history in history', *New Left Review*, 1982 (133), 6.
2. For the founding analysis in this area, which has much to teach feminist studies while demanding feminist studies comprehend deconstructions of imperialist discourse and practice see Edward Said, *Orientalism*, London, Routledge & Kegan Paul, 1978.
3. Linda Nochlin, 'Why have there been no great women artists? in Elizabeth Baker and Thomas B. Hess (eds), *Art and Sexual Politics*, London, Collier Macmillan, 1973, 2. See also the article in which she poses the corollary question, 'Why have there been great male ones?' 'The de-politicisation of Courbet . . .', *October*, 1982 (22).
4. Thomas Kuhn, *The Structure of Scientific Revolutions*, Chicago, University of Chicago Press, 1962.
5. For a classic statement see Mark Roskill, *What is Art History?*, London, Thames & Hudson, 1976.
6. T. J. Clark, 'On the conditions of artistic creation', *Times Literary Supplement*, 24 May 1974, 561–3.
7. For example see the title and the currency thereby afforded to *The Social Production of Art*, Janet Wolff, London, Macmillan Press, 1981.
8. Karl Marx, *Grundrisse*, (1857–8) translated Martin Nicolaus, Harmondsworth, Penguin Books, 1973, 92.
9. Raymond Williams, 'Base and superstructure in Marxist cultural theory', in *Problems in Materialism and Culture*, London, Verso Books, 1980, 46.
10. Raymond Williams, *The Long Revolution* (1961), Harmondsworth, Penguin Books, 1965 (edn 1980), 55–6.
11. Marx, op. cit., 100.
12. R. Barthes, 'The rhetoric of the image', in S. Heath (ed.), *Image-Music-Text*,

London, Fontana, 1977. This remains a classic example of this practice of analysis.

13. K. Marx, *The Eighteenth Brumaire of Louis Napoleon*, (1852) in K. Marx and F. Engels, *Selected Works in One Volume*, London, Lawrence & Wishart, 1970. For discussion see also S. Hall, 'The "political" and the "economic" in Marx's theory of classes', in A. Hunt (ed.), *Class and Class Structure*, London, Lawrence & Wishart, 1977.

14. Dale Spender (ed.), *Men's Studies Modified the Impact of Feminism on the Academic Disciplines*, Oxford, Pergamon Press, 1981.

15. The Cambridge Women's Studies Group, *Women in Society Interdisciplinary Essays*, London, Virago, 1981, 3.

16. Mary Kelly, 'On sexual politics and art', in Brandon Taylor (ed.), *Art and Politics*, Winchester School of Art, 1980, reprinted in Rozsika Parker and Griselda Pollock, *Framing Feminism: Art and the Women's Movement 1970–85*, London, Pandora Press, 1987.

17. The list of publications is now substantial. For a list and further discussion of 'the feminine stereotype' see Rozsika Parker and Griselda Pollock, *Old Mistresses: Women, Art and Ideology*, London, Routledge & Kegan Paul, 1981; London, Pandora Press, 1986.

18. Parker and Pollock, *Old Mistresses; Women, Art and Ideology*, London, Routledge & Kegan Paul, 1981, reprinted Pandora Press, 1986, 3.

19. Griselda Pollock, 'Art, art school and culture – individualism after the death of the artist', *Block*, 1985/6 (11), and *Exposure* (USA), 1986, 24 (3).

20. For fuller discussion of this point see Griselda Pollock, 'The history and position of the contemporary woman artist', *Aspects*, 1984 (28).

21. The point was made in a seminar by Adrian Rivkin at the University of Leeds in 1985. See also Simon Watney, 'Modernist studies: the class of '83', *Art History*, 1984, 7 (1). On Althusser see Louis Althusser, 'Cremonini, painter of the abstract', and 'A letter on art ..', in *Lenin and Philosophy and other Essays*, translated by Ben Brewster, London, New Left Books, 1971.

22. Elizabeth Cowie, 'Woman as sign', *M/F*, 1978 (1).

23. For a further elaboration of the position and a very relevant critique see Lon Fleming, 'Lévi-Strauss, feminism and the politics of representation', *Block*, 1983 (9).

24. Juliet Mitchell, *Psychoanalysis and Feminism*, London, Allen Lane, 1974, xxii.

25. The quotation is from Jeffrey Weeks, *Sex, Politics and Society: The Regulation of Sexuality since 1800*, Harlow, Longman, 1981, 33. Michel Foucault elaborates the case in *The History of Sexuality: An Introduction* (*La Volonté de savoir*) (1976), London, Allen Lane, 1978, 127. 'We must say that there is a bourgeois sexuality, and that there are class sexualities. Or rather, that sexuality is originally, historically bourgeois, and that, in its successive shifts and transpositions, it induces class specific effects.'

26. Foucault, op cit., 129.

27. Jacqueline Rose, 'Sexuality in the field of vision', in the book of the same title, London, Verso Books, 1986.

28. Charles Harrison, 'Introduction: modernism, problems and methods', Units

1–2, *Modern Art and Modernism*, Milton Keynes, Open University Press, 1983, 5.

29. Fred Orton and Griselda Pollock, 'Les données Bretonnantes: la prairie de représentation', *Art History*, 1980, 3 (3); Fred Orton and Griselda Pollock, 'Avant-gardes and partisans reviewed', *Art History*, 1981, 4 (3).

30. Christine Delphy, in *New French Feminisms: An Anthology*, edited and translated by Elaine Marks and Isabelle de Courtivron, Brighton, Harvester Press, 1981, 198.

31. Deborah Cherry and Griselda Pollock, 'Patriarchal power and the Pre-Raphaelites', *Art History*, 1984, 7 (4), 494.

2 VISION, VOICE AND POWER: FEMINIST ART HISTORIES AND MARXISM

1. M. Schapiro, 'On the nature of abstract art', *Marxist Quarterly*, January–March 1937, 77–8.

2. T. J. Clark, *Image of the People, The Absolute Bourgeois*, London, Thames & Hudson, 1973; *The Painting of Modern Life: Paris in the Art of Manet and his Followers*, London, Thames & Hudson, 1984.

3. J. Gardiner, 'Women in the labour process and class structure', in *Class and Class Structure*, edited by A. Hunt, London, Lawrence & Wishart, 1977, 163. See also L. Comer, 'Women and class: the question of women and class', *Women's Studies International Quarterly*, 1978, 1, 165–73.

4. The meanings of the term culture are often confusing. Some use the word to refer to high civilization, others, in anthropology, mean by the word a way of life which involves transformation of nature into socially used artefacts. In Marxist usages it both has that latter sense, broadened to encompass a way of life or community, and on the other hand can signify a grouping of ideologies. I use culture in this article to define a level of society different from the political and the economic, which is made up of all the practices that produce sense. These include ideology, science and art which share linguistic and visual forms of communication, interact within one another and are organized through institutions such as schools, universities, publishing, broadcasting and the institutions of high and popular culture and entertainment. In this, culture is a site therefore of a particular kind of struggle, cultural struggle, which entails challenges to particular regimes of sense, orders of representation – ways in which the world is imaged for us, represented to us and interpreted for and by us. See Francis Mulhern, 'On culture and cultural struggle', *Screen Education*, 1980 (34).

5. In his widely distributed television series, *Civilisation*, the English art historian Kenneth Clark offered 24 weekly escapes into imaginary history of beautiful objects and creative people. Art history offers this escape which ordinary history studies no longer can.

6. E.g. E. Guhl, *Die Frauen in der Kunstgeschichte* (1958), Ellen Clayton, *English Female Artists* (1876), M. Vachon, *La Femme dans l'Art* (1893).

Notes

7. Cited in G. Wall, 'Translator's preface' to P. Macherey, *A Theory of Literary Production*, London, Routledge & Kegan Paul, 1978, vii. For full discussion of this point see G. Pollock, 'Artists, media and mythologies', *Screen*, 21 (3), 1980, 57–96.
8. A. Gabhart and E. Broun, in *Walters Art Gallery Bulletin*, 24 (7), 1972.
9. G. Pollock, 'The history and position of the contemporary woman artist', *Aspects*, 1984 (28).
10. Cited in Octave Uzanne, *The Modern Parisienne*, London, Heinemann, 1912.
11. F. Antal, 'Remarks on the method of art history', reprinted in F. Antal, *Essays in Classicism and Romanticism*, London, Routledge & Kegan Paul, 1966, 175–89.
12. ibid., 189.
13. ibid., 187.
14. R. Parker, 'Breaking the mould', *New Statesman*, 98 (2537), 2 November 1979, 682.
15. Nicos Hadjinicolaou, *Art History and Class Struggle* (1973), translated by Louise Asmal, London, Pluto Press, 1978, chs 2–4.
16. P. Macherey, *A Theory of Literary Production* (1966), translated by G. Wall, London, Routledge & Kegan Paul, 1978, 80.
17. C. Sterling, 'A fine David reattributed', *Metropolitan Museum of Art Bulletin*, 1951, IX (5), 132.
18. J. Laver, 'Woman painters', *Saturday Book*, London, 1964, 19; and for a critical study of these stereotypes see C. Nemser, 'Stereotypes and woman artists', *Feminist Art Journal*, April 1972, 1, 22–3.
19. For a very valuable discussion of the difference between consumption-orientated criticism and production analysis see Raymond Williams, 'Base and superstructure in Marxist culture theory', in *Problems in Materialism and Culture*, London, Verso Books, 1980.
20. L. Althusser, *Essays on Ideology*, London, Verso Editions, 1983; P. Hirst, *On Law and Ideology*; J.O. Thompson, *Studies in the Theory of Ideology*, London, Polity Press, 1984; J. Lavrain, *The Concept of Ideology*, London, Hutchinson, 1979.
21. E.g. Hadjinicolaou, op. cit., chs 8–10.
22. For a fuller discussion see 'Modernity and the spaces of femininity', in this volume, pp. 50–90.
23. The most developed discussion of the issues of how to think through the social totality as a complex of many relations and determinations remains Karl Marx, 'Introduction' to *Grundrisse* (1857–8), translated by Martin Nicolaus, Harmondsworth, Penguin Books, 1973. For a helpful introduction see Stuart Hall, 'Marx's notes on method: a 'reading' of the 1857 introduction', *Cultural Studies*, 1974 (6) (Birmingham University Centre for Contemporary Cultural Studies).
24. 'Woman as sign in Pre-Raphaelite literature: the representation of Elizabeth Siddall' in this volume, pp. 91–115.
25. Elizabeth Cowie, 'Woman as sign', *M/F*, 1978, 1, 50.
26. Claude Lévi-Strauss, *The Elementary Structure of Kinship* (1949), London, Eyre

& Spottiswoode, 1969. See also Lon Fleming, 'Lévi-Strauss, feminism and the politics of representation', *Block*, 1983 (9).

27. Cowie, op. cit., 60.

28. K. Millett, *Sexual Politics*, New York, 1971, 25.

29. H. Hartman, 'The unhappy marriage of Marxism and feminism', *Capital and Class*, Summer 1979, (8), 11.

30. L. Nochlin, 'Why have there been no great women artists', in *Art and Sexual Politics*, edited by E. Baker and T. Hess, New York, Macmillan, 1973, 1–43; also originally published in *Art News*, 1971, and reprinted full length in *Woman in Sexist Society: Studies in Power and Powerlessness*, edited by V. Gornick and B. K. Moran, New York, Basic Books, 1971. I cite this 1971 version.

31. ibid., 480.

32. ibid., 508–9.

33. L. Nochlin and A. Sutherland Harris, *Women Artists 1550–1950*, New York, Alfred Knopf, 1976, 44.

34. ibid., 140.

35. L. Vogel, 'Fine arts and feminism: the awakening conscience', *Feminist Studies*, 1974 (2), 3.

36. G. Greer, *The Obstacle Race*, London, Weidenfeld & Nicholson, 1979, 327.

37. Nochlin and Sutherland Harris, op. cit., 44. All feminist art historians are indebted to the scholarship and initiative of these two authors. Their exhibition and its catalogue are a major contribution without which the arguments here mounted would not have been possible.

38. See M. and R. Wittkower, *Born Under Saturn*, Oxford, Oxford University Press, 1963, for this history of the change in status and identity of the artist in the Renaissance period.

39. *The Journals of Marie Bashkirtseff* (1890, ed. M. Blind), new edition introduced by Rozsika Parker and Griselda Pollock, London, Virago Books, 1984, and *The Correspondence of Berthe Morisot* (1953, edited by D. Rouart), new edition introduced by Kathleen Adler and Tamar Garb, London, Camden Press, 1986.

40. M. H. Grant, *Flower Painting through Four Centuries*, England, Leigh-on-Sea, 1952, 21.

41. I found Cora Kaplan's work on women and their 'intervention into the high patriarchal discourse of bourgeois culture' – epic poetry – very helpful on this point. In poetry women were likewise permitted to write in the lesser modes of lyric poetry or ballads and sonnets but the prestigious forms like epic poetry were preserved; a woman daring to use the form was threatening to abrogate the power of public speech, the authority of her own voice for her own causes. See C. Kaplan, 'Introduction' to the Women's Press edition of Elizabeth Barrett Browning's great epic poem on women and art, *Aurora Leigh*, London, Women's Press, 1978.

42. See for instance Denis Diderot, *Diderot Salons*, edited by Jean Adhémar and Jean Seznec, Oxford, Clarendon Press, 1957–67, esp. vol. III, or Elizabeth Vigée Lebrun, *The Memoirs of Madame Vigée Lebrun, 1755–89*, translated by Gerard Shelly, London, John Hamilton, 1927.

43. Nochlin and Sutherland Harris, op. cit., 192.
44. Carol Duncan, 'Happy mothers and other new ideas in French art', *Art Bulletin*, December 1973, 570–83, reprinted in N. Broude and M. Garrard (eds) *Feminism and Art History*, New York, Harper & Row, 1982.

3 MODERNITY AND THE SPACES OF FEMININITY

1. For substantive evidence see Lea Vergine, *L'Autre moitié de l'avant-garde, 1910–1940*, translated by Mireille Zanuttin, (Italian edn 1980), Paris, Des Femmes, 1982.
2. See Nicole Dubreuil-Blondin, 'Modernism and feminism: some paradoxes' in Benjamin H. D. Buchloh (ed.), *Modernism and Modernity*, Halifax, Nova Scotia, Press of Nova Scotia College of Art and Design, 1983. Also Lillian Robinson and Lisa Vogel, 'Modernism and history', *New Literary History*, 1971–2, iii (1), 177–99.
3. T. J. Clark, *The Painting of Modern Life: Paris in the Art of Manet and his Followers*, New York, Knopf, and London, Thames & Hudson, 1984.
4. George Boas, 'Il faut être de son temps', *Journal of Aesthetics and Art Criticism*, 1940, 1, 52–65; reprinted in *Wingless Pegasus: A Handbook for Critics*, Baltimore, Johns Hopkins University Press, 1950.
5. The itinerary can be fictively reconstructed as follows: a stroll on the *Boulevard des Capucines* (C. Monet, 1873, Kansas City, Nelson Atkins Museum of Art), across the *Pont de l'Europe* (G. Caillebotte, 1876, Geneva, Petit Palais), up to the *Gare St Lazare* (Monet, 1877, Paris, Musée d'Orsay), to catch a suburban train for the twelve-minute ride out to walk along the *Seine at Argenteuil* (Monet, 1875, San Francisco, Museum of Modern Art) or to stroll and swim at the bathing-place on the Seine, *La Grenouillère* (A. Renoir, 1869, Moscow, Pushkin Museum), or to *Dance at Bougival* (A. Renoir, 1883, Boston, Museum of Fine Arts). I was privileged to read early drafts of Tim Clark's book now titled *The Painting of Modern Life* and it was here that this impressionist territory was first lucidly mapped as a field of leisure and pleasure on the metropolitan/suburban axis. Another study to undertake this work is Theodore Reff, *Manet and Modern Paris*, Chicago, University of Chicago Press, 1982.
6. Clark, op. cit., 146.
7. ibid., 253.
8. The tendency is the more marked in earlier drafts of material which appears in *The Painting of Modern Life*, e.g. 'Preliminaries to a possible treatment of *Olympia* in 1865', *Screen*, 1980, 21 (1), especially 33-7, and 'Manet's *Bar at the Folies-Bergère*' in Jean Beauroy et al. (eds), *The Wolf and the Lamb: Popular Culture in France*, Saratoga, Anma Libri, 1977. See also Clark, op. cit., 250-2, and contrast the radical reading of Manet's paintings which results from acknowledging the specificity of the presumed masculine spectator in Eunice Lipton's 'Manet and radicalised female imagery', *Art Forum*, March, 1975, 13 (7) and also Beatrice Farwell, 'Manet and the nude: a study of the iconography of the Second Empire', University of California, Los Angeles,

PhD, 1973, published New York, Garland Press, 1981.

9. Tamar Garb, *Women Impressionists*, Oxford, Phaidon Press, 1987. The other two artists involved were Marie Bracquemond and Eva Gonzales.

10. Roszika Parker and Griselda Pollock, *Old Mistresses: Women, Art and Ideology*, London, Routledge & Kegan Paul, 1981, 38.

11. I refer for example to Edouard Manet, *Argenteuil Les Canotiers*, 1874 (Tournai, Musée des Beaux Arts) and to Edgar Degas, *Mary Cassatt at the Louvre*, 1879–80, etching, third of twenty states (Chicago, Art Institute of Chicago). I am grateful to Nancy Underhill of the University of Queensland for raising this issue with me. See also Clark, op. cit., 165, 239 ff., for further discussion of this issue of flatness and its social meanings.

12. See also Berthe Morisot, *View of Paris from the Trocadéro*, 1872 (Santa Barbara, Museum of Art), where two women and a child are placed in a panoramic view of Paris but fenced off in a separate spatial compartment precisely from the urban landscape. Reff, op. cit., 38, reads this division quite (in)differently and finds the figures merely incidental, unwittingly complying with the social segregation upon which the painting's structure comments. It is furthermore interesting to note that both these scenes are painted quite close to the Morisot home in the Rue Franklin.

13. Griselda Pollock, *Mary Cassatt*, London, Jupiter Books, 1980. Contrast G. Caillebotte, *Portraits*, 1877 (New York, private collection).

14. See, for instance, M. Merleau-Ponty, 'Cézanne's doubt', in *Sense and Non-Sense*, translated by Hubert L. Dreyfus and Patricia Allen Dreyfus, Evanston, Illinois, Northwestern University Press, 1961.

15. Janet Wolff, 'The invisible flâneuse; women and the literature of modernity', *Theory, Culture and Society*, 1985, 2 (3), 37–48.

16. See George Simmel, 'The metropolis and mental life', in Richard Sennett (ed.) *Classic Essays in the Culture of the City*, New York, Appleton-Century-Crofts, 1969.

17. Richard Sennett, *The Fall of Public Man*, Cambridge, Cambridge University Press, 1977, 126.

18. Walter Benjamin, *Charles Baudelaire; Lyric Poet in the Era of High Capitalism*, London, New Left Books, 1973, chapter II, 'The flâneur', 36.

19. 'What was new in the nineteenth century was not the ideal of the woman by the hearth, *la femme au foyer*, in itself, but the unprecedented scale on which it was propagated and diffused.' John MacMillan, *From Housewife to Harlot, French Nineteenth-Century Women*, Brighton, Harvester Press, 1981, 9. For an excellent study of the English case see Catherine Hall, 'The early formation of Victorian domestic ideology', in Sarah Burman (ed.), *Fit Work for Women*, London, St Martin's Press, 1979.

20. Jules Simon, *La Femme au vingtième siècle*, Paris, 1892, 67.

21. A fascinating interpretation of this process is offered in Bonnie G. Smith, *Ladies of the Leisure Class: The Bourgeoises of Northern France in the Nineteenth Century*, Princeton, Princeton University Press, 1981. She documents the shift from married women's active involvement in family business and management of financial affairs common in the early nineteenth century to

Notes

the completed practice of domesticity, which involved total dissociation from family businesses and money, accomplished by the 1870s. See especially chapters 2–3.

22. Shirley Ardener, *Women and Space*, London, Croom Helm, 1981, 11–12.
23. Catherine Hall and Leonore Davidoff, 'The architecture of public and private life: English middle-class society in a provincial town 1780–1850', in Derek Fraser and Anthony Sutcliffe (eds), *In Pursuit of Urban History*, London, Edward Arnold, 1983, 326–46.
24. Jules Simon, op. cit., quoted in MacMillan, op. cit., 37. MacMillan also quotes the novelist Daniel Lesuer, 'Le travail de la femme la déclasse', *L'Evolution Feminine: ses résultats economiques*, 1900, 5. My understanding of the complex ideological relations between public labour and the insinuation of immorality was much enhanced by Kate Stockwell's contributions to seminars on the topic at the University of Leeds, 1984–5.
25. Jules Michelet, *La Femme*, in *Oeuvres completes* (Vol. XVIII, 1858–60), Paris, Flammarion, 1985, 413. In passing we can note that in a drawing for a print on the theme of omnibus travel Mary Cassatt initially placed a man on the bench beside the woman, child and female companion (*c.* 1891 Washington, National Gallery of Art). In the print itself this masculine figure is erased.
26. Sennett, op. cit., 23.
27. *The Journals of Marie Bashkirtseff* (1890), introduced by Rozsika Parker and Griselda Pollock, London, Virago Press, 1985, entry for 2 January 1879, 347.
28. Charles Baudelaire, 'The painter of modern life', in *The Painter of Modern Life and Other Essays*, translated and edited by Jonathan Mayne, Oxford, Phaidon Press, 1964, 9.
29. ibid., 30.
30. The pictures to fit the schema would include the following examples:

A. Renoir, *La Loge*, 1874 (London, Courtauld Institute Galleries).

E. Manet, *Music in the Tuileries Gardens*, 1862 (London, National Gallery).

E. Degas, *Dancers backstage, c.* 1872 (Washington, National Gallery of Art).

E. Degas, *The Cardinal family, c.* 1880, a series of monotypes planned as illustrations to Ludovic Halévy's books on the backstage life of the dancers and their 'admirers' from the Jockey Club.

E. Degas, *A café in Montmartre*, 1877 (Paris, Musée d'Orsay).

E. Manet, *Café, Place du Théâtre Français*, 1881 (Glasgow, City Art Museum).

E. Manet, *Nana*, 1877 (Hamburg, Kunsthalle).

E. Manet, *Olympia*, 1863 (Paris, Musée du Louvre).

31. Theresa Ann Gronberg, 'Les Femmes de brasserie', *Art History*, 1984, 7 (3).
32. See Clark, op. cit., 296, note 144. The critic was Jean Ravenal writing in *L'Epoque*, 7 June 1865.
33. See Clark, op. cit., 209.
34. The escapade in 1878 was erased from the bowdlerized version of the

journals published in 1890. For discussion of the event see the publication of excised sections in Colette Cosnier, *Marie Bashkirtseff: un portrait sans retouches*, Paris, Pierre Horay, 1985, 164–5. See also Linda Nochlin, 'A thoroughly modern masked ball', *Art in America*, November 1983, 71 (10). In Karl Baedecker, *Guide to Paris*, 1888, the masked balls are described but it is advised that 'visitors with ladies had better take a box' (p. 34) and of the more mundane *salles de danse* (dance halls) Baedecker comments, 'It need hardly be said that ladies cannot attend these balls.'

35. Carl Degler, 'What ought to be and what was; women's sexuality in the nineteenth century', *American Historical Review*, 1974, 79, 1467–91.

36. Benjamin, op. cit., 45.

37. The exception to these remarks may well be the work of Gustave Caillebotte especially in two paintings exhibited at the third Exposition de Peinture in April 1877: *Portraits in the Country* (Bayeux, Musée Baron Gerard) and *Portraits (In an Interior)* (New York, Alan Hartman Collection). The former represents a group of bourgeois women reading and sewing outside their country house and the latter women indoors at the family residence in the Rue de Miromesnil. They both deal with the spaces and activities of 'ladies' in the bourgeoisie. But I am curious about the fact of their being exhibited in a sequence with *Paris Street, Rainy Day*, and *The Bridge of Europe* which are both outdoor scenes of metropolitan life where classes mix and ambiguity about identities and social positions disturb the viewer's equanimity in complete contrast to the inertia and muffled spaces evoked for the enclosed worlds of drawing-room and terrace of the family estate in the two portrait paintings.

38. Pollock, op. cit. (1980).

39. For instance François Gérard, *Cupid and Psyche*, 1798 (Paris, Musée du Louvre).

40. George Moore, *Sex in Art*, London, Walter Scott, 1890, 228–9.

41. Mary Ann Doane, 'Film and the masquerade; theorizing the female spectator', *Screen*, 1982, 23 (3–4), 86.

42. Mary Kelly, 'Desiring images/imaging desire', *Wedge*, 1984 (6), 9.

43. There are of course significant differences between the works by Mary Cassatt and those by Berthe Morisot which have been underplayed within this text for reasons of deciphering shared positionalities within and against the social relations of femininity. In the light of recent publications of correspondence by the two women and as a result of the appearance in 1987 of a monograph (Adler and Garb, Phaidon) and an exhibition of works by Morisot it will be possible to consider the artists in their specificity and difference. Cassatt articulated her position as artist and woman in political terms of both feminism and socialism, whereas the written evidence suggests Morisot functioning more passively within the haut bourgeois formation and republican political circles. The significance of these political differences needs to be carefully assessed in relation to the texts they produced as artists.

44. For discussion of class and occupation in scenes of women bathing see

Notes

Eunice Lipton, 'Degas's bathers', *Arts Magazine*, 1980, 54, also published in Eunice Lipton, *Looking into Degas: Uneasy Images of Woman and Modern Life*, University of California Press, 1986. Contrast Gustave Caillebotte, *Woman at a Dressing-Table*, 1873 (New York, private collection), where the sense of intrusion heightens the erotic potential of a voyeuristic observation of a woman in the process of undressing.

4 WOMAN AS SIGN IN PRE-RAPHAELITE LITERATURE: THE REPRESENTATION OF ELIZABETH SIDDALL

1. J. Nicholl, *Dante Gabriel Rossetti*, London Studio Vista, 1975, 70–7.
2. G. Pollock, 'Artists, mythologies and media: genius, madness and art history', *Screen*, 1980, 21 (3), 57–96.
3. W. E. Fredeman, 'Impediments and motives: biography as unfair sport', *Modern Philology*, 1970, 70, 149.
4. W. E. Fredeman, *Pre-Raphaelitism: A Bibliocritical Study*, 1965, Cambridge, Harvard University Press, 210.
5. E. Cowie, 'Woman as sign', *M/F*, 1978, 1 (1), 49–63.
6. ibid., 60.
7. See J. Ruskin, *Sesame and Lilies* (1867); further discussion of the point is to be found in R. Parker and G. Pollock, *Old Mistresses: Women, Art and Ideology*, London, Routledge & Kegan Paul, 1981.
8. L. Nochlin and A. Sutherland Harris, *Women Artists 1550–1950*, New York, Alfred Knopf, 1976, catalogue entry and bibliography; A. Troyen, 'The life and art of Elizabeth Eleanor Siddall', senior essay, History of Art Department, Yale University, 1975, on deposit in the Tate Gallery Library. There is an album of photographs of works by Siddall in the Ashmolean Museum, Oxford, and the Fitzwilliam Museum, Cambridge.
9. R. C. Lewis and M. S. Lasner (eds), *Poems and Drawings of Elizabeth Siddal*, Wolfville, Nova Scotia, Wombat Press, 1978.
10. J. Gere, 'Introduction', *Dante Gabriel Rossetti: Painter and Poet*, Royal Academy, London, 1973, 14.
11. N. Hadjinicolaou, *Art History and Class Struggle* (1973), translated by L. Asmal, London, Pluto Press, 1978, chapter 2.
12. For a major example of feminist historiography and analysis of history as representation, see the film *Song of the Shirt*, Susan Clayton and Jonathan Curling, GB, Film and History Project 1973.
13. For an example of a massively researched study see Jan Marsh, *Pre-Raphaelite Sisterhood*, London, Quartet Books, 1985.
14. Census Returns 1841 (HO 107 1083 6 11) list at Upper Ground Street: Charles Siddall, 40, cutler, Elizabeth, 38, Ann, 16, Elizabeth, 11, Lydia, 9, Clara, 5, James, 3. For 1851 (HO 107 1563 fo 332 DU) the Returns at 8 Kent Place include Charles Siddall, 50, cutler, Charles, 24, cutler, Elizabeth, 21, Clara, 14, James, 12, Henry, 9. The Returns for 1861 (RG 9 329 of 34 p. 8) list at 8 Kent Place Elizabeth Siddall, widow, 59, James, 22, cutler, Mary, 28,

dressmaker, Clara, 25, mantlemaker, Henry, 18, cutler.

15. See S. Alexander, 'Women's work in nineteenth-century London: a study of the years 1820–50', in J. Mitchell and A. Oakley (eds), *The Rights and Wrongs of Women*, Harmondsworth, Penguin Books, 1976, 59–111.

16. C. Hall, 'Gender divisions and class formation in the Birmingham middle class', in R. Samuel (ed.), *People's History and Socialist Theory*, Routledge & Kegan Paul, 1981, 164–75.

17. M. Foucault, *The Archaeology of Knowledge* (1969), translated by A. Sheridan Smith, London, Tavistock, 1972, 128. 'We are now dealing with a complex volume, in which heterogeneous regions are differentiated and deployed, in accordance with specific rules and practices that cannot be superposed. Instead of seeing on the great mythical book of history, lines of words that translate in visible characters thoughts that were formed in some other times and place, we have in the density of discursive practices, systems that establish statements as events (with their own conditions and domain of appearance) and things (with their own possibility and field of use). They are all these systems of statements (whether events or things) that I propose to call an *archive.*'

18. M. Foucault, *Discipline and Punish: The Birth of the Prison* (1975), Harmondsworth, Penguin Books, translated by A. Sheridan, 1977; D. Cherry, 'Surveying seamstresses', *Feminist Art News*, 1983 (9).

19. W. M. Rossetti, *Dante Gabriel Rossetti as Designer and Writer*, 1889; *Dante Gabriel Rossetti: His Family Letters with a Memoir*, 1895; 'Dante Rossetti and Elizabeth Siddal', *Burlington Magazine*, 1903, I, 273–95; *Some Reminiscences*, 1906.

20. W. M. Rossetti, 1903, 273.

21. W. M. Rossetti, 1889, 3. This representation is recirculated in modern literature on Pre-Raphaelitism.

22. W. M. Rossetti, 1895, I, xi. The author did not claim to reveal all: 'I have told what I choose to tell, and left untold what I do not choose to tell; if you want more be pleased to consult some other informant' (I, xii).

23. For example, T. Hall Caine, *Reminiscences of Dante Gabriel Rossetti*, 1882; W. P. Frith, *My Autobiography and Reminiscences*, 1887–8; C. H. Hope, *Reminiscences of Charles West Cope, R. A.*, 1891; F. M. Hueffer, *Ford Madox Brown: A Record of His Life and Work*, 1896; J. W. Mackail, *The Life of William Morris*, 1899; J. G. Millais, *The Life and Letters of Sir John Everett Millais*, 1899; and other examples cited elsewhere in these notes.

24. Gabriel Charles Rossetti styled himself Dante Gabriel Rossetti and is referred to by W. M. Rossetti as Dante Rossetti.

25. R. Buchanan, 'The fleshly school of poetry, the poetry of Mr. D. G. Rossetti', *Contemporary Review*, 1871 (18), 332–50: *The Fleshly School of Poetry and other Phenomena of the Day*, 1872.

26. O. Doughty, *A Victorian Romantic: Dante Gabriel Rossetti*, London, Muller, 1949, 125.

27. W. M. Rossetti, 1906, 193; cf. W. M. Rossetti, 1903, 273: 'She maintained an attitude of reserve, self-controlling and alien from approach'; and Rossetti,

1895, I, 173–4: 'Her character was somewhat singular – not quite easy to understand, and not at all on the surface. Often as I have been in her company . . . I hardly think that I ever heard her say a single thing indicative of her character, or of her serious underlying thought.'

28. W. M. Rossetti, 1895, I, 171; cf. Rossetti, 1903, p. 272 'In Elizabeth Siddal's constitution there was a consumptive taint.'

29. See B. Ehrenreich and D. English, *Complaints and Disorders: The Sexual Politics of Sickness*, London, Writers and Readers Publishing Cooperative, 1973: L. Duffin, 'The conspicious consumptive: woman as invalid', in S. Delamont and L. Duffin (eds), *The Nineteenth-Century Woman*, London, Croom Helm, 1978. It should also be stressed that the death of Elizabeth Eleanor Siddall was not due to consumption or illness but to an accidental overdose of laudanum prescribed for neurological pain following on a stillbirth.

30. V. Surtees (ed.), *The Diary of Ford Madox Brown*, London, Yale University Press, 1982, 101.

31. M. Edwards, 'Elizabeth Eleanor Siddal, the age problem', *Burlington Magazine*, 1977, 119, 112.

32. J. Ruskin to H. Acland, *c.* 1855, MSS Acland, d. 72, fol. 46, Bodleian Library, Oxford pbd. Ruskin 36, 206. F. G. Stephens, *Dante Gabriel Rossetti*, 1894, 36. W. M. Rossetti, 1895, I, 172.

33. Edwards, op. cit., 112.

34. W. M. Rossetti, 1895, I, 171; Rossetti, 1903, 274; W. H. Hunt, *Pre-Raphaelitism and the Pre-Raphaelite Brotherhood*, 1905–6, I, 198–9: Stephens, op. cit., 36.

35. Marsh, op. cit., 20–3 does investigate the Siddall family's position and suggests that as tradesmen or skilled craftsmen and shopkeepers, they hovered on the lower fringes of the bourgeoisie. Charles Siddall called himself a cutler but it is probable that he was not a fully trained and apprenticed silver cutler but one of those who manufactured iron implements and who were greatly resented by the skilled silver cutlers. Their geographical location in South London and their clientele suggest integration into a working-class community. There is no doubt it was viewed from outside with some horror: cf. letters by D. G. Rossetti to William Allingham, 23 July 1854, in which he wrote of 'degradation and corruption' and 'that dark place where she was born'.

36. W. M. Rossetti, 1903, 273, my italics.

37. In the *Burlington Magazine* of 1903 W. M. Rossetti shifted the chronology forward by suggesting that D. G. Rossetti fell in love 'before 1850 was far advanced' – and that an engagement had taken place probably 'before the end of 1851'. A situation for the encounter is imagined: 'Rossetti sat to his friend for the head of the Jester in the oil picture (*Twelfth Night*), and it was probably in the studio of Deverell that he first met his future wife' (274–5). See also divergent accounts in Stephens, op. cit., 36; Frances Deverell's memoirs, discussed in W. M. Rossetti, *The P.R.B. Journal*, (ed. W. Fredeman), Oxford, Clarendon Press, 1975, xx; and Hunt, op cit., 198–9 who indicates that 'Rossetti although he betrayed an admiration from the

beginning, did not for a full year or two profess any strong personal feeling for her'. In September 1850 Hunt and Stephens presented to Jack Tupper that Siddall was Hunt's wife. D. G. Rossetti's response – in a letter to his brother – was to persuade Hunt to apologize – to Tupper (O. Doughty and J. R. Wahl) *Dante Gabriel Rossetti: Letters* (4 vols), Oxford, Clarendon Press, 1965–7, vol. I, 92.

38. W. M. Rossetti, *The P.R.B. Journal*, 1975, 34, 37, 59–62, 65–8, 83–4.
39. W. M. Rossetti, *The P.R.B. Journal*, 1975, 62, 67.
40. W. M. Rossetti, 1903, 274.
41. W. M. Rossetti, 1895, 188.
42. T. Hilton, *The Pre-Raphaelites*, London, Thames & Hudson, 1970, 101.
43. ibid., 179–81.
44. A. I. Grieve, *The Art of D. G. Rossetti: The Watercolours and Drawings of 1850–55*, Norwich, Real World Books, 1978, 71–2. This text and others by the same author are marked by different emphases to other publications on Rossetti; they do not engage in sensationalist biography. Rather they are concerned to install Rossetti as a precursor to the 'modern movement' for his art is claimed to be as 'uncompromisingly visual as, say, Morris Louis's stain paintings' (p.3).
45. ibid., 71.
46. R. Pearsall, *The Worm in the Bud: The World of Victorian Sexuality*, Harmondsworth, Penguin Books, 1969, 103, xiv.
47. R. Pearsall, *'Tell me Pretty Maiden': The Victorian and Edwardian Nude*, Harmondsworth, Penguin Books, 1981, cited in L. Nead's review, 'Representation, sexuality and the nude', *Art History*, 1983, 6 (2).
48. M. Foucault, *The History of Sexuality, I: An Introduction* (1976), London, Allen Lane, 1979.
49. L. Nead's article, see note 47, challenges these prevalent myths about Victorian sexuality and morality and draws upon J. Weeks's historical analysis in *Sex, Politics and Society: The Regulation of Sexuality since 1800*, London, Longman, 1981.
50. Parker and Pollock, op. cit., chapter 3.
51. Sexuality is to be understood here not as a personal innate essence or drive which can be expressed or repressed, and not as the origin or cause for the work of art. Rather it is defined by Michel Foucault: 'Sexuality must not be thought of as a kind of natural given which power tries to hold in check, or as an obscure domain which knowledge tries gradually to uncover. It is the name given to a historical construct; not a furtive reality that is difficult to grasp, but a great surface network in which the stimulation of bodies, the intensification of pleasures, the incitement to discourse, the formation of special knowledges, the strengthening of controls and resistances, are linked to one another, in accordance with a few major strategies of knowledge and power.' Foucault, op. cit. (1979), 105–6.
52. Nicoll, op. cit., 85.
53. In certain variants, as has been noted, it is stated that 'Rossetti and Lizzy alone, lived together, slept together'. Hilton, op. cit., 101.

54. Gere, op. cit., 14; cf. 'model, mistress and housekeeper . . . her obvious charms, her rough good nature and robust health coupled to a total lack of education, offered perhaps too welcome a contrast to the refined and ailing Lizzie' (catalogue entry on Fanny Cornforth in *Dante Gabriel Rossetti*, Royal Academy, London, 1973, 66, no. 282).

55. V. Surtees, *Dante Gabriel Rossetti 1828–1882: The Paintings and Drawings: A Catalogue Raisonné*, Oxford, Clarendon Press, 1971, I, 68–9. Such considerations reactivate a debate in W. M. Rossetti, 1895, in which issue is taken with W. B. Scott's assertions that 'the paradoxical conclusion that women and flowers were the only objects worth painting was brought about by the appearance of other ladies beside Miss Siddal coming into his [Rossetti's] orbit'. *Autobiographical Notes of the Life of W. B. Scott*, edited by W. Minto, 1892, I, 202. W. M. Rossetti contests this representation of his brother's works. O. Doughty's *A Victorian Romantic* also raised some of these issues within the biographic narrative of Rossetti's life but this work is to be distinguished from the proliferating discourses of the 1960s onwards in which a specific notion of 'liberated' sexuality is proposed as the decisive feature of and explanatory factor for his art.

56. See Essay 6.

57. Surtees, op. cit., I, 157 ff. The section 'Portraits' is divided into (Identified) and Unidentified.

58. On authorship debates see M. Foucault, 'What is an author?', *Screen*, 1979, 20 (1), 13–34, and G. Nowell-Smith, 'Six authors in pursuit of *The Searchers*', *Screen*, 1976, 17 (1).

59. Surtees, catalogue nos 272 (Mrs Ford Madox Brown), 274 (Mrs Ford Madox Brown), 276 (Lady Burne-Jones), 268 (Fanny Cornforth), 288 (Fanny Cornforth), 325 (Louisa Ruth Herbert), 354 (Annie Miller), 363 (Mrs William Morris), 365 and 399 of the same name. (The nomenclature is from Surtees.)

60. Contrast for instance Surtees, nos 273, 274 (Mrs Ford Madox Brown), 268 and 288 (Fanny Cornforth), 363 and 364 (Mrs William Morris).

61. In the *Burlington Magazine*, 1903, W. M. Rossetti's essay is accompanied by 'Fascimiles of five unpublished drawings by Dante Rossetti in the collection of Harold Hartley'. Four of these show a female figure lounging in an armchair, otherwise unoccupied. They are claimed to be drawings of Elizabeth Siddall. Of one of these drawings (Surtees, no. 486) W. M. Rossetti wrote, 'The face here in its reposeful quiet, presents more of an aspect which prevailed in Miss Siddal, or even predominated' (292).

62. These points will be developed in Essay 6 in which a more detailed analysis of representational practices in this period will be provided. Another approach considering literary production in the 1850s particularly which argues that the discourse on woman is a displaced articulation of problems of the masculine position is C. Christ, 'Victorian masculinity and the angel in the house', in M. Vicinus (ed.), *The Widening Sphere*, London, Methuen, 1980, 146–62.

63. L. Bland, 'The domain of the sexual: a response', *Screen Education*, 1981 (39).

64. L. Nead, 'Woman as temptress: the siren and the mermaid in Victorian

painting', *Leeds Art Calendar*, 1982, no. 91, and Nead, 'Representation, sexuality and the nude', (see note 47).

65. For example, *Beatrice Meeting Dante at a Wedding Feast Denies Him Her Salutation* (Surtees, I, no. 50), *Dante Drawing an Angel at the Anniversary of the Death of Beatrice* (Surtees, I, no. 58), *Dante's Dream at the Time of the Death of Beatrice* (Surtees, I, no. 81), *The Salutation of Beatrice* (Surtees, I, no. 116A, 116D).

66. See *The Pre-Raphaelites*, London, Tate Gallery, 1984, *Lady Clare* 1854–7 (England, private collection) (222), *Lady of Shalott*, 1853 (London, Jeremy Maas) (198).

67. Deborah Cherry and Griselda Pollock, 'Patriarchal power and the Pre-Raphaelites', *Art History*, 1984, 7 (4), 494.

6 WOMAN AS SIGN: PSYCHOANALYTIC READINGS

1. Jacqueline Rose, 'Sexuality in the field of vision', in Kate Linker (ed.), *Difference On Representation and Sexuality*, New York, New Museum of Contemporary Art, 1985, 33. Also reprinted in J. Rose, *Sexuality in the Field of Vision*, London, Verso Books, 1986.

2. See Essay 4, p. 113.

3. Francis L. Fennell, *Dante Gabriel Rossetti: An Annotated Bibliography*, New York, Garland Publishing, 1981.

4. Una Stannard, 'The mask of beauty', in Vivian Gornick and Barbara K. Moran (eds), *Woman in a Sexist Society*, New York, Mentor Books, 1972, 187.

5. ibid., 191.

6. For example Jacqueline Rose in the essay cited in note 1.

7. John Tagg, 'Power and photography', *Screen Education*, 1980 (36), 53.

8. 'One of them, and he was perhaps always the organizer and driving spirit of the Brotherhood, formed a new group of seven, and this second wave was to bring Pre-Raphaelite painting international fame and a major role in the European symbolist movement.' Alan Bowness, *The Pre-Raphaelites*, London, Tate Gallery, 1984, 26.

9. Michel Foucault, 'What is an author?' *Screen*, (1969), 1979, 20 (1); also reprinted in *Language Counter-Memory Practice*, Oxford, Basil Blackwell, 1977. Authorship theory argues that the author is to be understood as the effect of the text to which an authorname is apprehend, i.e. not a unitary source and originator of meanings but an entity construed by both the production (writing) and consumption (reading) of texts. This analysis of the textually construed author is to be distinguished from the valid recognition of a social producer of texts, located in specific social and gender relations of production. The conditions of production which determined the making of works by Rossetti – for whom the work was made how, and from what economic as well as ideological resources – do merit historical analysis since they were not typical of artists of this period but none the less are significant in terms of the shift taking place to fully capitalized modes of artistic production. This is not my concern here but the subject of another paper in progress.

10. Frederick W. H. Myers, 'Rossetti and the religion of beauty', *Essays Modern*,

London, 1897, reprinted in Derek Sandford (ed.), *Pre-Raphaelite Writing: An Anthology*, London, Dent, 1973, 95.

11. Alistair Grieve, 'The work of Dante Gabriel Rossetti', London University, PhD thesis, 1969. For a nineteenth-century statement of the art for art's sake argument and its Venetian connection see F. G. Stephens writing on *The Blue Bower* (VS 178) in *The Athenaeum*, 21 October 1865 (1982), 545–6: 'like a lyrical poem, which aims at effects quite as much by means of inherent beauty and melodious colouring as by mere subject, which is superficial. Titian and Giorgione produced lyrics of this sort in abundance.'

12. John Nicoll, *Rossetti*, London, Studio Vista, 1975, 96–7.

13. Virginia Allen, '"One strangling golden hair": Dante Gabriel Rossetti's *Lady Lilith*', *Art Bulletin*, June 1984, LXVI (2).

14. Jacques Lacan, 'What is a picture?' in *The Four Fundamental Concepts of Psychoanalysis*, edited by J. A. Miller, translated by A. Sheridan, Harmondsworth, Penguin Books, 1979, 111: 'In a way that is at once vague and precise, and which concerns only the success of the work, Freud declares that if a creation of desire, which is pure at the level of the painter, takes on commercial value . . . it is because its effect has something profitable for society, for that part that comes under its influence. Broadly speaking, one can say that the work calms people, comforts them. . . . But for this to satisfy them so much, it must also be that other effect, namely, that *their* desire to contemplate finds some satisfaction in it.'

15. G. H. Fleming, *That Ne'er Shall Meet Again: Rossetti, Hunt, Millais*, London, Michael Joseph, 1971, 161.

16. The memorial implications became explicit in the painting *Beata Beatrix* 1864, London, Tate Gallery, VS 168 in Virginia Surtees, *Dante Gabriel Rossetti 1828–1882. The Paintings and Drawings, A Catalogue Raisonné*, Oxford, Clarendon Press, 1971. Henceforward all works by Rossetti will be referenced to this catalogue by number and VS prefix. The relation between mourning and melancholia were explored in a paper of that title by Freud in 1917.

17. Cited in Fleming, op. cit., 161. Compare the comment of Algernon Swinburne that *Bocca bacciata* was 'more stunning than can decently be expressed', recorded in *The Diaries of George Price Boyce*, edited by V. Surtees, Norwich, 1980, p. 89.

18. Cited in Surtees, op. cit., I, 69.

19. See Jeffrey Weeks, *Sex, Politics and Society, The Regulation of Sexuality since 1800*, London, Longman, 1981, 21, and for fuller discussion see Heather Dawkins, 'Diaries and photographs of Hannah Cullwick', *Art History*, 1987, 10 (2).

20. See note 18.

21. Catherine Hall, 'The early formation of Victorian domestic ideology', in Sarah Burman (ed.), *Fit Work for Women*, London, St Martin's Press, 1979.

22. Peter Cominos, 'Late Victorian sexual respectability and the social system,' *International Review of Social History*, 1963 (8).

23. For discussion of Rossetti and the Venetian models for these paintings see

Diane MacLeod, *Dante Gabriel Rossetti: A Critical Study of the Late Works*, University Microfilms, Ann Arbor, 1983.

24. For instance, Henri Gervex, *Rolla*, 1878, Bordeaux, Musée des Beaux Arts; for discussion see Hollis Clayson, 'Representations of prostitution in early Third Republic France', PhD thesis, University of California, 1984.

25. Quoted by Susan Casteras, 'The double vision in portraiture', in Maryan Wynn Ainsworth, *Dante Gabriel Rossetti and the Double Work of Art*, New Haven, Yale University Art Gallery, 1976. See also William Holman Hunt, *Pre-Raphaelitism and the Pre-Raphaelite Brotherhood*, London, 1905–6, vol. I, 341: 'Rossetti's tendency then in sketching a face was to convert the features of the sitter to his favourite ideal type, and if he finished along these lines, the drawing was extremely charming, but you had to make believe a good deal to see the likeness.'

26. Comment derives from T. J. Clark, 'Preliminaries to a possible treatment of *Olympia* in 1865', *Screen*, 1980, 20 (1), 36.

27. Lance K. Donaldson-Evans, *Love's Fatal Glance: A Study of Eye Imagery in the Poets of the Ecole Lyonnaise*, University of Mississippi, Romance Monographs Inc., 1980. I am grateful to Dr Patricia Simons of Sydney University for this reference and discussion of this paper.

28. John Berger, *Ways of Seeing*, London, BBC and Penguin Books, 1972, 52, discussion of Charles II's commission of a portrait of Nell Gwynne by Peter Lely.

29. Sarah H.P. Smith, 'Dante Gabriel Rossetti's flower imagery and the meaning of his paintings', PhD thesis, University of Pittsburg, 1978.

30. For example William Blake, 'The sick rose', in *Songs of Innocence and Experience*, 1789–94.

31. Letter dated 1865 to D. G. Rossetti in *The Works of John Ruskin*, ed. E. T. Cook and A. Wedderburn, London, 1903–12, vol. XXXI, 491.

32. The expulsion from the Garden of Eden, from a unity which in patriarchal rewrites of older myths of origin is with the Father God instead of an earth Mother Goddess, dramatizes mythical the transition from a dyadic phase of the imaginary unity with the originator-mother to the world of difference, separation and perpetual loss. In Judaeo-Christian versions of an Oedipus legend its sexism is installed in the fact that Eve is blamed for the separation and made to pay for it.

33. *The Athenaeum*, 21 October 1865, (1982), 546.

34. In his debate with T. J. Clark over *Olympia* (Manet, 1863) Wollen attempted to dispel Clark's doubts about the inconsistency of graphic modes employed within a single image by suggesting that the 'endless oscillation between a fantasy of the *femme fatale*, dominating and ruthless and that of an *odalisque*, compliant, open and abject', may well be explicable in terms of fetishism: 'Fetishism is perhaps the classic instance of how incommensurable operations of the psyche can be sutured, contained, secured, stalemated.' (*Screen*, 1980, 21 (2), 22). I think Wollen is correct to see the development in mid-nineteenth-century visual representation of a particular fetishistic construction of the female form, but I am here suggesting that the oscillation is between the fantasy of the phallic mother and the negative image of the

same, the fatal woman. Particularly relevant to this phenomenon in the work labelled 'Rossetti' is the issue of the scale of the figures and the positioning of the spectator.

35. A work titled *Aspeta Medusa* was commissioned in 1867 by C. P. Mathews of Ind Coope & Co (VS 183) though it was later rejected and the project abandoned. A poem exists of this title.

> Andromeda, by Perseus saved and wed,
> Hankered each day to see the Gorgon's head:
> Till o'er the fount he held it, bade her lean
> And mirrored in the way was safely seen
> That death she lived by.
>
> Let not thine eyes know
> Any forbidden thing itself, although
> It once should save as well as kill; but be
> Its shadow upon life enough for thee.

36. Sigmund Freud, 'Fetishism' (1927), Pelican Freud Library, Harmondsworth, Penguin Book, 1977, vol. 7, *On Sexuality*, 351.
37. John Ellis, 'Photography/pornography, art/pornography', *Screen*, 1980, 20 (1), 101.
38. Laura Mulvey, 'You don't know what is happening, do you, Mr Jones?', *Spare Rib*, 1973 (8), reprinted in Rozsika Parker and Griselda Pollock, *Framing Feminism: Art and the British Women's Movement 1970–1985*, London, Pandora Press, 1987.
39. Laura Mulvey, 'Visual pleasure and the narrative cinema', *Screen*, 1975, 16 (3), 14.
40. Rose, op. cit., 31.
41. Lucy Bland, 'The domain of the sexual, a response', *Screen Education*, 1981 (39), 59.
42. Lee Davidoff, 'Class and gender in Victorian England', in Judith L. Newton *et al.* (eds), *Sex and Class in Women's History*, London, Routledge & Kegan Paul, 1983, 24–7.
43. Sigmund Freud, 'On the universal tendency to debasement in the sphere of love', (1912), Pelican Freud Library, op. cit., vol. 7, 251: 'The whole sphere of love in such people remains divided in two directions personified in art as sacred and profane (animal) love. Where they love they do not desire and where they desire they cannot love. ... The main protective measure against such a disturbance which men have recourse to in this split in their love consists in a psychical *debasement* of the sexual object, the overvaluation that normally attaches to the sexual object being reserved for the incestuous object and its representatives.'
44. F. G. Stephens, *The Portfolio*, May 1894, 68–9.
45. John Ellis, op. cit., 102–5.
46. That is to say, the body which must travail in childbirth and suffer with age. For a contemporary analysis of the conflicts between femininity, its

representations and ageing see Mary Kelly, *Interim*, 1986, discussed in the next chapter.

47. Walter Pater, 'Leonardo da Vinci' (1869), *The Renaissance: Studies in Art and Poetry* (1873), Glasgow, Fontana, 1975, 122–3: 'She is older than the rocks among which she sits; like a vampire she has been dead many times, and learned the secrets of the grave.'

48. Bland, op. cit., 60.

49. Jacques Lacan, 'The mirror phase as formative of the function of the I', in *Ecrits: A Selection*, translated by A. Sheridan, London, Tavistock Press, 1977; Jacqueline Rose, 'The imaginary' in Colin MacCabe (ed.), *The Talking Cure*, London, Macmillan, 1981.

50. Jean Roussel, 'Introduction to Jacques Lacan', *New Left Review*, 1969 (51) 65. See also Steve Burniston and Chris Weedon, 'Ideology, subjectivity and the artistic text', *On Ideology*, Working Papers in Cultural Studies no. 10, Birmingham Centre for Cultural Studies, 1977.

51. Mulvey, op. cit., 7.

52. ibid., 14.

53. I have found Barthes's essay 'The face of Garbo' extremely suggestive in attempting to analyse the development of the face-image; see *Mythologies* (1957), translated by A. Lavers, London, Paladin, 1973. Laura Mulvey's analysis of the iconic function of the image of woman is specifically based on the cinematic machine. She locates fetishistic scopophilia precisely, however, in those moments when the narrative drive and flow of cinematic imagery is suspended by iconic insertions of gigantic close-ups of disembodied faces, unnaturally illuminated and floating freely, abstractly, on the vast surface of the screen. There is a connection from the cinema conditions of viewing such images to other sites of consumption, through the circulation of these close-ups and other fashioned similarly as publicity stills for fans. I am suggesting a structural link between emergence in the mid-nineteenth century of a pictorial convention of representation producing woman as icon in a 'freeze frame' and the insertion into narrative cinema of the atemporal icons which makes Mulvey's analysis particularly pertinent. Fetishism refers, however, not only to the remaking of the imaged figure, but to a structure of viewing which depends upon a relation between separation (of the viewer) – (from) representation – (in a position of) speculation (i.e. a mirror). Although the cinematic machine organizes spectatorship precisely in this fetishizing manner, in the dark, cut off from consciousness of one's own body and place by prolonged immobility and exclusively visual excitation, the viewing of still photographs or framed paintings can achieve a similar structure. In the still image which the cinematic close-up replicates, separation is assured by the absence of what is represented at the time of viewing and by the mirror-like effects of the framed image. The spectatorship of paintings is rhetorically as well as socially cued and these images were produced for relatively private contemplation within the study or home. This fetishistic character of imagery and image consumption as defined by Mulvey is identified

Notes

precisely with the atemporal close-up of a body part. Voyeurism on the other hand concerns narratives of investigation and punishment.

54. Jacqueline Rose, 'Introduction II', in J. Mitchell and J. Rose (eds) *Feminine Sexuality, Jacques Lacan and the Ecole Freudienne*, London, Macmillan, 1982, 42: 'Sexual difference is then assigned according to whether individual subjects do or do not possess the phallus, which means not that anatomical difference *is* sexual difference (the one strictly reducible from the other), but that anatomical difference comes to *figure* sexual difference, that is, becomes the sole representative of what that difference is allowed to be.'

55. Julian Treuherz, *Pre-Raphaelite Paintings from the Manchester City Art Gallery*, Manchester, 1980, 108. The poem written to accompany the painting can be quoted in contrast with this view:

> Mystery: lo! betwixt sun and moon
> Astarte of the Syrians: Venus Queen
> Ere Aphrodite was. In silver sheen
> Her twofold girdle clasps the infinite boon
> Of bliss whereof the heaven and earth commune:
> And from her neck's inclining flower stem lean
> Love-freighted lips and absolute eyes that wean
> The pulse of hearts to the spheres' dominant tune.
> Torch bearing, her sweet ministers compel
> All thrones of light beyond the sky and sea
> The witnesses of Beauty's face to be:
> That face, of Love's all-penetrative spell
> Amulet, talisman, and oracle, –
> Betwixt the sun and moon a mystery.

56. John Goode, 'Woman and the literary text', in Juliet Mitchell and Ann Oakley (eds), *The Rights and Wrongs of Women*, Harmondsworth, Penguin Books, 1976, 218.

57. The theoretical resources used by Goode are clearly the writings of Pierre Macherey, *A Theory of Literary Production*, which also inform T. J. Clark's formulation in his essay 'On the social history of art', in *Image of the People*, London, Thames & Hudson, 1973, from which I am adopting this argument about the way in which texts rework the ideological materials which structure their production.

58. Goode, op. cit., 237.

59. See Raymond Williams, 'The Bloomsbury fraction' in *Problems in Materialism and Culture*, London, Verso Editions, 1980, 158–9. 'But in their effective moment, for all their difficulties, they were not only a break from their class . . . but a means towards the necessary next stage of development of that class itself.' A paper developing William's analysis is in progress.

7 SCREENING THE SEVENTIES: SEXUALITY AND REPRESENTATION IN FEMINIST PRACTICES – A BRECHTIAN PERSPECTIVE

1. For discussion of this strategy against the 'biological' canon of 'all women' shows see Mary Kelly, 'Beyond the purloined image', *BLOCK*, 1983 (9), 68.

2. Kate Linker, 'Foreward', *Difference - On Sexuality and Representation*, New York, New Museum of Contemporary Art, 1984, 5.

3. Hal Foster, 'Post modernism: a preface', in *The Anti-Aesthetic – Essays on Post Modern Culture*, Port Townsend, Bay Press, 1983, reprinted as *Post Modern Culture*, London, Pluto Press, 1985, xii.

4. The ideology of art which neo-expressionist criticism recirculates is simply articulated in this text: 'The artists' studios are full of paint pots again and an abandoned easel in an art school has become a rare sight. Wherever you look in Europe or America you find artists who have rediscovered the sheer joy of painting. . . . In short artists are involved in painting again, it has become crucial to them, and this new consciousness of the contemporary significance of the oldest form of their art is in the air, tangibly, wherever art is being made. This new concern with painting is related to a certain subjective vision, a vision that includes both an understanding of the artist himself as an individual engaged in a search for self-realisation and as an actor on a wider historical state.' Christos M. Joachimides. 'A new spirit in painting', in the catalogue of the title, London, Royal Academy of Arts, 1981, 14.

5. For a fuller account of this see Kate Linker, 'Representation and sexuality', *Parachute*, 1983 (32), reprinted in Brian Wallis (ed.), *Art After Modernism: Rethinking Representation*, New York, New Museum of Contemporary Art and Boston, David R. Godine, 1984. For another site of critical address to psychoanalytically based theories of sexual difference see the issue of *Screen* 1987, 28 (1), 'Deconstructing difference'.

6. Hal Foster, 'Introduction', *Recordings, Art, Spectacle, Culture Politics*, Port Townsend, Bay Press, 1985, 9.

7. ibid., 9–10.

8. T. J. Clark, 'Preliminaries to a possible treatment of *Olympia* in 1865', *Screen*, 1980, 21 (1) 38–41.

9. See *Aesthetics and Politics: Debates Between Ernst Bloch, George Lukacs, Bertolt Brecht, Walter Benjamin, Theodor Adorno*, translation editor Ronald Taylor, London, New Left Books, 1977.

10. Peter Wollen, 'Manet: modernism and avant-garde', *Screen*, 1980, 21 (2), 25.

11. ibid., 23.

12. In his later work on this topic published in *The Painting of Modern Life, Paris in the Art of Manet and His Followers*, New York, Knopff, and London, Thames & Hudson, 1984, Clark does position the prostitute as central to the discourses of modernity but still he attempts to fix this figure in terms of class and not gender relations, see 78, 117.

13. Laura Mulvey, 'Visual pleasure and the narrative cinema', *Screen*, 1975, 16 (3).

14. Carol Duncan and Alan Wallach, 'The Museum of Modern Art as late capitalist ritual: an iconographic analysis', *Marxist Perspectives*, 1978, 1.
15. Lucy Lippard, 'Sweeping exchanges: the contribution of feminism to the art of the seventies', *Art Journal*, 1980, 41 (1/2), 362.
16. Nichole Dubreuil-Blondin, 'Feminism and modernism: some paradoxes', in *Modernism and Modernity. The Vancouver Conference Papers*, edited by Benjamin Buchloh, Halifax, Nova Scotia College of Art and Design Press, 1984, 197.
17. For an example of this attitude see Eva Cockcroft, 'Abstract expressionism: weapon of the cold war', *Art Forum*, June 1984.
18. Mary Kelly, 'Re-viewing modernist criticism', *Screen*, 1981, 22 (3) 45.
19. It should be pointed out that these two formulations are not necessarily compatible and indeed Foucault's analysis implicated psychoanalysis in the historical construction of social regulation of persons via the constructions of sexuality. See Michel Foucault, *The History of Sexuality*, Vol. 1, *An Introduction* (1976) translated by Robert Hurley, London, Allen Lane, 1979. Also see Stephen Heath, *The Sexual Fix*, London, Macmillan, 1982.
20. Anthony Easthope, 'The trajectory of *Screen* 1970–79', in Francis Barker (ed.), *The Politics of Theory*, Colchester, University of Essex, 1983.
21. See *Screen*, 1974, 15 (2), 'Brecht and a revolutionary cinema' and 1975/6, 16 (4), transcript of the Edinburgh Film Festival Brecht Event.
22. Stephen Heath, 'From Brecht to film: theses, problems', *Screen*, 1975/6, 16 (4), 39.
23. Stephen Heath, 'Lessons from Brecht', *Screen*, 1974, 15 (2), 108–9.
24. ibid., 107–8. It is relevant to note the parallels between Heath's arguments and those mounted in the previous chapter. For instance: 'Think in this respect of the photograph, which seems to sustain exactly this fetishistic structure. The photograph places the subject in a relation of specularity – the glance –, holding him pleasurably in the safety of disavowal; at once knowledge – this exists – and a perspective of reassurance – but I am outside this existence . . . the duality rising to the fetishistic category *par excellence*, that of the beautiful', 107.
25. See Roland Barthes, 'The death of the author', in Stephen Heath (ed.) *Image-Music-Text*, London, Fontana, 1977.
26. Julia Kristeva, 'The system and the speaking subject', reprinted in Toril Moi, *The Kristeva Reader*, Oxford, Basil Blackwell, 1986.
27. Louis Althusser, 'Ideology and ideological state apparatuses' in *Lenin and Philosophy and Other Essays*, translated by Ben Brewster, London, New Left Books, 1971.
28. Brecht himself was quite adamant about the historically varying forms of social individuality and because these changed at different stages and epochs of capitalism, cultural practices must be specific to their moments. See E. Bloch *et al.*, *Aesthetics and Politics*, London, Verso Books, 1977, 79.
29. Heath, 'Lessons from Brecht', 1974, 124.
30. See Terry Lovell, *Pictures of Reality. Aesthetics, Politics and Pleasure*, London British Film Institute, 1980.

31. Heath, 'Lessons from Brecht', 1974, 123.
32. See Annette Kuhn, *Women's Pictures: Feminism and Cinema*, London, Routledge & Kegan Paul, 1982; Rozsika Parker and Griselda Pollock, *Framing Feminism: Art and the Women's Movement 1970–85*, London, Pandora Press, 1987.
33. Heath, 'From Brecht to film', 38.
34. ibid., 35.
35. Claire Johnstone and Paul Willemen, 'Brecht in Britain: the independent political film (on *The Nightcleaners*)', *Screen*, 1975/6, 16 (4).
36. Mary Kelly, *Post Partum Document*, London, Routledge & Kegan Paul, 1983, 188.
37. Heath, 'Lessons from Brecht', 124.
38. Colin MacCabe, 'Realism and the cinema: some Brechtian theses', *Screen*, 1974, 15 (2), 12. The point is clearly made in John Tagg, 'Power and photography', *Screen Education*, 1980, 36, 53, where he writes that realism 'works by the controlled and limited recall of a reservoir of similar "texts", by a constant repetition, a constant cross-echoing'.
39. Heath, 'Lessons from Brecht', 120.
40. See Paula Marincola, *Image Scavengers: Photography*, Philadelphia Institute of Contemporary Art, 1982, and Abigail Solomon Godeau, *The Stolen Image and Its Uses*, Syracuse, New York, 1983. Also Abigail Solomon Godeau, 'Winning the game when the rules have been changed: art, photography and postmodernism', *Screen*, 1984, 25 (6).
41. Jean Baudrillard, *For a Critique of the Political Economy of the Sign*, St Louis, Telos Press, 1981 and 'The precession of the simulacra', reprinted in Brian Wallis (ed.), *Art After Modernism: Rethinking Representation*, New York, The New Museum of Contemporary Art, 1984.
42. The panels are reproduced in *Screen*, 1983, 24 (4–5). Other work by Mitra Tabrizian has been published as follows: *College of Fashioning Model Course* in *Screen Education*, 1982 (40), *Women In Iran* in *Feminist Review*, 1982 (12), *Correct Distance, Part I* in *Screen*, 1984, 25 (3-4), *Correct Distance, Part II* in *Feminist Review*, 1984 (28).
43. ibid., 155.
44. ibid., 155.
45. Yve Lomax, 'The politics of montage', *Camerawork*, 1982, 9.
46. *Broken Lines: More and No More Difference*, text and photographs by Yve Lomax, *Screen*, 1987, 28 (1).
47. See *Three Perspectives on Photography*, London, Arts Council, 1978, 52–5, for Yve Lomax's text 'Some stories which I have heard: some questions which I have asked'.
48. Judith Williamson, 'Images of "woman" – the photographs of Cindy Sherman', *Screen*, 1983, 24 (6).
49. Reprinted in *Sense and Sensibility in Feminist Art Practice*, Nottingham Midland Group, 1982. This was a catalogue for an exhibition curated by Carol Jones and introduced by Griselda Pollock.
50. Quoted from a wall panel in the exhibition *Difference On Representation and*

Sexuality, London Institute of Contemporary Art, 1985. Reading this text requires some familiarity with the current of psychoanalytical theory in which representation is premissed on absence, i.e. Freud observed little children playing a game of constantly throwing a toy which was repeatedly returned. Vocalization accompanied this play which Freud read as the beginning of symbolization used to 'cover' the absence of the mother. At the Oedipal moment the gap or lack concerns the mother's phallus which becomes the signifier of lack and the primary signifier in a language system which institutionalizes lack – words are substitutes for absent things and persons. This schema is mapped on to the production of sexual difference in which this play of presence, absence, lack and wholeness produces the binary opposition of man, and woman being lack.

51. Anne Marie Sauzeau Boetti, 'Negative capability as practice in women's art', *Studio International*, 1976, 191 (979), reprinted in Rozsika Parker and Griselda Pollock, *Framing Feminism, Art and the Women's Movement 1970–85*, London, Pandora Press, 1987.

52. For special discussion of the five British artists see Lisa Tickner's essay in the catalogue for the show.

53. 'For time flows on . . . methods become exhausted; stimuli no longer work. New problems appear and demand new methods. Reality changes; in order to represent it, modes of representation must also change.' Bertolt Brecht, 'Against George Lukacs', in E. Bloch *et al.*, *Aesthetics and Politics*, London, New Left Books, 1977, 82.

54. Sylvia Harvey, 'Whose Brecht? Memories for the eighties', *Screen*, 1982, 23 (1), 45-59.

55. Laura Mulvey, 'Visual pleasure and the narrative cinema', *Screen*, 1975, 16 (3), 8.

56. Based on a conversation with Paul Smith in *Parachute*, 1982 (26), reprinted in *Sense and Sensibility in Feminist Art Practice*, Nottingham Midland Group, 1982, n.p. See also Griselda Pollock, 'Theory and pleasure', introduction to the same catalogue.

57. The issue is more fully explained in Mary Kelly, 'Desiring images/imaging desire', in *Wedge* (USA), 1984 (6), another version of the paper is printed in *Desire: ICA Documents*, London, Institute of Contemporary Arts, 1984. The point also links back to discussions at the end of Essay 3.

58. Sylvia Harvey, op. cit., 56.

59. The major reference point for analysing the social inscriptions in the family album of snaps is Jo Spence, *Beyond the Family Album*, 1979. See Jo Spence, *Picturing Myself; A Political and Personal Autobiography*, London, Camden Press, 1986.

60. Marie Yates, 'Photography and fine art, Part 2', *Ten: 8*, 1986 (23), 39.

61. ibid.

62. Bertolt Brecht quoted in Heath, 1974, 'Lessons from Brecht', 126.

63. Monika Gagnon, 'Texta scientiae (the enlancing of knowledge) Mary Kelly's "Corpus"', *C magazine*, 1986, Summer (10), 28.

64. Joanne Isaak, 'Women the ruin of representation', *Afterimage*, 1985, 12 (9), 5.

65. Kelly, 'Desiring images/imaging desire', 9 (note 57).
66. See Angela Partington's essay in Hilary Robinson (ed.), *Visibly Female*, London, Camden Press, 1987.
67. For a reading of diverse forms of feminist identificatory art and its relation to narcissism see Mary Kelly, 'On sexual politics and art' in Brandon Taylor (ed.), *Art and Politics*, Winchester School of Art, 1980, reprinted in Rozsika Parker and Griselda Pollock, *Framing Feminism, Art and the Women's Movement 1970–85*, London, Pandora Press, 1987; see also Kelly, 'Desiring images/imaging desire'.
68. See *Feminine Sexuality: Jacques Lacan and the Ecole Freudienne*, edited by Juliet Mitchell and Jacqueline Rose, London, Macmillan, 1982.
69. Sylvia Harvey, 'Whose Brecht? Memories for the eighties,' *Screen*, 1982, 23 (2), 58.

BIBLIOGRAPHY

Adler, K. and Garb, T. (1987) *Berthe Morisot*. Oxford, Phaidon Press.

Althusser, L. (1971) *Lenin and Philosophy and Other Essays* translated by B. Brewster. London, New Left Books.

—— (1983) *Essays on Ideology*. London, New Left Books.

Antal, F. (1966) *Essays in Romanticism and Classicism*. London, Routledge & Kegan Paul.

Ardener, S. (1981) *Women and Space*. London, Croom Helm.

Barker, F. (1983) *The Politics of Theory*. Colchester, University of Essex.

Barthes, R. (1977) *Image-Music-Text* translated by S. Heath. London, Fontana.

—— (1957) *Mythologies* translated by A. Lavers. London, Paladin (1973).

Bashkirtseff, M. (1890) *The Journals of Marie Bashkirtseff* (ed. M. Blind, 1890), introduced by R. Parker and G. Pollock. London, Virago (1984).

Baudelaire, C. (1863) *The Painter of Modern Life* translated by J Mayne. Oxford, Phaidon Press (1964).

Benjamin, W. (1973) *Charles Baudelaire: Lyric Poet in the Era of High Capitalism*. London, New Left Books.

Betterton, R. (1987) *Looking On: Images of Femininity in the Visual Arts and Media*. London, Pandora Press.

Bland, L. (1981) 'The domain of the sexual: a response'. *Screen Education* (39).

Bloch, E. (1977) *Aesthetics and Politics*. London, New Left Books.

Broude, N. and Garrard, M. (1982) *Feminism and Art History*. New York, Harper & Row.

Burniston, S. and Weedon, C. (1977) 'Ideology, subjectivity and the artistic text'. 'On Ideology' Working Papers in *Cultural Studies* (10); also in *On Ideology*, London, Hutchinson (1978).

Cambridge Women's Study Group (1981) *Women in Society: Interdisciplinary Essays*. London, Virago.

Cherry, D. (1983) 'Surveying seamstresses'. *Feminist Art News* (9).

Cherry, D. and Pollock, G. (1984) 'Patriarchal power and the pre-Raphaelites'. *Art History* 7 (4).

Christ, C. (1980) 'Victorian masculinity and the angel in the house' in M. Vicinus (ed.) *The Widening Sphere*. London, Methuen.

Clark, T.J. (1974) 'On the conditions of artistic creation'. *Times Literary Supplement*, 24 May.

—— (1980) 'Preliminaries to a possible treatment of "Olympia" in 1865'. *Screen*, 21 (1).

—— (1984) *The Painting of Modern Life: Paris in the Art of Manet and his Followers*. London, Thames & Hudson.

Clayson, H. (1984) 'Representations of prostitution in early Third Republic France'. PhD. thesis, University of California.

Comer, L. (1978) 'Women and class'. *Women's Studies Quarterly*, 1.

Cominos, P. (1963) 'Late Victorian sexual respectability and the social system'. *International Review of Social History*, 8.

Cowie, E. (1978) 'Woman as sign'. *M/F* (1).

Davidoff, C. and L. (1983) 'The architecture of public and private life . . .' in D. Fraser and A. Sutcliffe (eds), *In Pursuit of Urban History*. London, Edward Arnold.

Davidoff, L. (1983) 'Class and gender in Victorian England' in J.L. Newton (ed.) *Sex and Class in Women's History*. London, Routledge & Kegan Paul.

Dawkins, H. (1987) 'The diaries and photographs of Hannah Cullwick'. *Art History*, 1987, 10 (3).

Degler, C. (1974) 'What ought to be and what was: women's sexuality in the 19th Century'. *American Historical Review*, 79.

Delamont, S. and Duffin, L. (1978) *The Nineteenth-Century Woman*. London, Croom Helm.

Doane, M.A. (1982) 'Film and the masquerade: theorising the female spectator'. *Screen* 23 (3/4).

Dubreuil-Blondin, N. (1983) 'Modernism and feminism: some paradoxes' in B. Buchloh (ed.) *Modernism and Modernity*. Halifax, NASCAD Press.

Duncan, C. (1973) 'Happy mothers and other new ideas in French art'. *Art Bulletin*, 56 (101).

Duncan, C. and Wallach, A. (1978) 'The Museum of Modern Art as late capitalist ritual . . .'. *Marxist Perspectives*, 1.

Ehrenreich, B. and English, D. (1973) *Complaints and Disorders: The Sexual Politics of Sickness*. London, Writers and Readers.

Ellis, J. (1980) 'Photography/pornography: art/pornography'. *Screen*, 20 (1).

Fleming, L. (1983) 'Lévi-Strauss, feminism and the politics of representation'. *Block* (9).

Foster, H. (1983) *The Anti-aesthetic: Essays on Post Modern Culture*. Washington, Port Townsend, Bay Press (1983), London, Pluto Press (1985).

—— (1985) *Recordings: Art, Spectacle, Cultural Politics*. Washington, Port Townsend, Bay Press.

Foucault, M. (1969) *The Archaeology of Knowledge*, translated by A. Sheridan Smith. London, Tavistock (1972).

Bibliography

——— (1969) 'What is an author?' *Screen*, 20 (1).

——— (1975) *Discipline and Punish: The Birth of the Prison*, translated by A. Sheridan, London (1977).

——— (1979) *The History of Sexuality: An Introduction*. London, Allen Lane.

Fox-Genovese, E. (1982) 'Placing women's history in history'. *New Left Review* (133).

Freud, S. (1927) 'Fetishism'. *On Sexuality*, vol. 7 in Pelican Freud Library, Harmondsworth, Penguin Books (1977).

Gagnon, M. (1986) 'Texta scientiae (the enlacing of knowledge) Mary Kelly's "Corpus"'. *C Magazine* (10).

Gallop, J. (1982) *Feminism and Psychoanalysis: The Daughter's Seduction*. London, Macmillan.

Garb, T. (1986) *Women Impressionists*. Oxford, Phaidon Press.

Gardiner, J. (1977) 'Women in the labour process and class structure' in A. Hunt (ed.) *Class and Class Structure*. London, Lawrence & Wishart.

Gilman, S. (1985) *Difference and Pathology: Stereotypes of Sexuality, Race and Madness*. Ithaca and London, Cornell University Press.

Gornick, V. and Moran, B.K. (1972) *Woman in a Sexist Society*. New York, Mentor Books.

Greer, G. (1979) *The Obstacle Race*. London, Weidenfeld & Nicholson.

Gronberg, T.A. (1984) 'Les Femmes de Brasserie'. *Art History*, (3).

Hadjinicolaou, N. (1973) *Art History and Class Struggle* translated by L. Asmal. London, Pluto Press (1978).

Hall, C. (1979) 'The early formation of Victorian domestic ideology' in S. Burman (ed.) *Fit Work for Women*. London, St Martin Press.

——— (1981) Gender divisions and class formations . . .' in R. Samuel (ed.) *People's History and Socialist Theory*. London, Routledge & Kegan Paul.

Hall, S. (1974) 'Marx's notes on method: a "Reading" of the "1857 introduction"'. *Cultural Studies* (6).

Hartman, H. (1979) 'The unhappy marriage of marxism and feminism'. *Capital and Class* (8).

Harvey, S. (1982) 'Whose Brecht? memories for the eighties.' *Screen*, 23 (1).

Heath, S. (1974) 'Lessons from Brecht'. *Screen*, 15 (2).

——— (1975) 'From Brecht to film: theses, problems'. *Screen*, 16 (4).

Isaak, J. (1985) 'Women – the ruin of representation'. *Afterimage*, 12.

Kelly, J. (1984) *Woman, History and Theory*. Chicago, University of Chicago Press.

Kelly, M. (1980) 'On sexual politics and art' in B. Taylor (ed.) *Art and Politics*. Winchester, School of Art.

——— (1981) 'Reviewing modernist criticism'. *Screen*, 22 (3).

——— (1983) *The Post Partum Document*. London, Routledge & Kegan Paul.

——— (1983) 'Beyond the purloined image'. *Block* (9).

——— (1984) 'Desiring images/imaging desire'. *Wedge* (6).

——— (1985) *Interim*. Edinburgh, Fruit-market Gallery and Riverside Studios.

Kristeva, J. (1973) 'The system and the speaking subject' (*Times Literary Supplement*) reprinted in T. Moi (ed.) *The Kristeva Reader*. Oxford, Basil Blackwell (1986).

Kuhn, A. (1982) *Women's Pictures: Feminism and the Cinema*. London, Routledge & Kegan Paul.

Kuhn, T. (1962) *The Structure of Scientific Revolutions*. Chicago, Chicago University Press.

Lacan, J. (1977) *Ecrits* translated by A. Sheridan. London, Tavistock.

—— (1979) *The Four Fundamental Concepts of Psychoanalysis* translated by A. Sheridan. Harmondsworth, Penguin Books.

Lewis, R.C. and Lasner, M.S. (1978) *Poems and Drawings of Elizabeth Siddall*. Wolfville, Nova Scotia, Wombat Press.

Linker, K. (1985) *Difference: On Representation and Sexuality*. New York, New Museum of Contemporary Art.

—— (1983) 'Representation and sexuality'. *Parachute* (32).

Lippard, L. (1980) 'Sweeping exchanges: the contribution of feminism to the art of the seventies.' *Art Journal* 41 (1/2).

Lipton, E. (1975) 'Manet and a radicalised female imagery'. *Art Forum*, 13 (7).

—— (1987) *Looking into Degas*. Los Angeles, University of California Press.

Lomax, Y. (1983) 'The politics of montage'. *Camerawork*, 9.

MacCabe, C. (1974) 'Realism and the cinema: some Brechtian theses'. *Screen*, 15 (2).

Macherey, P. (1978) *A Theory of Literary Production* translated by G. Wall. London, Routledge & Kegan Paul.

Macmillan, J. (1981) *From Housewife to Harlot: French Nineteenth-Century Women*. Brighton, Harvester Press.

Marks, E. and de Courtivron, I. (1981) *New French Feminisms*. Brighton, Harvester Press.

Marsh, J. (1985) *The Pre-Raphaelite Sisterhood*. London, Quartet Books.

Marx, K. (1857) *Grundrisse* translated by M. Nicolaus. Harmondsworth, Penguin Books (1973).

Marx, K. and Engels, F. (1970) *Selected Works in One Volume*. London, Lawrence & Wishart.

Mitchell, J. (1974) *Psychoanalysis and Feminism*. London, Allen Lane.

Mitchell, J. and Oakley, A. (1976) *The Rights and Wrongs of Women*. Harmondsworth, Penguin Books.

Mitchell, J. and Rose, J. (1982) *Feminine Sexuality: Jacques Lacan and the Ecole Freudienne*. London, Macmillan.

Morisot, B. (1986) *The Correspondence of Berthe Morisot*, ed. D. Rouart (1953), introduced by K. Adler and T. Garb. London, Camden Press.

Mulhern, F. (1980) 'On culture and cultural struggle'. *Screen Education* (34).

Mulvey, L. (1973) 'You don't know what is happening, do you, Mr. Jones?' *Spare Rib* (8) (1983) in Parker and Pollock, *Framing Feminism*. London, Pandora (1987).

—— (1975) 'Visual pleasure and narrative cinema. *Screen*, 16 (3).

—— (1981) 'Afterthoughts on visual pleasure and narrative cinema'. *Framework* (15/17).

—— (1985) 'Changes'. *Discourse* (Fall).

Nead, L. (1983) 'Representation, sexuality and the nude'. *Art History* (2).

Bibliography

Nemser, C. (1972) 'Stereotypes and women artists'. *Feminist Art Journal* (April).

Nochlin, L. (1973) 'Why have there been no great women artists?' in E. Baker and T. Hess, *Art and Sexual Politics*. London, Collier Macmillan.

—— (1982) 'The depoliticisation of Courbet . . .' *October* (22).

Nochlin, L. and Sutherland Harris, A. (1976) *Women Artists 1550–1950*. New York, Alfred Knopf.

Orton, F. and Pollock, G. (1980) 'Les données Bretonnantes . . .' *Art History*, 3 (3).

Parker, R. and Pollock, G. (1981) *Old Mistresses: Women, Art and Ideology*. London, Routledge & Kegan Paul; Pandora Press (1986).

—— (1987) *Framing Feminism: Art and the Women's Movement 1970–85*. London, Pandora.

Phillips, A. and Taylor, B. (1980) 'Sex and skill: notes towards a feminist economics'. *Feminist Review* (6).

Pollock, G. (1980) 'Artists, media and mythologies'. *Screen*, 21 (3).

—— (1980) *Mary Cassatt*. London, Jupiter Books.

—— (1984) 'The history and position of the contemporary woman artist'. *Aspects* (28).

—— (1985) 'Art, art school and culture'. *Block*, 1985/6, (11); *Exposure*, 24 (3) (1986).

Robinson, H. (1987) *Visibly Female*. London, Camden Press.

Rose, J. (1986) *Sexuality in the Field of Vision*. London, Verso Books.

Said, E. (1978) *Orientalism*. London, Routledge & Kegan Paul.

Schapiro, M. (1937) 'On the nature of abstract art'. *Marxist Quarterly* (Jan. – Mar.).

Sennett, R. (1977) *The Fall of Public Man*. Cambridge, Cambridge University Press.

Silverman, K. (1983) *The Subject of Semiotics*. Oxford, Oxford University Press.

Simmel, G. (1969) 'The metropolis and mental life' in R. Sennett (ed.) *Classic Essays on the Culture of the City*. New York, Appleton.

Smith, B.G. (1981) *Ladies of the Leisure Class*. Princeton, Princeton University Press.

Smith-Rosenberg, C. (1985) *Disorderly Conduct: Visions of Gender in Victorian America*. New York, Alfred Knopf.

Spence, J. (1986) *Picturing Myself: A Political and Personal Autobiography*. London, Camden Press.

Spender, D. (1981) *Men's Studies Modified – The Impact of Feminism on the Academic Disciplines*. Oxford, Pergamon Press.

Tagg, J. (1980) 'Power and photography'. *Screen Education* (36).

Vergine, L. (1982) *L'Autre moitié de l'avant-garde 1910–1940*. Paris, Des Femmes.

Vogel, L. (1974) 'Fine arts and femininism: the awakening conscience'. *Feminist Studies* (2).

Wallis, B. (1984) *Art After Modernism: Re-thinking Representation*. Boston, David R. Godine.

Watney, S. (1984) 'Modernist studies: the class of '83'. *Art History*, 7 (1).

Weeks, J. (1981) *Sex, Politics and Society: The Regulation of Sexuality since 1800.* Harlow, Longman (1983).

Williams, R. (1980) 'Base and superstructure in Marxist cultural theory' essay in *Problems in Materialism and Culture.* London, Verso.

Wolff, J. (1981) *The Social Production of Art.* London, Macmillan.

—— (1985) 'The invisible flâneuse: women and the literature of modernity'. *Theory, Culture and Society,* 2 (3).

Wollen, P. (1980) 'Manet, modernism and avant-garde'. *Screen,* 20 (2).

Wright, E. (1984) *Psychoanalytic Criticism: Theory in Practice.* London, Methuen.

Yates, M. (1987) 'Photography and fine art'. *Ten:8* (23).

Young, R. (1986) 'Sexual Difference'. *The Oxford Literary Review* 8 (1 and 2).

INDEX

Index

233

Index

Kelly's *PPD* 170–1; and modernist art history 2; and psychoanalysis 12–13; visual 28; and women's studies 1
image, and Lacanian theory 147, 148
imaged discourse 170, 198
Image Scavengers (exhibition, 1982) 171
imaginary order/mode/phase 145–6, 148
impressionist painting 52
Impressionists 55
individualism 11, 20, 97, 159
inscription
and description 123; product of art as 83; of sexual difference 8, 81, 84, 123; unconscious as site of 127; and working process 84; writing as 170
Institute of Contemporary Arts, London 155
Irigaray, Luce 50, 87n

Jones, Allen 140

Kaufmann, Angelica 45
Kelly, Mary
and depropriation 171; on feminist art 8, 15, 87n, 155, 156, 160–2; on woman as spectator 86–7; *Corpus* 188, 189–97; *Interim* 187–98; *Post partum document* (*PPD*) 158, 167–71, 180; *Women and work* 166, 168
kinship 31, 95
Knorr, Karen 171
Kolbowski, Sylvia 155
Krowle, Judith 171
knowledge 7, 11
Kruger, Barbara 155
Kuhn, Thomas 2

Labadists 38
Lacan, Jacques, and Lacanian Theory 12, 145, 161, 162, 169, 188
'Lack's last laugh' 178
ladyhood 131
language
of art 46; and culture 31; and formation of subject 169–70; and ideology 21; and psychoanalysis and meaning 155–6; and sexual identity 33; and sexuality and meaning 155–6; and symbolic order 145–6
Lapouge, G. 50
Laver, James 26, 27
Lebrun, Elisabeth Vigée, *see* Vigée Lebrun, Elisabeth
Leeds University 121
leisure 16, 52

Levine, Sherrie 155
Lévi-Strauss, Claude 31, 95
Leyster, Judith: *The proposition* 37–8
liberal feminism 35
Linker, Kate 155
Lippard, Lucy 160
Lipton, Eunice 88
literary: analysis 152; criticism 3–4, 26; realism 164; studies 6; theory 12
Lomax, Yve 155, 156, 171, 174–9, 180; *Open rings and partial lines* 176–7, 179
look
and Cassat's work 75; feminine as object of 114; Irigaray on 50; of masculine spectator 134; and Rossetti's work 113, 126; and sexual difference 84; space of 66
looking
Freud on 148; for men or women 81; sexual politics of 85–6; and scopic field 13
love, and desire 130, 153
Lukacs, George 157, 163, 164

madonna(s) 126, 145
madonna/Magdalen 113
man, meaningfulness of term 148
Manet, Edouard 34, 52–3, 62, 73, 74, 80; *A bar at the Folies-Bergère* 52, 53, 54, 85; *Before the mirror* 81; *Musique aux Tuileries* 74; *Olympia* 52, 54n, 74–5, 85, 157, 158–9
manliness 131
Marcus, Steven 109
Marie Antoinette 46, 47, 48
Marx, Karl 2–3, 4, 6
Marxist cultural theory 2–6, 13, 14; and feminist art histories 18–49
masculine: creativity 21, 94–5, 106; sexuality 147, 154; spectator 75
masculinity
of art 40; of artist 11, 20–1; bourgeois ideas of 11, 140; definitions of 9, 21–2, 108; and femininity 33–4, 92, 122; in Lacanian theory 149; and modernist painting 159; and Rossetti's work 124; social determination of 114; spaces of 62, 84
materialism 5, 13, 161
materiality 160–1, 163, 169
meaning
and language and sexuality 155–6; and materiality 160; and Other 187; in paintings 149; passive consumption of 180; and *PPD* (Kelly)

235

Index

paradigm 2; of woman in art 160
paradigm shift 2, 5, 17
paradigms of practice 14
Paris 51–2, 55, 62, 70, 72–3, 78, 88
Parker, Rozsika 11, 21, 23, 41, 55, 81
Pater, Walter 126, 144
patriarchal: discourse 187; ideologies of art 96; social relations, changing 24; visual field 15
patriarchy
definitions of 32–3; and Lacanian theory 156
Pearsall, Ronald 109–10
personal, the: feminist theorization of 169
perspective 64
Petersen, J.J. 38–9
phallocentrism 147–8, 177
phenomenology 65
photography
documentary 174; illusions of 121, 124; and truth 175
Picasso, Pablo: *Demoiselles d'Avignon* 54, 159
pleasure
Brechtian definition of 179; feminists and 180; visual 14, 126, 128, 130
pluralism 23
'political modernism' 179, 198
politics, *see* feminist art history, sexual politics
Pollock, Griselda 11, 21, 23, 41, 55, 81, 91, 120, 162
pop art 140
pornography 130, 140
portraits 122
positionality 13, 81–2, 123, 148
postmodernism 14, 158, 160, 199
'post-modernism of reaction' 156
post-structuralism 162, 182, 199
PPD, see Kelly, Mary, *Post partum document*
power
and art history 11, 114; of bourgeois man 25, 113, 141; and gender 8, 9, 12, 54, 55, 79; network of 99; and relationships 33; regimes of 1
practice 4
Pre-Raphaelites 91–115
Pre-Raphaelites, The (exhibition, 1984) 16–17, 114–15
Pre-Raphaelitism, studies of 11
private/public division 67–71
private sphere 67, 79–85
problematic 8, 17, 198

producer/viewer 83, 123, 182, 187
production
art and 19, 27, 126, 160–1; and Brechtian theory 171; and consumption 126, 160–1, 171; cultural 5, 12, 17, 20, 30; social locus of 183; use of term 2–4
prostitute(s) 131, 144
proximity 63, 87
Psychoanalyse et Politique 12
psychoanalysis, and feminism 12–13, 40, 127–8, 147, 149, 156–9, 162, 167, 190, 198–9 *and see* Freud, Lacan
public/private division 67–71
public spaces 75–9

queens 145

race 1, 5, 7, 10, 15, 159
realism
and art 170–1; Brechtian critique of 164, 171; classic 159; epistemological 164; and fantasy 122, 146; feminism and 165; literary 164; and modernism (Wollen/Clark debate) 157–8; and photographs 124; representation 171; and Rossetti 123–4
reflection theory 28, 63
regime
of power 1; of representation 14; of truth 9
Rembrandt van Rijn 28
Renoir, Auguste 73, 74, 80; *The first outing* 75; *The loge* 75, 76; *Madame Charpentier and her children* 80
representation
art history as system of 96; cinematic 121, 140, 147–8, 153–4, 159, 175; definition of 6; and femininity 188; in feminist practice 155–99; and Marxist theory 6–7, 27; in nineteenth century 13; pictorial space of 63; and realism 171; regime of 14; and sexuality 153; spaces of 64; and subjectivity 164
Reynolds, Sir Joshua 44
Richon, Olivier 171
Riegl, Alois 18, 23
romantic: love, and art 109; novels 105; topos 104
Rose, Jacqueline 13, 120
Rossetti, Christina 106, 126–7
Rossetti, Dante Gabriel
drawings by 111–13, 122; feminist readings of 12, 13, 121, 124, 126; and Elizabeth Siddall, *see* Siddall,